FILM
AND
VIDEO
ART

Edited by Stuart Comer

FILM AND VIDEO ART

Tate Publishing

First published 2009 by order of the Tate Trustees
by Tate Publishing, a division of Tate Enterprises Ltd,
Millbank, London SW1P 4RG
www.tate.org.uk/publishing

© Tate 2009

With thanks to C Richard and Pamela Kramlich for their
generous donation towards this publication

British Library Cataloguing in Publication Data
A catalogue record for this book is available from the
British Library

ISBN 978-1-85437-607-7

Distributed in the United States and Canada by Harry N.
Abrams, Inc., New York
Library of Congress Control Number: 2006937946

Designed by 01.02
Printed in Hong Kong by Printing Express Ltd

Frontispiece: Tactia Dean, *Kodak* 2008 (detail of p.150)
Pages 6–7: Gary Hill, *Inasmuch As It Is Always
 Already Taking Place* 1990, 16-channel video
 and sound installation, Museum of Modern Art,
 New York 1990–1
Page 12: Phantasmagoria from *Memoires Recreatifs,
 Scientifiques et Anecdotiques* (detail of p.16)
Page 26: László Moholy-Nagy, *Ein Lichtspiel Schwarz
 weiss grau (Light Play: Black-White-Grey)* 1930
 (detail of pp.38–9)
Page 46: Chris Welsby, *Colour Separation* 1974
 (detail of p.62)
Page 66: Andy Warhol, *Outer and Inner Space* 1965
 (detail of p.78)
Page 86: Catherine Sullivan, *The Chittendens* 2005
 (detail of p.106)
Page 122: Richard Billingham, *Fishtank* 1998
 (detail of p.130)
Page 132: Grahame Weinbren, *Sonata* 1991/3
 (detail of p.139)
Page 144: Tactia Dean, *Kodak* 2008 (detail of p.150)
Pages 152–3: Tacita Dean, *Disappearance at Sea* 1996,
 16mm colour anamorphic film with optical
 sound (detail)

Contents

Editor's Note

Anthony McCall
Between You and I 2006
Installation at Peer/The
Round Chapel, London
2006

A polymorphous camera has always turned, and will turn forever, its lens focused upon all the appearances of the world.[1] Hollis Frampton

It remains one of the many fascinating ironies of artists' film and video that the history of this diverse body of work, defined to a large extent by its use of light, has remained until recently in the dark. Large episodes within this unwieldy history of vanguard artists, visionary experiments and promiscuous technologies have remained completely invisible. Fortunately this occluded history is gradually moving back into focus due to the wide-ranging use of video and film in art exhibitions internationally. As many emerging artists exploit the digital glow of the internet, others return again to the dark space of the cinema, celebrating the fluidity of a medium marked by constant technological shifts. The artist Anthony McCall has suggested that the worlds of art and of avant-garde film are like the strands of Watson and Crick's double-helix model for DNA, spiraling closely around one another without ever quite meeting.[2] This book travels around and across these threads to trace, articulate and bring together some of the rich and varied histories of artistic engagement with the moving image.

For more than a century, artists using cinematic and televisual media have challenged and exploited the industrial, commercial and formal conventions that automatically arise to regulate any new moving image technology. These experiments have encouraged significant shifts in our understanding of the intricate relations between images, perception, authorship, time, space and our own corporeal presence as viewers. As the radical proliferation of moving image technologies continues to accelerate and extend into the twenty-first century, it becomes increasingly urgent to identify, exhibit and understand this hybrid history so we can establish our critical bearings within our rapidly evolving media culture.

It has not been assumed that only one trajectory can be plotted through these narratives. Rather, each text in this publication has its own thematic coherence, relating not simply to movements and modes in prior moving image work but also to the multiple threads that feed into film and video art practice at any given time. The volume aims to introduce and examine the importance of artists' film and video within the broader context of the history of art, and to acknowledge its relevance to cinema, performance, the gallery, television, the internet and beyond, not to mention its crucial role in dissolving the boundaries between these various areas of practice.

Artists have used the camera, the screen, and the space in between. They have used magic lanterns, slide film, Super-8, 16mm and 35mm film, video on monitors, video on multiple screens, video projected to a spectacular scale on urban buildings and downsized to the smallest of portable devices. They have produced one-minute films, eight-hour films and videos streaming infinitely online. There are cameraless films, hand-painted films, films produced according to strict rules, and films that defy every conceivable rule. Artists have used the projected image as a mirror, a weapon, an analytical tool, and a *mise en abyme* in which the virtual and the real unfold into one another with increasing complexity.

Just as YouTube confessionals find precedent in the earliest video experiments by Joan Jonas and Vito Acconci during the late 1960s, the split optics, fragmented screens and decentered networks we now experience through immersive video installation and the internet are unthinkable without the psychedelic multi-screen environments of Stan VanDerBeek's *Movie-Drome* 1963, the three-screen 'Polyvision' system Abel Gance developed for his film *Napoléon* in 1927, and even much earlier optical devices.

For all the vibrant diversity of these approaches, artists have always met substantial challenges to funding, presenting and distributing film and video

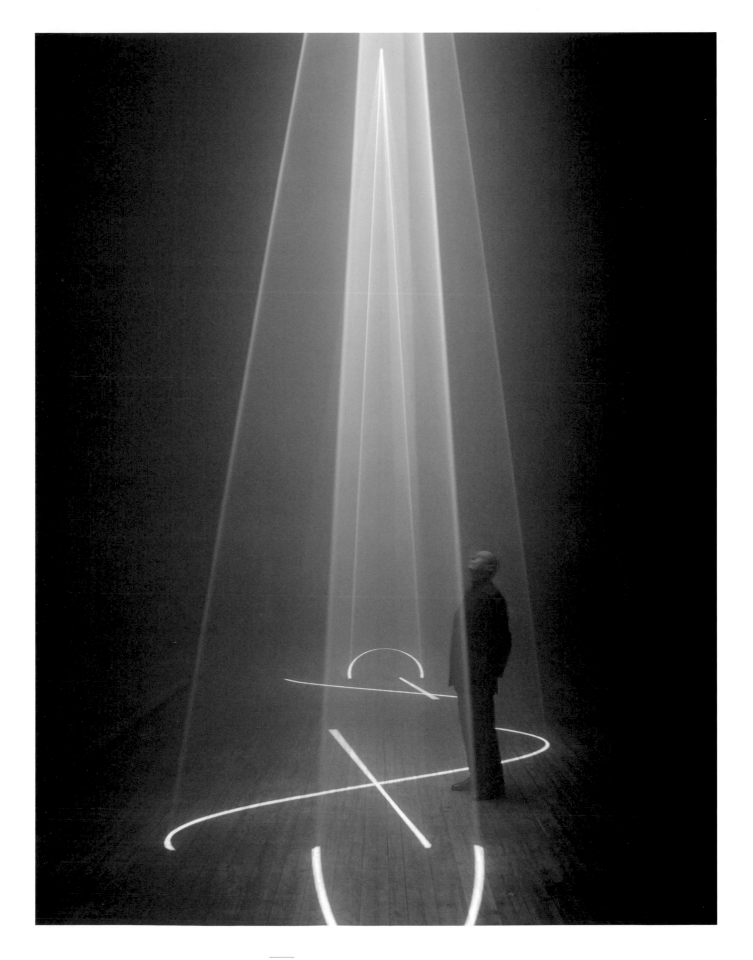

work. Neither the art world nor the film and television industries have successfully devised an economy or an architecture that fully accommodates and activates the radical potential of the moving image. While the history of experimental film remains rarely shown in either the multiplex or the art museum, the recent embrace of video, documentary and cinematic installation in the gallery still for the most part politely ignores its roots in Expanded Cinema, radical political filmmaking, experimental animation, and many other moving image genres. Fortunately, while some artists march headlong into new digital terrain to further complicate and expand the possibilities of these media, many others help to unearth repressed histories as they experiment with increasingly obsolete media such as 16mm film.

This publication attempts to rewind through the myriad permutations of moving image practice to plot a roughly linear history in which each chapter considers a specific period of time and the tendencies it witnessed. Ian White asks how and for whom have histories been developed to comprehend techniques for the illusion of movement that pre-date cinema as it is commonly recognised. How do we come to grips with a medium whose very nature, as well as its history, is defined by loss and dematerialisation? A.L. Rees provides two lively and detailed chapters, split roughly between the pre- and post-World War II eras. He chronicles the shifting priorities of various film avant-gardes as they coalesced around strategies for either abstraction or for 'new visions' of the real. Christopher Eamon considers one of the defining traits of moving image work, its temporal and ephemeral nature, focusing in particular on the mid-twentieth century explosion of performance and intermedia work that rethought our relationship to time. Michael Newman provides a comprehensive atlas for navigating the decided shift from cinema to gallery that occurred during the 1990s. He eloquently details how remediation has transformed not only the moving image itself, but also the subjectivity of the viewer. As the internet dramatically transforms the fundamentals of broadcast media, it is easy to forget the radical potential once offered by television and its mass audience. John Wyver discusses the utopian promise of video art on television, and why it proved to be short-lived, while Christiane Paul focuses on the shift from celluloid to software that has defined the digital age. She outlines the turn towards interactivity and virtuality that has melted the structures of cinema into a decidedly more hybrid affair. Finally, Pip Laurenson grapples with both the philosophical and pragmatic concerns that define the conservation of time-based media. The acute vulnerability of film and video, and the difficulties that surround its preservation, remain significant factors facing the institutional collection, and therefore the posterity and visibility, of artists' moving image work.

Artists such as Len Lye scratched the film-strip to render visible the hidden medium with which the filmmaker works, and this publication similarly seeks to scratch the surface of an overwhelmingly large and complex field in order to shed more light on its secret histories as well as its thrilling possibilities. It is doomed to neglect vast quantities of artists and practices, in particular those in regions of the world beyond Western Europe and the United States. Countries such as Brazil, China, India, Lebanon and Poland have become vibrant hubs for moving image work by artists, and increasingly scholars and curators have offered impressive evidence that histories in these areas run very deep indeed. As media archaeologies become more sophisticated, one hopes that the focus will become naturally more international as the digital shift furthers our hopes for a more global approach to practice and history.

In addition to my own editorial role, *Film and Video Art* has been shaped by two people in particular – both of whom have been instrumental in developing a stronger platform for the importance of film and video at Tate. Gregor Muir first proposed a volume of this kind during his tenure as Tate's inaugural Kramlich

Curator of Contemporary Art, during which time he developed a collection strategy for moving image work and co-curated the exhibition *Time Zones: Recent Film and Video* (2004). Sophie Howarth, formerly Curator of Adult Learning at Tate Modern, further developed plans for the book while she also presented crucial film programmes such as *Shoot Shoot Shoot – The First Decade of the London Film-Makers' Co-operative and British Avant-Garde Film 1966–1976* (2002, curated by Mark Webber) and *Flashing Into the Shadows: The Artists' Film After Pop and Minimalism 1966–1976* (2002, curated by Chrissie Iles and Eric de Bruyn). With gratitude to Gregor, Sophie and all of the authors of this publication, it is my sincere hope that our efforts will provide the information and insight necessary to ignite an increased interest in this overlooked and urgent area of artistic practice.

1 Hollis Frampton, 'For a Metahistory of Film: Commonplace Notes and Hypotheses' (1971), *Circles of Confusion: Film, Photography, Video, Texts 1968–1980,* Rochester 1983, p.111.
2 Anthony McCall, 'Line Describing a Cone and Related Films', *October*, no.103, Winter 2003, pp.42–62.

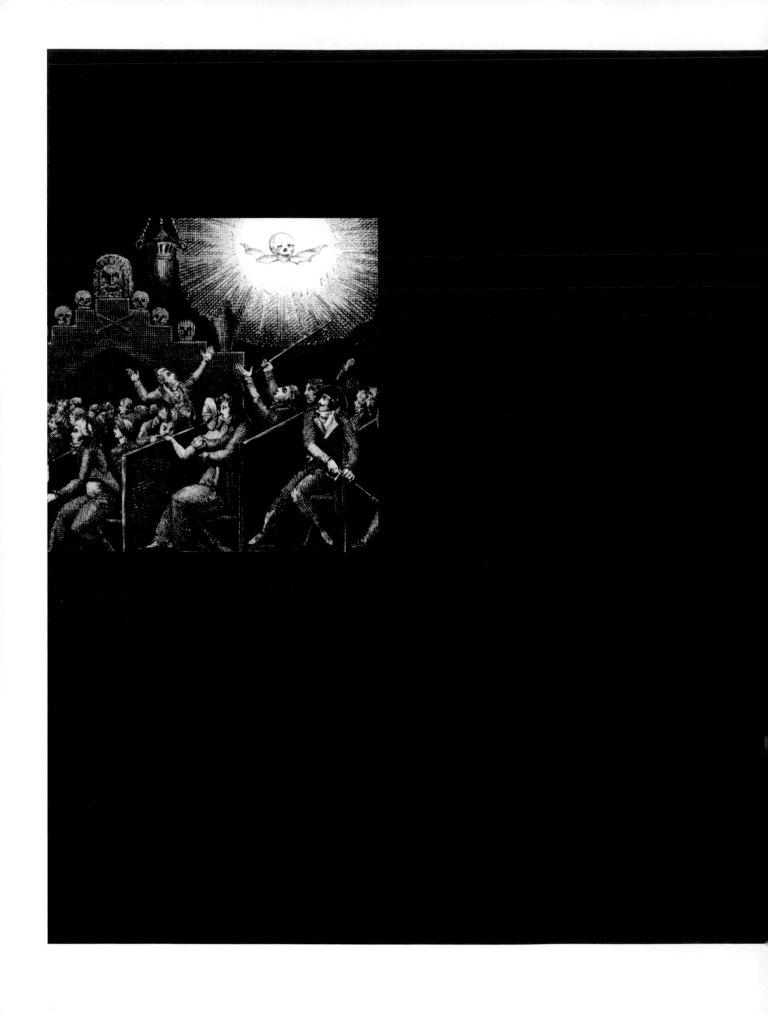

Ian White

LIFE ITSELF!
THE 'PROBLEM'
OF PRE-CINEMA

'Cinema.' It is a word that everyone understands, because it is something that almost everyone has experienced. We go to the cinema. The word means both the building and what we see there. Box office, popcorn, the auditorium, narrative films of a certain length, of one genre or another: the experience is so complete that many people do not think of these kinds of films as being just one amongst many kinds of films – and videos – that might be shown in the very same auditorium. We do not think about the industrial system of production and distribution that generates our assumptions about cinema as just one way amongst others by which things might be organised. This other work – let us say, work made by artists – is remarkably different from the institution that comes to mind when we read the word 'cinema'. So the category of experience and architecture evoked by this word needs to be refined – differentiated – to make any account of what artists' film and video might actually be, how it is made, what its structure might be, its politics, how we read it.

Early moving-image devices such as the Magic Lantern and the Camera Obscura are routinely termed 'pre-cinematic'. But the division between 'pre-cinema' and 'cinema' along technological lines is also problematic. When exactly does pre-cinema begin to manifest itself? What is this 'cinema' that the 'pre-cinematic' comes before? Is it an undifferentiated everything that comes after the moment of Antoine Lumière's first public screening of a film at the Grand Café in Paris on 28 December 1895? The cultural theorist Raymond Williams, in his book *Television*, characterises such events as the capitalisation of the sideshow into the 'established form' of the 'motion-picture theatre', where the theatrical auditorium becomes a new system of social communication.[1] By this definition, the birth of cinema is a specifically economic variation of a form – let us call it 'industrial cinema' – rather than the invention of a new one. How useful, then, is this division between a technology-based before and after?

Perhaps it is more relevant to trace the roots of the illusion of movement sought not only by moving-image technologies but also by sculpture and painting. We may then find that divisions between pre-cinema and cinema can be made along different lines, whose divergent trajectories can still be seen in artists' moving-image works today. This essay condenses the information from two different books – Laurent Mannoni's *The Great Art of Light and Shadow* and Philippe-Alain Michaud's *Aby Warburg and the Image in Motion* – and cites some artists' films and videos that further complicate or elucidate an otherwise binary relationship between cinema and what came before it. Moreover, it points out a profound contradiction that characterises the illusion of reality sought by industrial cinema.

Whose History?

Laurent Mannoni's *The Great Art of Light and Shadow: Archaeology of the Cinema* (first published in 1995 in French, translated into English in 2000) is widely regarded as the most thorough account of (technological) pre-cinema to date. Based upon Mannoni's extensive practical and academic research as curator of the collections of equipment at the Cinémathèque Française and the Centre National de la Cinématographie in Paris, it describes various forms of moving image from the Camera Obscura to the Magic Lantern and the invention of celluloid. In his introduction to the book, the academic Tom Gunning claims that the common desire to locate the origins of cinema in such ancient practices as 'the attempt to capture motion in cave paintings, the succession of images in Egyptian tombs, or in the shadows cast on the walls of Plato's cave' is more useful in terms of appreciating how the form is culturally understood than of explaining its invention. Mannoni's history begins, by contrast, in 'the sixteenth- and seventeenth-century renaissance of science and technology in Europe'.[2]

He starts with the Camera Obscura – literally, Latin for 'dark chamber'.

TAB: I.

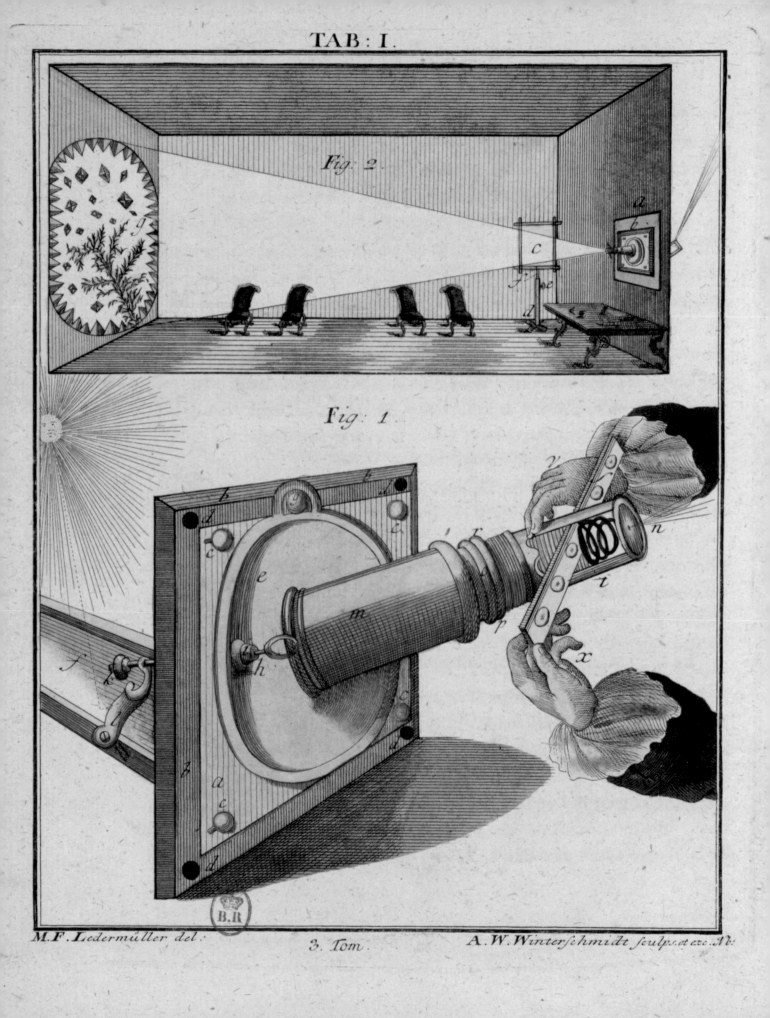

Fig: 2

Fig: 1

3. Tom.

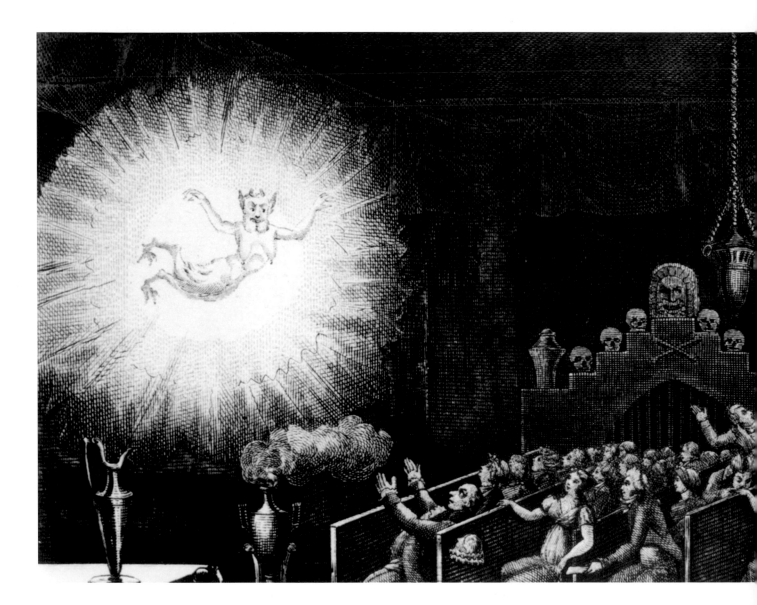

Phantasmagoria
from *Memoires
Recreatifs, Scientifiques
et Anecdotiques* by
Étienne-Gaspard
Robertson, Paris 1831
Engraving
Bibliothèque nationale
de France, Paris

If a room is in darkness with a small aperture open onto the daylit world, an image of what is outside will be projected, upside down, into that room. Werner Nekes, the filmmaker and collector of optical devices, claims its 'optical principle' to have already been recognised by Chinese Mohist mathematicians in the fourth century BC.[3] It reappears in Aristotle's observation of the image of a solar eclipse from inside the dark canopy of a plane tree. It is the basis of the camera/projector that was originally purpose-built as a scientific instrument for the viewing of the sun, to a design that remained practically the same from the thirteenth to the sixteenth century. Leonardo da Vinci described how the device was as much the model of an eye as it was an embryonic machine, and how it could also turn actual objects into images. In 1589, another Italian, Giovanni Battista della Porta, described how not only objects, but (choreographed) people on the outside of the chamber, complimented by sound on the inside, introduced narrative and fantasy to the projected image.

As well as defining a range of basic operations, the Camera Obscura also conceptually defines the terms of our debate. The bulb of the film projector is the metaphorical sun of the Camera Obscura. But in the Camera Obscura, that which is being projected is actually there, outside the room, present in the same literal instant as its image is viewed. The Camera Obscura was used both scientifically and as a device for conjuring spectacle, and it also institutes what would become the exploitable assumption: that the projected image is always somehow connected to the sense that what is being watched is actually there – the implication of industrial cinema and its codes. That the screen is a window onto a world that we must believe actually exists is the determination of standard narrative film: to entertain through identification and empathy.

Mannoni describes the development of the Camera Obscura in the name of entertainment and occasionally of science, whereby increasingly complicated arrangements of mirrors and lenses were added in order to produce the increasingly convincing illusion of the image as 'reality'. He credits a seventeenth-century scholar, the Dutchman Christiaan Huygens, with the invention of the Magic Lantern in 1659. (It had been falsely claimed as his own by Athanasius Kircher in the second edition of his extraordinary book of 1644, *Ars Magna Lucis et Umbrae*). Huygens used his skills as a scientist to develop a machine that would feature a precisely calculated combination of perfectly wrought lenses to project a series of slides (drawings onto glass) that ultimately effect the entirely mechanically produced illusion of a moving image. Afraid that the potential commercial exploitation of his Lantern would be a populist and anti-scientific co-option, negatively impacting on his scholarship, Huygens determined his own invention as a folly, obscured his authorship of it and attempted to divert its dissemination.

Regardless of his efforts, the Magic Lantern, with modifications, not only endured but also raised the realism stakes for the next two centuries. Like the Camera Obscura, portable versions of it ensured its international success (via travelling showmen and as home entertainment). At its most baroque, the Magic Lantern was the modest device behind what by all accounts were the extraordinary spectacles known as Phantasmagoria, dominant throughout the nineteenth century and another capitalised sideshow.

Étienne-Gaspard Robertson opened his impressive Fantasmagorie in Paris in 1798 in the eerily appropriate Couvent des Capucines – becoming one of a number of attractions in the semi-derelict convent, with its tombstones and cloisters (a late eighteenth-century entertainment complex). His show terrified, amazed and mystified audiences with its conjured figures that seemed actually to move, to be there in reality, rushing towards spectators only to miraculously disappear. Hidden from view, it was the projector itself that was moving, displaying increasingly finely painted slides and deliberately preying upon

superstition and quackery for its impact. This modified Magic Lantern ran on tracks forwards and backwards, had adjustable lenses, a range of projection methods, was accompanied by theatrical sound effects and was hugely successful. Entry to the rooms in which the show occurred was through a disconcerting series of initially darkened passageways – disorientating spectators in a way not entirely unfamiliar to cinema audiences in the twenty-first century, moving from box office to auditorium. The Fantasmagorie was a deception of the highest, finest, order that exploited technological modifications and audiences at once. It was also, according to Mannoni, 'one of the greatest precursors of the cinematograph show'.[4]

This was big business and with it came competition. Robertson filed for a patent in January 1799 against the backdrop of a rival show, the Fantasmaparastasie, staged by Léonard André Clisorius. Robertson succeeded in temporarily closing Clisorius's show, only for his tactic to backfire when the reports of the state-appointed official scientists' examination were made public. The very mysteries that sustained the spectacle (and Robertson's income was dependent on his secret techniques) had been systematically detailed, and were now in the realm of public knowledge rather than protected as the pseudo-science of personal, special powers. A rash of new shows opened across Paris and, eventually, Europe.

The Magic Lantern – or variations of it – was not only one of industrialised entertainment's finest prospects; in tandem with its provision of mass spectacle, it was also used academically, politically and in science proper. In Germany around 1685, a book by Johannes Zahn, a monk, suggested that the device could be used to project time itself, or the exact direction of the wind at any given moment, and could magnify botanical specimens. Modified into something called the

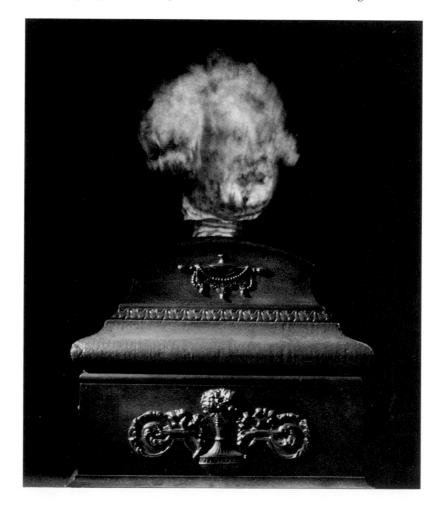

A portrait of Danton projected onto smoke coming from a sarcophagus
Recreation of the 1790s performance from *Etienne-Gaspard Robertson: La vie d'un fantasmagore* by Françoise Levie, Brussels 1990
Bibliothèque nationale de France, Paris

Megascope around 1756, the Magic Lantern was able to project whole paintings and sculptures, by placing them inside an enlarged lantern box. The Comte de Paroy, in around 1791, suggested that Queen Marie Antoinette should consider the device as an educational aid for the irrepressible Dauphin. In 1789, it assumed a wider political power, providing, in the context of the travelling fair, convincing, urgent slide shows of aristocratic abuses of the French people. In London, the Royal Polytechnic Institution, founded in 1838, became a temple to projection, featuring exquisitely painted slides that reinforced the projected image's relationship to pedagogy, often detailing journeys of discovery, pioneering adventurers and story-based lessons in natural history.

As competition for audiences increased, the painted image used for projection continued to be refined in the form of such hand-painted wonders as the Panorama (a painted 360-degree view) and the Diorama (also a 360-degree view, which demonstrated the passage of time, from day to night, for example, through lighting effects). Like the Phantasmagoria, both were housed in purpose-built spaces, the architecture of which was integral to its illusion. Louis Jacques Mandé Daguerre opened a famous Diorama in Paris in 1822 with Charles Marie Bouton that was destroyed by fire in 1839. After a period of collaboration with Nicéphore Niépce, he revealed the first Daguerrotype, the photograph's precursor, in the same year.

The transition from the painted to the photographic slide was accompanied by the mechanisation of projection machinery. Devices such as the Thaumatrope (a flat disc with different images painted on either side that merged when the disc was spun) or the Zoetrope (still images arranged on the inside of a drum, the sides of which contained viewing slits, which are seen to move when it is spun) were introduced. These worked on the principle of perfect illusion: the regulation of the space between images could be correlated to the length of time for which the retina would retain an image after it had passed.

From around 1872, Eadweard Muybridge developed a way to photograph movement in animals and humans using multiple cameras, rapidly taking shots one after the other, but it was scientific study that interested him, not moving images, and his methods were obsolete by 1890. In 1881–2, Étienne-Jules Marey wanted to find a method to photograph the flight of birds. Taking its cue from Pierre Jules César Janssen's 'revolver' (used to photograph the passage of Venus across the solar plate), Marey's 'photographic rifle' was able, as a single instrument, to take successive shots from one point of view (despite which its images were still displayed either as a series of stills, or animated via the drum of a Zoetrope rather than projection). Etienne-Jules Marey's Chronophotography, the capturing of a rapidly executed series of still images to describe movement, developed from 1882, and the American Edison Kinetoscope, invented to project series of still images in a peep show-like box, for individual viewers, evolved from 1891.

Celluloid was christened in 1872, although it had been available for a few years prior to this. The critically important perforations (the simple modification that allowed the filmstrip to be moved accurately in the camera and the projector) were introduced circa 1889. Edison used celluloid in his Kinetoscope around 1894, while a number of developmental projection devices had extended the investigation of how to project a series of (hand-drawn or photographic) images rapidly, one after the other, including Marey's chronophotographic projector and his sometime co-worker Georges Demenÿ's Phonoscope.

This list of inventions might give the impression that they happened regardless of social or economic circumstance, that the imperative to capture and reconstitute reality is a given compulsion. If it does, then this illustrates the fact that such a linear telling of this history is also a 'problem'. It was precisely a combination of the social and economic possibilities of technological 'progress'

that the Lumières exploited at what we regard in this history as the birth of cinema. The Lumières were credited with the first public filmshow in 1895, after developing their Cinématograph with Jules Carpentier. Their projection machine precision-manoeuvred the perforated filmstrip and co-ordinated this action with the opening and closing of a shutter to mask the strip and to produce the illusion of the moving image. When Antoine Lumière organised this screening on 28 December 1895, he pulled into focus the paradigm of cinema that we receive today – a paradigm with an economic base and a simultaneous socialising effect: to make money by bringing people together, or to show the same work to the maximum number of ticket-buyers the maximum number of times.

Antoine's public screening followed a private event at which one of his two sons, Louis Lumière, had shown, amongst other things, a one-minute long film – a film that was also the first to be shown in December. It was spectacular not because it presented fantasy, costumes, narrative. Its brilliance was measured by the degree of detail it could present of an everyday event. In the hierarchy of reality, its image emulated life: mundanity was thrilling, more incredible than the smoke and mirrors of the Phantasmagoria. Its subject? Workers leaving a factory at lunchtime: industrial cinema.

Which beginning?

In a later essay, Mannoni replaces the term 'pre-cinema' with the term 'art of deception'.[5] In this way, he extends the scope of cinema as a category to incorporate such devices as Marey's Chronophotography and the Kinetoscope. Such a reorganisation of the category erodes the link between cinema and the theatrical auditorium (and its social, cultural and economic determinants), and asserts that, whatever its materials, the form is defined by its illusion of movement. Creating the effect of the real meant perfecting the art of deception.

At the other end of the spectrum is an entirely different set of relations between art, movement and culture explored by the art-historian Aby Warburg that is described in Philippe-Alain Michaud's book. From the late nineteenth, into the early twentieth century, Warburg developed not so much an art history as a methodology of cultural analysis based upon depictions of movement, such that it entirely avoids the determining terminology of pre-cinema/cinema while still describing something that has a cultural if not technological relevance to our own enquiries. Warburg did not pay particular attention to the phenomenon of the moving image. His work was peculiarly transhistorical, transgeographical and transcultural, a kind of visionary anthropology. He rejected the art-historian J.J. Winckelmann's assertion that the great link between the Renaissance and Antiquity resided in its appreciation of classicism as stasis. Instead, Renaissance painting (that of Sandro Botticelli in particular) was redefined through its interpretations of Antiquity's representations of gesture – the serpentine body in motion. Warburg's early work on Botticelli's *Birth Of Venus* (1484–6) was centred around contrasting readings of the Hellenistic sculpture of the mythological figure Laocoön and his sons, strangled to death by sea snakes as he made sacrifice at the altar of Neptune. Winckelmann understood this sculpture as 'an example of static serenity' proven by 'the violent contradiction between the calm appearance of the hero's face and the twisting of his limbs'. Warburg came to the opposite premise – that motion, not stasis, was the focus of the sculpture – using it to read Botticelli's painting as representing not only the (photographic) instance of the action it depicted, but the whole of the action as if it were being observed (filmed) over time. Representation in the painting had been 'taken to the point where movement yields the formula of its recomposition'.[6]

Warburg connected the Renaissance and Antiquity through the Intermedi – astounding, city-wide, public theatrical spectacles organised in Florence in 1589 to celebrate the marriage of Archduke Ferdinand I through a combination of

pageantry, supernatural stagecraft and symbolism. He compared this with the rituals of the North American Hopi Indians that he had personally experienced in 1895, these discrete sources being yoked together by their visual, socio-cultural or cognitive parallels.

Bernardo Buontalenti's redesign of the old Uffizi theatre for the Florentine Intermedi that Warburg studied involved the introduction of the proscenium arch, framing the stage, separating audience from spectacle. The visible frame, in physically demarcating life from art, fundamentally established the possibility of illusion. Philippe-Alain Michaud quotes Eisenstein's claim that the proscenium arch is one 'of the first manifestations of cinematographic space'.[7] This is the same sixteenth-century moment in which Mannoni found his own, different origins for cinema.

As Michaud describes it, Warburg's project stands in metaphorical relationship to the devices that anticipated industrial cinema. Michaud quotes William Dickson's description of first showing his newly developed Kinetoscope in 1889 to the man who employed him and whose name the device would be given: Thomas Edison. He projected a film of himself on a four-foot-square screen: 'The crowning point of realism was attained … when Mr Dickson himself stepped out on the screen, raised his hat and smiled.'[8] Dickson's 'moving' figure is described not as an image, but as the man himself. The Kinetoscope was effectively a remodelling of the camera used to record the images it projected, and this machine had effected the convincing reconstitution of movement.

Dickson's films were made in the purpose-built Black Maria (nick-named after the police van that its odd shape resembled), a bizarre room with a ceiling aperture, the whole of which rotated smoothly, annulling the effects of the sun while harnessing its power, suspending his subjects not only in space but also in time. The figures in the films are removed from any kind of local context, posed against an empty ground that echoed early Renaissance painting. In the Black Maria on 24 September 1894, Dickson recorded two performances by Native Americans, passing through town with the Buffalo Bill Show. The recordings (*Indian War Council* and *Sioux Ghost Dance*) prefigured the trajectory of Warburg's anthropological inquiry into their indivisibility of symbol and movement. But to suggest them as anthropological relies upon our art of deception: removed from time and space in the Black Maria, these performances were not observed rituals, but the doubly artificial recordings of culture re-enacted.

The ultimate expression of Warburg's work was the epic compendium he called *Mnemosyne* (Memory), begun in 1923. An art history with an exclusively visual text, without words, it summarises his odyssey of association. Against a black ground, Warburg places disparate yet comparative, remarkably relating images; pictures of things relate to images of paintings, non-art to high-art, in dynamic arrangement. Each page of images is then re-photographed. Michaud relates these pages to Sergei Eisenstein's theory of montage, the combination of elements becoming their product rather than their sum. Critically, *Mnemosyne* is not a film, but is structured *like* a film, and the theory it proposes is indivisible from its means of articulation.

Is *Mnemosyne* pre-cinema? And can we ask the same question of the sculpture of Laocoön and the paintings of Botticelli? Are pedagogic situations, such as the slide shows of French aristocratic abuse and the Royal Polytechnic Institution screenings described above, cinema or pre-cinema? Rather than defining them as something that came before – that led up to – the moment of 'cinema', could we see them as related to the newsreel, the public information film, anthropological film, the advertisement, the party-political broadcast? Is this 'cinema' that seems to be so defining not actually part of a continuum of images that might also incorporate the 'teaching' offered by stained-glass windows or religious painting, the social status of a fresco?

Life itself?

There is no motion in a motion picture,
Only the projector moves the strip,
Pulled along by wheels and sprockets,
The protruding teeth to get a grip. [...]

The importance of holes is no delusion,
To them we'll always be the thrall,
For providing us with all the illusion of movement,
On a flat white wall.

From Owen Land, *On the Marriage Broker Joke as Cited by Sigmund Freud in Wit and its Relation to the Unconscious or Can the Avant-Garde Artist be Wholed?* 1973–7

The making and distributing of feature films – industrial cinema – provides the form and/or content for a number of artists' work, or becomes a model of exhibition for it, to varying degrees. Joseph Cornell's *Rose Hobart* 1936 condenses George Melford's feature film *East of Borneo* 1931 into a twenty-minute montage focusing on the actress of Cornell's title. In Douglas Gordon's *24 Hour Psycho* 1993, Alfred Hitchcock's *Psycho* 1960 is slowed down to a duration of twenty-four hours and projected onto a screen in the gallery. We cannot watch the film in full; it becomes an object of consideration rather than a narrative entertainment. It manifests its acritical reverence for industrial cinema and for this particular example of it, by turning the original film into a quasi-religious object of worship.

Differently, the Austrian artist VALIE EXPORT's first feature film, *Invisible Adversaries* 1977 is not an artwork, but what we might understand as an independent or art-house feature, available to rent from specialist distributors. The American artist Sharon Lockhart makes 35mm films (as well as photographs) and while the films might be shown (and sold) in the gallery, they are also – like *Invisible Adversaries* – in distribution. Matthew Barney's films are shown in cinemas but are not in distribution.[9] The appropriation of industrial cinema is perhaps nowhere more complete than in *Zidane: A 21st Century Portrait* 2006, by Gordon and Philippe Parreno, where the work was commercially mass-distributed *and* acquired by museum collections. Each of these works assumes a different position towards or away from industrial cinema, and it is precisely this that turns the commercial form into a strategy for the artwork or uses the content of its products (feature films) as material. Some of these works might occupy a place in industrial cinema, but they are also *about* it.

There is another legacy where, historically and politically, industrial cinema has theoretically informed artistic practice, providing a set of terms, a standard structure and operating principle to react against: narrative, pleasure, fantasy, escapism – illusion – and their manifestations of ideology. Those artists working in the New York and London Filmmakers' co-operatives in the 1970s (Michael Snow or Peter Gidal, for example) – working, then, between the theatrical auditorium and the gallery space – made works that were explicitly anti-narrative, repetitive, theoretically informed and attempted the opposite in terms of content to industrial cinema. Again, these works (in part) are about industrial cinema, but not of it.

Yvonne Rainer's film *Journeys from Berlin/1971* 1980 deploys a variety of pedagogic structures that relate more to the public lecture than to the tropes of narrative or entertainment in industrial cinema. It variously combines readings from the memoirs of political activists (the Red Army Faction, Vera Zasulich in nineteenth-century Russia, Emma Goldman) with a conversation about the nature of revolution and political violence, a surreal therapy session, diary extracts and a scrolling text that provides information (dates, times) on the activity and arrests of Andrea Baader and Ulrike Meinhof, amongst others. Images

Kutlug Ataman
The 4 Seasons of Veronica Read 2002
Four-screen video installation, Museum of Contemporary Art, Sydney, 2002

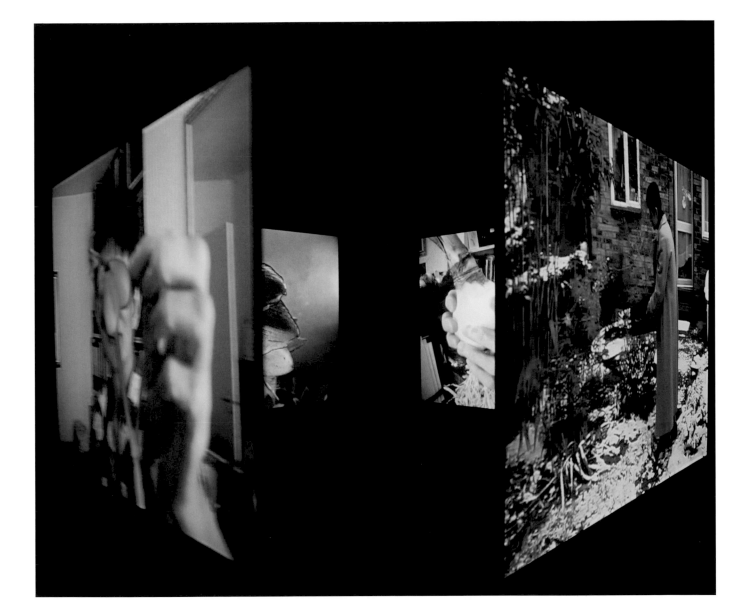

do not illustrate these stories, but present another layer of interpretation, another element that the viewer must read – voices are heard against a panning aerial shot over Stonehenge, pharmacies in Germany, a mantelpiece repeatedly seen displaying different objects – to such an extent that the viewer becomes entangled in a web of readings and this becomes the content of the work.

Sited not in the auditorium, but in the gallery, Kutlug Ataman's *The 4 Seasons of Veronica Read* 2002 is a four-channel installation work. It documents the life and obsession of a British woman dedicated to raising Amaryllis bulbs. The work is a sustained, durational study, the record of an intense engagement between the artist and the cultivator. It not so much documents as gently exposes her relentless, compulsive activity. As such, it is not a documentary that constructs an argument over a fixed period of time, but a work that reveals its subject, slowly, obsessively – like a scientific experiment rather than a cinematic spectacle, like a culture growing in a petri dish.

The filmmaker Owen Land's Poet, in the quotation that opens this section, speaks in pithy, ironic eulogy to another material element of the moving image: the humble hole. Mannoni's *The Great Art of Light and Shadow* might be read as the story of this same hole. It is also a history that identifies these two divergent legacies – the image as object of worship, and the image as material – as constituting the development of the medium. In his history, Mannoni quotes a journalist describing the public Lumière screening, whose remark echoes the enthusiasm that Michaud emphasises in Dickson's account of the Kinetoscope: 'It was life itself, it was movement captured in real life.'[10] This recurring motif, pivotal in the (mis)reading of the image as real, exposes a final irony in the linear equation from the Camera Obscura to the capitalised sideshow.

Hollis Frampton's film *Nostalgia* 1971 consists of a series of shots of single photographs. Each photograph is on screen for the length of time it takes for it to curl up, burn, disintegrate on the hotplate on which it lies. As we witness this methodical disintegration, we hear a description not of the photograph we are looking at, but of the one that comes next. When that next appears, we become immediately conscious of that which is past (its description), trying against the passage of time (and the new description being spoken) to remember those previous words. Hearing the new description, we desperately try to retain it for the arrival of what it details. After a number of photographs have gone by in this way, we realise that even in the awareness of our desire to anticipate what

comes next is the inevitability of loss. The film conceptualises cinema. Its entire content is the persistence of that which is not there (not being looked at, not being heard), the opposite of 'life itself', in fact.

The first moving image projected by Huygens' Magic Lantern shows a drawing of a skeleton based on Hans Holbein's *The Dance of Death* 1538. The Phantasmagorian Robertson borrowed most of his techniques from the real inventor of the spectacle, Paul Philidor (a pseudonym), whom he refused to credit. Philidor would produce phantasmagoria shows by special appointment, consoling the grieving with their now 'living' dead, a moving picture of the deceased. The curtain covering Robertson's screen (and Clisorius') showed a picture of a tomb. The sophisticated animation of the Choreutoscope (a slide projection that allowed a gradual changing of shape, developed around 1884) invariably included a 'skeleton dance' that Mannoni links back again to Huygens and Holbein. In 1892, Demenÿ attempted to exploit Chronophotography for financial gain, believing in the potential popularity of the 'living' portrait of the departed, a plan so vast that Mannoni describes it as 'taking in practically all the possibilities of the future cinematographic industry'.[11] Reading this history in this way, reading industrial cinema through an artist's work such as Frampton's *Nostalgia*, it is death, not life, that is the subtext of this place we go to and the things we think we see there.

1 Raymond Williams, *Television*, London 2003, pp. 10–11.
2 Laurent Mannoni, *The Great Art of Light and Shadow: Archaeology of the Cinema*, trans. Richard Crangle, Exeter 2000, p.xxi.
3 *Eyes, Lies and Illusions*, exh. cat., Hayward Gallery, London 2004, p.201.
4 Mannoni 2000, p.171.
5 Laurent Mannoni, 'The Art of Deception', in *Eyes, Lies and Illusions* 2004, p.42.
6 Philippe-Alain Michaud, *Aby Warburg and the Image in Motion*, trans. Sophie Hawkes, New York 2004, p.86.
7 Ibid. p.155.
8 Ibid. p.48.
9 During the course of writing this essay Barney's works have been made accessible to the general public on DVD.
10 Michaud 2004, p.461.
11 Ibid. p.358.

A.L. Rees

MOVEMENTS IN FILM
1912-40

There were two distinct ways in which artists first came to use film in the early twentieth century. Some saw it as a chance to explore pure graphic abstraction in a time-based form, while others seized on the unique properties of the lens and montage editing to produce a 'new vision' of reality.

The first might be called the path of 'visual music', a term coined by the English art critic Roger Fry in 1912 to define a new and 'purely abstract language of form' in the advanced art of his time. His friend the painter Duncan Grant approached this idea in his semi-cinematic *Abstract Kinetic Collage Painting with Sound* 1913–14, a sequence of scrolling coloured rectangles made from cut paper, viewed through an aperture and accompanied by a Bach concerto.

This modest experiment was perhaps a modernist counterpart to the earlier Symbolist-inspired 'colour organs' of Alexander Scriabin, Wallace Rimington and other composer-researchers who believed that musical notes had colour equivalents, and that the tones of sound and vision could evoke each other. This is sometimes called 'synaesthetic' art, because it linked or synthesised the eye and the ear, one sense stimulating the other. Leading European moderns like Wassily Kandinsky, the pioneer of non-figurative painting and its leading theorist at the time, and the avant-garde composer Arnold Schoenberg also planned ambitious stage works that combined abstract colour, drama and sound around 1909–13. Schoenberg wanted to film his opera *The Lucky Hand* (1913) in a style 'of the utmost unreality', but like many other imaginative proposals for artists' cinema in the silent era, it was never made.

The second route to artists' cinema was more pictorial, and not based on an analogy with music. Rather than the goal of pure abstraction, this kind of film art was inspired by the fragmented optics of the Cubists, which had exploded the single point of view and substituted for it an unstable but also dynamic sense of vision. New aspects of the image were revealed by the camera-eye and then reassembled in editing the shots. While painting remained the master-code for the new film art, it here took a different post-Cubist swerve into 'the new objectivism' of such multi-media modernists as László Moholy-Nagy. For this strand, film was also a token of modernity: a new art for the new age. Abstract in a different sense, this path leads to the film poem with its representational content, but also to the avant-garde documentary with its political and radical aspiration.

These distinct paths overlapped, since essentially they were two kinds of abstract cinema that largely ignored the conventions of the acted film or 'screenplay'. But there were differences. The first route, Fry's 'visual music', aimed to bring together image, sound and colour in film, often to fuse them into one sensory experience. The second route, that of post-Cubist film, broke more radically with the musical analogy and the synthesis of seeing and hearing. Here, the shot, edited in fragments even down to the single film frame, led to a wholly new kind of film art, more analytic than synthetic.

Nonetheless, both paths were historically related in complex ways, since each had emerged from their shared origins in Symbolist art of the 1880s. That background was developed and refined in the synaesthetic cinema, and rejected by those who followed the Cubists, but was nonetheless entwined in the trajectories of individuals and movements for the next century and beyond. Examples include Fry himself, or cinema's greatest theorist Sergei Eisenstein, whose early montage films like *Strike* 1924 and *Battleship Potemkin* 1925 were succeeded by the radical melodrama of his late work such as *Ivan the Terrible* 1944–6. But these waves or pulsations in the history of art would have come to nothing, as far as film is concerned, without the scientific experimentation that had led to the invention of the 'cinema effect' in the 1880s and 1890s, in the same era as Symbolist art.

The science of motion was investigated in the photographic studio by Eadweard Muybridge and by painters such as Thomas Eakins, in the USA, and

Fernand Léger
Ballet mécanique 1924
35mm film, silent

in the stricter conditions of the laboratory by Étienne-Jules Marey and his team in France. Using a multi-camera set-up, Muybridge's projects broke down motion into a sequence of stages that led directly to the invention of the cinema. Muybridge himself contrived a zoetrope, or 'wheel of life', to animate and even project the rapid flicker between static images of a running horse or an athlete. Marey ingeniously caught the motion of fencers, athletes, soldiers, birds and animals on a single photographic plate, to track or diagram their actions as a linear sequence. Towards the end of his career (he died in 1904) Marey pre-empted abstract art in a series of vivid photographs of sound vibrations, patterns in water and geometrical figures. The results were startlingly close to the early abstract paintings of such artists as František Kupka and Robert Delaunay. Marey also made some astonishing motion-picture films himself, with the aid of a more showman-like collaborator, Georges Demenÿ.

A direct line is often and rightly traced from Marey to the Cubists and Futurists, who took from his science of chronophotography the raw material for a newly fragmented vision that literally shattered the harmony of appearances. But at the same time, the scientific exposure of a hidden world of abstract motion and form also directly fed the Symbolist imagination. These currents were mixed. Speculations about a 'fourth dimension' (and beyond) figured in the thinking of 'spiritual' artists like Piet Mondrian and Kandinsky as well as of 'materialist' artists such as El Lissitzky and Alexander Rodchenko, in their evolution from late nineteenth-century aesthetics through to the new art of the 1920s and 1930s.

The very first attempts by artists to make films reveal these mixed origins. Pablo Picasso's friend, the Polish-born painter Léopold Survage, planned an ambitious abstract film in 1912–14 that was never made – the paintings for it, on paper, are in the wrong format for the screen – called *Colour Rhythms*. It expressed an impulse to create an abstract light-play finally achieved a generation later by film artists such as Oskar Fischinger. At the same time, the Italian Futurists, brothers Arnoldo Ginna and Bruno Corra, painted abstract shapes of stars and circles in colour on the filmstrip itself. These too do not survive, but are fully described by Corra in his 1912 essay 'Abstract Cinema – Chromatic Music'.

From the Futurists also came the first 'humoresque' films such as *Vita Futurista* 1916, or a short love-story told exclusively by filming the feet and legs of the three protagonists, which set off yet another avant-garde genre, the burlesque or parody film. These acknowledge the impact of the commercial popular cinema, then graduating from side-shows and music-halls to the more sophisticated film theatres sweeping the USA and Europe. Thus, from the same Futurist milieu, before the First World War, came two major forms that dominated the early film avant-garde: the wholly abstract film and the comic/lyric film. But while a visionary Futurist manifesto of 1916 looks ahead to a new art of cinematic 'polyexpressiveness' ('synthetic, dynamic, free-wording ... immensely vaster and lighter than all the existing arts'), at this time artists had only limited means with which to make films at all and their first steps were relatively primitive. This is why the Cubist cinema associated variously with artists from Fernand Léger to Walter Ruttmann and Hans Richter in the mid-1920s was only able to develop a decade after the Cubist painting that inspired it (c.1912–15), when film-making became a more widespread if still limited option.

Man Ray and Marcel Duchamp were ahead of the game in purchasing small ciné-cameras in New York in 1920. With these they made their first experiments, which led to such classics as Duchamp's *Anémic Cinéma* 1926 and Man Ray's *Emak Bakia* 1926. Léger, on the other hand, was asked to collaborate on a film with American cinematographer Dudley Murphy, who wanted to work with a modern artist. Murphy's first attempt, with Man Ray, did not succeed, but some of their footage survives in the now-famous film made with Léger, *Ballet Mécanique* 1924. This is perhaps the key work of the 'Cubist cinema', a prismatic collage of

Hans Richter
Rhythm 21 c.1924–6
35mm film, silent

Walter Ruttmann
Lichtspiel Opus 1921
35mm film, silent

ciné-effects in a rapid montage of urban life, dancing machines and abstract forms. By this time, in Germany, Walter Ruttmann, an architect-painter and studio animator for Lotte Reininger, had made his abstract 'Opus' series (1921–5), which inspired Oskar Fischinger. Hans Richter and Viking Eggeling, from the Dada-Constructivist movement, experimented with scroll-drawings and then films, from around 1919 through to the mid-1920s.

This set the pattern that lasted for the next decade, and survives in our own time. A few of these artists made their films more or less on their own, while others worked with professionals or at the margins of the major film and animation industries. For some, film was an additional medium to add to their practices in – or across – different media. Traditional barriers were being crossed, as by Duchamp, and film had the added excitement of its sheer newness. In general, they made only a few films, if highly significant ones. Other artists, such as Fischinger, took up film as their primary if not sole medium, but this trend did not fully emerge until after the Second World War. The artists of this generation, and many later ones, continued to paint, sculpt or work in other media whether or not they continued to make films. Ruttmann is a major exception, turning exclusively to documentary in the late 1920s.

The films themselves have had a long-lasting impact, especially after abstraction blended with Surrealism (with the ex-Dadaists Man Ray and Richter) or bred a counter-reaction (as with Buñuel/Dalí and Artaud) towards the end of the 1920s. Duchamp's *Anémic Cinéma* is very simple in form, and more critical than celebratory of its medium, as the title suggests. It intercuts sensual, rotating spirals with similarly turning and ungraspable punning texts, heralding conceptual art by a half-century. The wholly abstract films of 1920–8 made in Germany have a different status, as examples of pure cinema, albeit also based on the amalgam of graphic art with time-based media.

Around 1919, in the transition from Zurich Dada to its politicised rebirth in post-war Berlin, Richter and Eggeling first attempted to make their linear, organic scroll drawings unfold and develop in time by proposing to film them. They achieved this, separately, after 1921. Richter became a prolific filmmaker during the Weimar period, his 'Rhythm' series a landmark of the abstract cinema. The interacting and overlapping frames and squares of such films as *Rhythm 21* (probably made in 1924–6) anticipate the digital age when, as Lev Manovich put it, 'the avant-garde became incorporated into the computer'. At the same time they are integral works that reveal form, motion and temporality as their sole and sufficient filmic content. The more professionally accomplished *Opus 1–4* abstract cycle by Ruttmann also begins with organic imagery, as in the conflict between blobs and spirals with hard-edged points and lines in *Opus 1* and *2*. In the last two films of the series, the curves have become sinuous, while the rectangles and lines make up a dazzling and rapid flicker pattern that pre-empts Op art and digital streaming.

Eggeling's austere *Diagonal Symphony* 1924, his only completed film before his early death in 1925, takes the organic theme into cerebral but also intuitive directions. Unlike his peers, he was uninterested in colour, sound or spatial

Viking Eggeling
Diagonal Symphony
1924
35mm film, silent

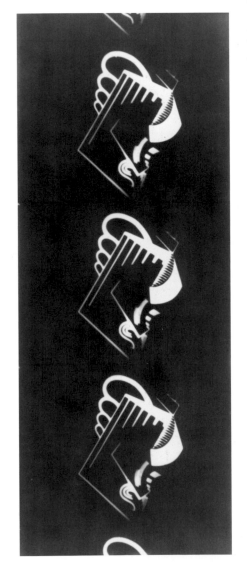

illusion, so that (in contrast to the visual dynamics and push-pull recession and displacement of forms in Ruttmann and Richter) his graphic lines and wedges curve and interact purely on the flat screen surface. Eggeling's intense and serious personality, as well as his search for a 'ground-bass' theory of 'the rules of plastic counterpoint' (in the words of his friend Jean Arp), impressed modern artists such as Paul Klee, Lissitzky and Theo Van Doesberg, the last two of whom publicised and developed his ideas in the 1920s.

But by the end of the 1920s and into the next decade, as political tensions grew in Germany, Italy and Russia, many filmmakers on the left adopted 'the social imperative', as Richter called it. This was the central platform of the second major international conference of avant-garde filmmakers from Europe and Japan, held in Belgium in 1930. In contrast, the first – at La Sarraz, Switzerland, 1929 – had focused on the abstract cinema. It also reflected a growing awareness of the new Soviet cinema, led by filmmakers forged in the crucible of Futurist painting, poetry and architecture, such as Eisenstein, Dziga Vertov and Vsevolod Pudovkin. Their mentors in painting went further. Kasimir Malevich exhorted Eisenstein to abandon drama altogether, as Vertov had, while artists such as Lissitzky foresaw a new age of abstract electrical-mechanical art. But Soviet montage itself, especially in *Battleship Potemkin* and Vertov's *Man With a Movie Camera* 1929, became a prime model for the non-realist codes of fast, elliptical cutting and pace that promised a fusion of political radicalism with experimental cinema.

Celebrating all kinds of experimental film were a host of journals and a smaller number of books, notably by Jean Epstein, Richter and the English writer Winifred Ellerman, known as Bryher, companion of H.D., the American poet. Bryher was an editor of the magazine *Close Up* (1927–33), published in Switzerland, that enthused about the new cinema from abstraction to Soviet montage, documentaries to scientific films. Its contributors included Man Ray, Dorothy Richardson and Eisenstein himself. Typically, film journals were more wide-ranging than later factional accounts of the avant-gardes might imply, embracing the best of Hollywood as well as the international Art Cinema of Carl Dreyer, Jean Vigo, Georg Pabst and Abel Gance, to take film into subjects and styles beyond the commercial norms.

Nowhere was this stronger than in France, where the avant-garde aspiration turned from post-dada abstraction in the early 1920s to a more lyrical and neo-symbolist direction by the end of the decade. This passage – which is also roughly that from Cubism to Surrealism – can be traced in the careers of such prolific directors as Germaine Dulac. Her output includes wholly abstract films made in the wake of Léger's *Ballet mécanique* but also the pointedly feminist *Smiling Madame Beudet* 1923, whose dream sequences evoke the state of mind of a woman oppressed by bourgeois marriage. The French pioneered a second artists' avant-garde, less concerned to transform abstract painting into graphic motion (as did the Germans, for example) than to explore the new optic or 'photogenie' unleashed by the camera lens. This seemed to offer a route to a visual cinema that followed on from the lessons of modern painting, from Impressionism to Cubism and the colour-synchrony of Delaunay and his wife Sonya. Her cinematic designs with Blaise Cendrars (*Trans-Siberian Express* 1913), also indicated the important presence of poets and writers in the French film milieu. Guillaume Apollinaire, founding spirit of dada and Surrealism, was among the first film enthusiasts before his early death in 1918. Survage's drawings had been printed in his own journal, along with many other impassioned hymns of praise to the birth of the 'New Art' of cinema.

The French journals inspired by Louis Delluc and other publicists were like the international 'little magazines' in the rest of Europe that similarly recorded the advances of new abstract films, but in France were more focused on cinema itself than on its relation to the other arts. It was, in a sense, more medium-specific,

partly because the French film-production system encouraged or allowed such innovative talents as Gance, Marcel L'Herbier and Jean Epstein to make full-length films of great complexity and ambition. In addition, and again like the rest of Europe, the French film-clubs – especially in Paris – were cultural centres to promote independent cinema. Some even had the idea – repeated many times over the course of the rest of the century – of making new independent films with funds generated by screenings.

They also published a remarkable quantity of advanced film theory, comparable to the abstract and Soviet school. Along with the sadly short-lived Henri Chomette (brother of René Clair), whose lyric films of urban life and natural imagery include *Five Minutes of Pure Cinema* 1925, Epstein was one of the subtlest exponents of 'photogenie', in which the meaning of an object is transformed by the camera lens. His cheerfully titled 1921 book *Bonjour Cinéma!* sums up an era of first-wave optimism. The works of this French school – in parallel with artists' films by Léger and Man Ray – have had a long life. Gance's *Napoléon* is an epic of modern reconstruction (by British historian Kevin Brownlow) as well as a widely screened epic film in its own right, while the art journal *October* has influentially translated many of Epstein's visionary writings.

But the very successes of this group – sometimes known as the 'impressionists' – were also a limitation. The terse and intensive abstractions of Richter, Eggeling, Man Ray and others, made with minimal professional aid, are personal, authored works that continued to inspire artist-filmmakers in later decades. The films of the French school, by contrast, were often lavishly executed with complex interiors, extras, costumes and even racing-cars. L'Herbier, for example, could draw on the design skills of Léger and Robert Mallet-Stevens for the sets of *L'Inhumaine* 1924. Moments of rapid and visionary montage punctuate his films, and determine the extraordinary non-linear sequencing of Epstein's *The Mirror Has Three Faces* 1927. But the films are also bourgeois melodramas, driven by the central erotic and emotional fantasies of a power-crazed protagonist, sometimes evoking a quasi-symbolist aesthetic that is closer to the turn of the century than to the heady 1920s.

Cinematic impressionism in France was ultimately crushed by two tendencies – realism and Surrealism – that seemed opposite to each other but actually turned out to have more in common as the 1930s turned into an age of political upheaval. An emblematic moment was the uproar that greeted Dulac's film of a screenplay by the Surrealist Antonin Artaud, *The Seashell and the Clergyman*, in 1928. It is sometimes said that the Surrealists despised Dulac's film because of their misogynistic belief that the poet's original savage vision in this oedipul psychodrama had been weakened by her lyrical and impressionist interpretation. The reality was more complex, and Artaud's response to Dulac (whom he continued to respect) more subtle. It confirmed, however, his intransigence; the cinema had to be fundamentally negative, not summoning up the reassurance of the dream or image, and it had to be founded on fracture or 'shock' (a theory also espoused by Walter Benjamin) rather than associative montage (as in Dulac's film).

Artaud's anti-ocular polemics, and those of Surrealism more generally, were expressed concretely that same year in an independent film by Luis Buñuel and Salvador Dalí, two young Spaniards in their late twenties, both friends of the poet Lorca. Their first film, *Un chien andalou* 1928, was made outside the official Surrealist group, but was quickly adopted by the movement along with the directors themselves. The shot of an eye sliced open by a razor is still an iconic statement of Surrealist film, a physical assault on the spectator's sight in the very act of viewing. Composed of abrupt changes of time and space, its dislocated editing is post-cubist and disruptive. Motifs circulate without explanation (a striped box, a severed hand), characters turn into each other, linear time is

interrupted. Above all, death and fetishism upturn the boy-meets-girl plot
that the film sardonically parodies and absorbs from the commercial (and
impressionist) cinema. A static camera and degree-zero stylistics, based wholly on
the framed shot and the interrupted cut, make the starkest possible contrast with
the dynamics and flow of abstract film as well as 'Art Cinema'. Tangos intercut
with Wagner comprise the equally sardonic soundtrack.

In parallel to these overt assaults on the cinematic imagination, the films of
Man Ray offer a more playful but also insidious and oblique alternative. His first
film, partly made up of fragments shot on the camera he bought with Duchamp,
was *Return to Reason* 1923, requested by Tristan Tzara at short notice for a
performance that turned out to be the last manifestation of Paris Dada before the
Surrealist takeover a year later. Overnight, Man Ray filled out the few shots of his
paintings, a fairground at night and the model Kiki, with filmstrip 'rayograms',
made by placing objects and materials directly onto the celluloid. The result is
one of the most astonishing and forward-looking films of the classic avant-garde.
Opening with grain in motion (in fact, salt and pepper), then with nails and
sawblades imprinted in graphic outline, it moves into sculptural and rotating
space before ending with Kiki's nude body outlined against a window. The final
shot is, in fittingly Dada style, in negative.

The elliptical and non-linear structure continues in May Ray's more elaborate
films such as *Étoile de Mer* 1927, mostly shot through a stippled lens, and the
interplay of human and machine or prosthetic parts of *Emak Bakia*. The last film
he made in this era, *Les Mystères du Château de Dé* 1928, is a study of absences
and non-events. The camera tracks at low-level through the empty rooms of
a modernist house (designed by Robert Mallet-Stevens for the film's wealthy
sponsors) while inter-titles triumphantly report 'Personne!' or 'No one there!'
The film is a model for our contemporary fascination with vacancy, architecture
and virtual space.

Jean Cocteau
Blood of a Poet
1930
35mm film, sound

During the 1930s the French cinema metamorphosed into the classic films of Jean Renoir (son of the painter), Sasha Guitry and René Clair, along with the later films of L'Herbier, Gance and Dulac. Their impact on painters and writers, and the achievement of a serious cinema independent of Hollywood, is part of another history that extended across Europe, and constituted an Art Cinema that still survives today in world cinema aspirations to national and socially oriented film-making. The impulse to a purely experimental cinema, as an integral part of the wider arts rather than – as with Art Cinema – an addition to them, took different directions in the avant-garde. But two careers, a long one in the case of Jean Cocteau and a tragically short one in the instance of Jean Vigo, represent the cusp or turning-point of this historical moment.

Cocteau's reputation as a cinéaste and director really belongs to the post-Second World War Art Cinema, but his early film *Blood of a Poet* 1930 is best seen in relation to the radical avant-garde. It established the theme of the psycho-drama, the subjective and fragmented narrative that reveals inner life and conflict, with shared roots in the Expressionist films of F.W. Murnau and Robert Wiene such as *The Cabinet of Doctor Caligari* 1919, but coming to fruition for the avant-garde in the US after 1943. The protagonist of Cocteau's film, who is tellingly a painter-poet, undergoes a series of visions and trials that end with death and transfiguration. Suspending the film between two moments of time, the interrupted collapse of a chimney, Cocteau's sardonic conclusion shows the poet embalmed with laurels and turned into a bloodless monument. But the iconography is close to Surrealism, as in the mouth placed in the poet's hand by the Muse (played by Lee Miller), the transvestite imagery, the emphasis on childhood trauma (a fatal snowball fight), spirals and masks, and most memorably the leap of the poet into a mirror to reach across time. This ambitious sound film stands somewhat apart from the sophisticated ironies of Cocteau's postwar films where myth and the everyday are reconciled and the occult is framed within a realist space, akin to the later Buñuel if in a different spirit.

Vigo completed only two drama-films, *Zéro de conduite* 1929 and *L'Atalante* 1934. Their lyrical realism, with anarchist undertones, have had a far-reaching impact on the cinema since Vigo's early death at twenty-nine. His two short documentaries, *À Propos de Nice* 1929 and *Taris* 1930, are more experimental in style. The first is a Vertov-like dissection-by-montage of the bourgeois beach resort, replete with carnival masks and the body on display. The second stars the eponymous champion swimmer, first shown as an almost Magritte-like figure in his black suit and bowler hat, but then turning into an emblem of freedom when he swims unrestrained in his element. *Taris* employs a fluent film-language that includes fast and slow motion as well as near-mythic shots of the body in water.

Vigo's blend of social critique and poetic montage links his two short films to one of Buñuel's last films from pre-war Europe, made after the ambitious *L'Age d'or* (also with Dalí, 1932), an anti-imperialist drama of doomed love and social alienation that took disjunction of sound and image to new heights and which outraged the French right wing. This was *Land Without Bread* (1932, but reissued as a Republican fundraiser in the Spanish Civil War after 1936). Here, the poverty of Spanish peasants is coupled with a voice-over commentary that effectively subverts the naturalism of the images so that the viewer is left in critical and productive doubt about the veracity of the film medium as a record of truth.

The social documentary absorbed many of the talents of the experimental or avant-garde artists up to the start of the Second World War in 1939. Most of them belonged to the radical left, with the major exception of Ruttmann, who drew increasingly closer to the Nazi regime in Germany while his peers Richter and Fischinger chose exile to the US. Richter was in fact working on a documentary in Russia, produced by Eisenstein's companion Pera Attasheva, when Hitler's regime took power in 1933. By then he had successfully expanded his abstract style to

schw weiss grau

Previous spread:
László Moholy-Nagy
*Ein Lichtspiel schwarz
weiss grau* (*Light Play:
Black-White-Grey*)1930
35mm film, silent

include a new lyrical or surreal ethos, pursued in his own experimental films as well as in special effects and trailers for the industry.

Film Study 1926 is an exceptionally crafted abstract film with powerful figurative icons, from birds flying in reversed slow motion, a repeated shot of a sledgehammer that cuts the screen into a wedge, eyeballs adrift in film space to Fritz Lang-like 'searchlight' paths cut by triangles of light. The film-poem is given a Dada-Surrealist makeover in *Ghosts Before Noon* 1928. Here, objects rebel against their masters (as in dancing bowler hats), a figure endlessly climbs a ladder (like the looped washerwoman ascending a staircase in *Ballet mécanique*), and the time-based theme is underscored by a count-down clock. The visual dynamics of these films, the last of the Weimar avant-garde, are echoed in Richter's set-piece inserts for feature films, such as *Inflation* 1928, a rapid-edit montage vision of multiplying banknotes and social misery.

Throughout this period, lively film clubs, journals and film-making groups appeared in Hungary, Czechoslovakia and especially Poland, where Constructivism blended with Dada-Surrealism in the films of Stefan and Franciszka Themerson (later the founders of the avant-garde Gaberbocchus Press in London). The international experimental film in Eastern and Central Europe often combined the scientific (lightplay) and the documentary (city life) to create a new kind of film-poem, as in the Themersons' *Europa* 1932, their 'humoresque' social satire *Adventures of a Good Citizen* 1937 or their ad for an electricity company, *Short Circuit* 1935. Constructivist graphics and book designs were 'cinematised' in lay-out and photomontage, pioneered by Lissitzky and Rodchenko in Russia and internationally by Moholy-Nagy. Moholy-Nagy's projects include graphic schemas for city films, an abstract film of his light-sculpture and numerous documentaries, such as a study of the old port of Marseilles and another about the architecture of London Zoo (a modernist icon).

In Britain, film culture was led by the London Film Society (1925–39). Its members included artists like Frank Dobson, Roger Fry, E. McKnight Kauffer and Edmund Dulac, as well as Virginia Woolf and Alfred Hitchcock. The LFS premiered such radical new films as *Battleship Potemkin* and Vertov's *Enthusiasm* (Vertov turned the speakers up to full-blast for his sound-collage of factory noises and neo-electronic music). The Close Up group, with strong UK connections, made two films, notably a social drama of racial tension, *Borderline* 1930, in a strong style marked by German Expressionism and starring H.D., Bryher and Paul Robeson. But apart from a few brave independent directors such as Richard Massingham, and some left-wing campaign films like *Peace and Plenty* 1939, the heart of radical film production was centred in an unlikely institution – the Post Office. Here, and in other state-run organisations such as the Empire Marketing Board, the pioneering producer John Grierson led a team of young filmmakers to establish a documentary movement that remains a key British contribution to international film culture.

Radicalised by his experience of the new science of mass communications in the US during the 1920s, Scottish-born Grierson's mission was to spread social education through the film medium. He opposed the US-led entertainment cinema, and used the up-to-date techniques he had learnt while cutting the English-language version of *Potemkin* for the Film Society. His team was largely gathered from a generation of Cambridge-educated writers and cinéastes whose wider circle included Jacob Bronowski, William Empson, Basil Wright, Humphrey Jennings, Julian Trevelyan, Kathleen Raine and many other leading figures in British culture through to the television age. Many of them also took part in Mass Observation, an idiosyncratic fusion of anthropology, Marxism and Surrealism dedicated to the study of everyday social behaviour. Some, including Jennings and the poet David Gascoyne, were signed-up members of the Surrealist movement led by André Breton.

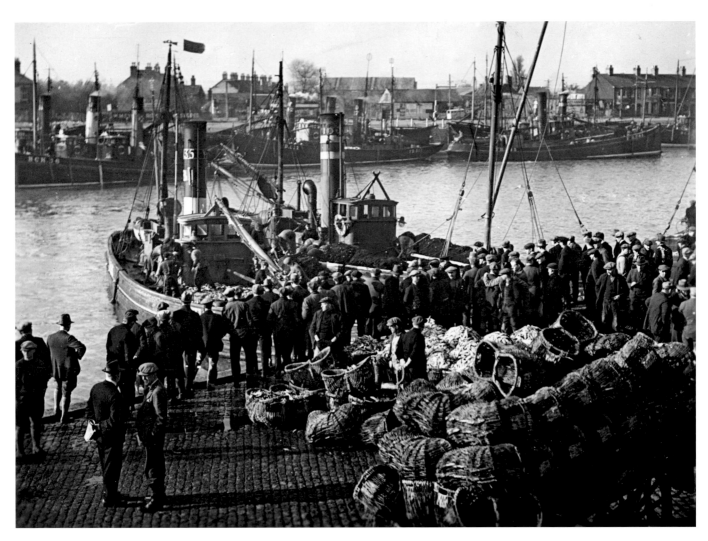

John Grierson
Drifters 1929
35mm film, silent

Sheltered and funded by a variety of British organisations, Grierson produced a major output of informational films that went well beyond their didactic brief, exploring and expanding the language of cinema. Many, of course, were conventional or bland, although even such straightforward mini-dramas as *The King's Stamp* 1935 or the comic musical burlesque *The Fairy of the Phone* 1936 contain imaginative montage-editing by the painter William Coldstream and other tyros. But several films made by the Post Office and similar corporate agencies go well beyond this, most famously *Night Mail* 1936, with its stunningly rapid-paced final section accompanied by Benjamin Britten's music and a breathless voiceover verse commentary written by W.H. Auden.

Grierson hired untamed spirits from the cinema and the arts to liven up the unpromisingly sober genre of social documentary. They included the veteran Robert Flaherty and (more successfully) the young Brazilian Alberto Cavalcanti, who had made now-classic films such as *Rien que les heures* 1926 in France. Cavalcanti pillaged GPO stock-footage and employed Britten and Auden for the chanted, multi-tracked sound-score of the intensively montaged *Coal Face* 1935, probably the most Brechtian film made in the UK. It celebrates the miners' labour but does not shirk the grim statistics of death and industrial injury. Likewise, *Housing Problems* 1935 by Edgar Anstey, made for a gas company, has direct-to- camera statements by working-class participants, mixed with statistics, diagrams, models and social realism that anticipate the future style of television. It was partly directed by Grierson's sister Ruby (killed at sea in 1940), who is said to have exhorted Bethnal Green tenants: 'The camera is yours, the

microphone is yours. Now tell the bastards what it is like to live in the slums.'

The two major talents nourished by Grierson's film units were Humphrey Jennings and Len Lye, friends who collaborated on at least one film but who took different directions as Surrealists and filmmakers. Famously named by Lindsay Anderson as 'the only real poet the British cinema has yet produced', the Surrealist painter Jennings cut his teeth on GPO films like *Spare Time* 1939, before maturing to the wartime 'home front' documentaries such as the legendary *Listen to Britain* 1942 and *A Diary for Timothy* 1945 (scripted by E.M. Forster). *Spare Time*, with a sparse commentary by the poet Laurie Lee, is a visual-music documentary evocation of leisure-time in three working towns in England and Wales. Perceptively depicting a soon-to-be-lost proletarian world in the street, at home and at play, its mixture of lyricism and sharp irony was taken further in Jennings' war-time propaganda films. *Listen to Britain* famously has no voiceover at all, but follows Vertov and anticipates Peter Kubelka in a sound montage that ranges from factories, airfields, a Mozart concert in the National Gallery and Flanagan and Allen chanting 'Underneath the Arches' to a sing-along audience of servicemen and women.

Jennings' main collaborator was an intense young Scots editor, Stuart McAllister, a first-class graduate of painting at Glasgow School of Art, and fellow student of Norman McLaren, another of Grierson's most imaginative acolytes. McLaren explored every facet of animation, except conventional cel techniques, to produce a vast corpus of lyrical abstract films, later joining Grierson in Canada to form its pioneering National Film Board. Such films as *Synchromy* 1957 explore synaesthetic colour and abstract form by using the image to generate the sound-track directly.

Len Lye's career as an experimental animator began after the young New Zealander moved to Britain and showed his paintings with such radical London art-groups as the Seven and Five Society. His *Tusalava* 1928 is an organically visual abstract film whose biomorphic imagery is partly drawn from Oceanic cultures. It was made in great poverty over two years, but Lye's palette expanded wildly when he was taken on by Grierson for lavishly coloured – but still firmly handmade – GPO productions such as *Colour Box* 1935 with Latin music rhythms and painted directly onto the filmstrip.

Rainbow Dance 1936 expands into figuration, experimental solarisation and negative colour, while the elaborate *Trade Tattoo* 1937 plunders and colourises stock GPO footage to construct a dynamic vision of industry, city life and luminous graphic art. In live-action films such as *N or NW* 1937 – ostensibly a reminder to use the right post-code – Lye pre-empts the flicker-edit techniques of later artists from Stan Brakhage to Scratch Video. His influential later films of the 1970s, made in the USA, are composed of austere but vibrant black and white marks directly scratched onto the film surface (and set to African music), but his GPO films are an inexhaustible anthology of experimental devices and colour-rhythms long before the digital age and the music videos that they in part predict.

Full abstraction and synaesthesia were the hallmark of Oskar Fischinger, who sustained and expanded the art of graphic animation into colour and sound throughout the 1930s and beyond. A contemporary of Richter and Ruttmann, and of the light-play experiments by Bauhaus artists, he explored three-screen and overlapping projection as early as 1926–7. With his brother Hans and wife Elfriede, Fischinger made adverts, as in the delightful parade of cigarettes in *Muratti Gets in the Act* 1934, as well as entertaining abstractions of swirling lines and curves set to popular classics by Brahms and Liszt. Leaving Nazi Germany in 1936, as a 'degenerate artist' and opponent of the regime, he had a brief and chequered career at the Disney, Paramount and MGM studios, where he felt his ideas were misunderstood and vulgarised.

With occasional patronage from the major studios and the redoubtable

Len Lye
Rainbow Dance 1936
35mm film, sound

Baroness Rebay of the Guggenheim Foundation, he nonetheless completed some astonishing films of pure colour imaging. The unfolding layers of flat colour and spatial play in films like *An Optical Poem* 1937, *Allegretto* 1936–43 or *Radio Dynamics* 1942 (actually a silent film) look ahead to the rise of colour-field painting a decade later. Living in Los Angeles, home to many wartime exiles from Arnold Schoenberg and Thomas Mann to Kurt Weill and Bertolt Brecht, Fischinger's abstract modernism was fused with synaesthetic mysticism. His interest in Eastern philosophy, archetypes, Buddhist mandalas and Goethe's colour symbolism made him a foundational figure of West Coast abstract film in the postwar period By then a hero to younger artists like Jordan Belson, he was restricted by lack of funding and later illness to one last major film work, *Motion Painting No. 1* 1947, laboriously executed on Plexiglas to a Bach concerto, but he continued to paint until his death in 1967.

Fischinger was one of many artists – including Lye and McLaren – who initially found support at the fringes of the animation cinema, where the norms and codes of the dominant mainstream were more relaxed. Occasional makers of films such as Anthony Gross, the English printmaker, as well as professionals such as Berthold Bartosch (who animated the woodcuts of Frans Masareel) or the husband and wife team Alexander Alexeieff and Claire Parker, funded their films in this way. Alexeieff and Parker invented an extraordinary pin-board system that permitted them to draw with reflected light, rather like mezzo-tint printmaking, in fluid, dissolving motion (as in *Night on Bare Mountain* 1933).

Although an American avant-garde rose rapidly in the postwar years, Fischinger's frustrated career suggests that the time was not yet ripe for a fully-fledged experimental cinema that could challenge the hegemony of Hollywood or connect to the wider arts. In much the same way, and for similar reasons, American modernists between the wars still looked to Europe as a lodestone. Back in 1912, the American painter Stanton Macdonald-Wright had experimented with light projection ideas in Paris that were not finally realised until he combined three-strip colour filmstrips with drawing in his hand-operated 'colour-organ', the Kinaidoscope, in the 1960s. A few dissident independent films were made at the fringes of Hollywood, as in the sarcastic *The Life of 4913 – a Hollywood Extra* 1929 by Robert Florey and Slavko Vorkapich. Then as now, the US mainstream soaked up and adapted modernist styles, such as commissioning classic 'dream-sequences' from Dalí for Hitchcock's *Spellbound*, or silently absorbing the influence of the international avant-gardes into Hollywood's expanding visual language.

The space that was left was occupied by the radical documentary, as in Europe, and by a similar plethora of adventurous journals to promote the new cinema, including the Soviet films of Eisenstein, Vertov and Pudovkin. Impelled by economic injustice and the approach of war, the film avant-garde gravitated to the social front opened by Roosevelt's New Deal, as did many painters and other artists who took part in federal-funded cultural projects, from mural painting to collecting folk songs among native communities and migrant workers. The documentary films produced by Pare Lorentz and others were an equivalent to Grierson's movement in the UK (itself inspired by an American model of mass-media culture), although mainly with higher production values and an unparalleled visual flair and rhetoric. They had learnt from Eisenstein, just as Eisenstein himself had learnt from D.W. Griffith. Paul Strand, best known as a pioneer fine-art photographer, shot many films in thus period. His camerawork underpins an early film (*The Wave*, made in Mexico, 1936) by the young Fred Zinnemann that dramatises the plight of poor fishermen, as well as the vivid portrayal of American society in *Native Land* 1942, with voice-over by Paul Robeson.

With only a few native and relatively isolated pioneers of abstract film in

the 1930s, such as Douglas Crockwell (a free-form painter of liquid-motion harmonies) and Mary Ellen Bute (an early champion of electro-acoustic experiment), what would be a postwar explosion of the film avant-garde in the USA was still nascent and barely visible, until the San Francisco 'Art in Cinema' screenings from 1947. Two earlier exceptions, both obscure at the time, indicate quite literally the shape of things to come. The first was Harry Smith, self-styled eccentric visionary and an assiduous collector of folksongs as well as a model of the freewheeling bohemian artist. Smith began painting on film in the 1940s and then expanded to include every technique he could imagine. Using a variety of hallucinogens to enhance his sense of colour, he synchronised the films to the new bebop jazz of Dizzy Gillespie (although he reissued the 'Early Abstractions' in the 1960s with a Beatles soundtrack instead). Some of the abstractions are wittily figurative, as in the animated dream-dancers of the Méliès-like *Bellhop and the Indian Princess*, but most consist of colour explosions made by painting, scraping or batiking the film surface.

The second exceptional heralds of a new avant-garde were the brothers John and James Whitney, composer and painter respectively, who also explored radical film ideas in the 1940s, notably in their five *Abstract Film Exercises* 1943–4. On John's return from studying in Paris (1938–9), where he had imbibed Schoenbergian tone-row systems and other modernist ideas, the two brothers set out to reinvent the abstract cinema. They critiqued abstract animation for its hand-drawn graphics, which they claimed were taken over from other media rather than being cinematic as such, and hence were only illustrative of abstraction on film. Instead, the Whitneys generated abstract shapes directly from light filtered through a series of stencils. These were less images than manipulable units, more intrinsic (they claimed) to the film medium than animated drawing, or painting on the filmstrip, and anticipating the pixel matrix of the computer. Shaping light in points and swathes with stencils, and synchronised to random sound that was generated by pendulums, the films compose their own sound, with colour added in an optical printer.

Here, the Whitneys not only freed cinema from its roots in other art forms, but also laid the ground for an audio-visual culture that later expanded from film technology and process to embrace video and digital media. The Whitneys soon pursued separate paths, the one (John) towards computerised imaging, the other (James) to the mandala-trance forms that typify West Coast abstraction, as in the pin-dot stencils of *Yantra* (1950–7). Their early perception that films could be shaped by points of mapped light led ultimately to the digital matrix, independent of either lens or brush. Their synaesthetic experiments also reinvigorated an early avant-garde aspiration towards primal forms and visual music. But waiting in the wings, in the 1940s and the postwar world, a very different avant-garde was also in formation. This was to re-establish the camera-eye and subjective vision as the core of the film vanguard, leading to a massive and influential expansion of the medium by North American artists from Maya Deren and Kenneth Anger to Stan Brakhage and Hollis Frampton. In Europe, meanwhile, a new combination of abstract art and metrical structure led film away from synaesthesia to radically break the bond between sound and image.

A.L. Rees

MOVEMENTS
IN FILM
1941-79

Film avant-gardes, whose energies were channelled into documentary cinema before and during the Second World War, began to stir again in two different contexts. The first and earliest was in the USA, where Maya Deren heralded the 'New American Cinema' with a series of short, experimental films (1943–5). She was soon joined by a host of others such as Kenneth Anger, Marie Menken and Sidney Peterson, all of them influential on the arts scene for the next two decades. By the early 1950s, experimental film of another kind – anti-art and more conceptual – appeared in Paris, through radical groups like the Lettristes and Situationists, and then in Austria with the birth of new abstract and action art. The European work was truly avant-garde in the sense that such films were little seen at the time, and many remain obscure to this day. In some cases this was because they came from the extreme fringes of art activity, in others – notably the films of Guy Debord – because the makers chose to resist the consumer culture by showing them rarely or not at all. The US filmmakers were quicker to construct film circuits of their own that ultimately led to the 'co-operative' system of screening and distribution, developed from groups like Amos Vogel's Cinema 16 and San Francisco's Art in Cinema. The self-help co-operative or collectivist idea was exported to Europe in the 1960s, where the international Underground cinema was in full swing.

While the first film avant-gardes of the 1920s were created largely by visual artists and painters like Richter, Eggeling and Léger, in postwar US and France the lead was taken by modernist and Surrealist poets and writers. In the USA and in Austria there were also connections to music, dance and live art, which were advancing into the gallery world as additions or rivals to painting and sculpture. The rise of Abstract Expressionism had less direct impact on film in the 1940s and 1950s, when this movement was at its height. There was a time lag into the 1960s before painterly abstraction and its 'action' methods appeared in film – Brakhage is often cited as an example – rather as cubist cinema only arrived a dozen years after the Cubist painting on which it was based. But there was a difference, a new phenomenon, hardly seen in the days when artists such as Man Ray or Fernand Léger added film to their prodigious output in other media. For the first time, in postwar North America, a group of filmmakers now claimed film as an independent art form, not an adjunct to work in another medium. They saw film as an alternative to painting and the other arts rather than an extension of them.

The re-birth of the avant-garde cinema in the US is emblematically linked to Maya Deren, a Russian born filmmaker, activist and critic of great acuity. Her classic experimental films and energetic crusading for the new film were sadly cut short by her early death at forty-four, in 1961. Deren's first film, made with her husband Alexander Hammid, was *Meshes of the Afternoon* 1943. It inaugurated a new genre, the 'psychodrama', or avant-garde narrative of inner life and conflict. Its typical features are montage and expressive symbolism, a heightened style that includes violence and distortion. But while the psychodrama picks up where Cocteau and the Surrealists left off in the 1930s, Deren herself was always keen to stress that she was a classicist in form and a photo-realist in vision, who believed that 'the object creates its own image' through cinematography. In this sense, she rejected the graphic cinema, with its base in drawing and design, along with the Surrealism and Freudianism that nonetheless permeate her films (she didn't like to be pigeonholed).

When the recently married couple made *Meshes*, Deren was emerging from a period of leftist political activism and journalism in the 1930s and as an assistant to the Katherine Dunham troupe, who took modern Caribbean dance to the USA. Hammid, a refugee from Czechoslovakia, where he had made some short experimental films, was a technical virtuoso working in Hollywood on documentaries. Their film set a much-followed model for filmmaking when they shot, acted and edited the films themselves, in their own home and on a tiny

Maya Deren
Meshes of the Afternoon
1943
16mm film, sound

Kenneth Anger
Fireworks 1947
16mm film, sound

budget. Crisply photographed and precisely edited, the film reworks an initial vision – a woman chasing a cloaked figure but never catching it – in four successive sequences that have the character of a dream. The theme of interruption and loss is echoed by shots of falling keys, barred doors, a phone off the hook and a broken mirror. Stunning matte-shots duplicate the heroine each time she reappears, to figure the concept of the multiple self.

After Deren separated from Hammid, she continued to work with him, and other collaborators like Hella Heyman, to produce two more films that comprise a trilogy with *Meshes*. In these, her symbolic language expands to include the quest for a missing object (a chess pawn) in *At Land* 1944 and the passage from stillness to motion in freeze-frames, an animated statue and a drowned bride (*Ritual in Transfigured Time* 1946). Each film exploits cinematic distancing-effects such as reverse motion, pixillation, slow motion, negative footage and montage ellipsis. Most of these are seen in the brief and intense *Study in Choreography for Camera* 1945, in which African-American dancer Talley Beatty leaps across spatial gaps from beach and forest to a museum and a modern apartment, with dramatic changes of speed and motion. Her later films include the sparse and cyclical poem of Chinese dance and boxing, *Meditation on Violence* 1948, and the mythopoeic astral fantasy *The Very Eye of Night* 1959. These have often been overlooked, as more formal and abstract than her experimental narratives, but were ahead of their time in forging links across cultures and between art forms like dance, music and film.

The psychodrama, with its air of menace and obsession, perhaps reflects (and intensifies) the prevailing postwar climate of impending threat also seen in film noir. In addition, it carves out a new space for the psychic subject, as in the oedipal theme of Sidney Peterson's *The Lead Shoes* 1949 and the children's games in the films of James Broughton. Kenneth Anger's early masterpiece *Fireworks* 1947, made when he was seventeen, launched a long and tortuous career of uncompleted projects and improvised recuts, and has an explicitly gay theme. A sleeper awakes to be tormented and torn apart by mocking sailors, but is reborn in a flow of light (fire) and balm (milk) to find himself back in bed but 'no longer alone'. Anger then left the USA for a decade (invited by Jean Cocteau after *Fireworks* won a prize at the Knokke festival). He returned to the USA and a very different culture in the early 1960s for his hymn to bike-boy anarchy (with a forward-looking rock soundtrack) and the new age of *Scorpio Rising* 1964. Inbetween, he embarked on the many versions of his sacrificial mini-epic *Inauguration of the Pleasure Dome* (1954–6). This spread across three screens of colour ritual and magic before being compressed back into a single-screen version of flowing animistic dissolves, with the original Leoš Janácek soundtrack replaced by rock music in the 1960s (and back again since, for video re-release).

By the time that Anger came back to the US, the climate had transformed from the Beat era into the Underground. Only Deren had been immune to a new era of improvisation (or 'Howling', as she called it, mocking Allen Ginsburg's iconic chant poem). Marie Menken used the handheld camera to create lightplay from car tail lights or to cruise the modernist sculpture of Isamu Noguchi. Younger filmmakers who emerged from Deren's tutelage (like Stan Brakhage) or later from the Film Co-op with Jonas Mekas, explored looser forms of non-narrative construction. Ken Jacobs, Ron Rice and the charismatic performance artist Jack Smith made eroticised, ironic beat fantasies, in which masks, costumes and objects stand in for a lost interiority. The swirling camera replaces the fixed shot, while failings in colour-stock, focus and graininess defy or challenge the norms of cinema. Never fully abstract, such films nonetheless carry a trace of improvised action-painting and the role of chance in the visual arts of the time. At the same time, as with Jack Smith, they predict the break-up of traditional media in the age of 'Happenings' and the first signs of live or 'performance' art.

Pull My Daisy 1959, by Alfred Leslie and Robert Frank, was an apex of the Beat film, with a freeform voice-over by Jack Kerouac loosely matched to the antics of poets Allen Ginsberg, Gregory Corso and Peter Orlovsky. It was much praised by Mekas' influential journal *Film Culture*, along with John Cassavetes' semi-improvised *Shadows* 1958, a docu-psychodrama on the themes of mixed race, jazz, youth and hanging around the streets (and the Museum of Modern Art). Since arriving in the US from postwar Europe in the 1940s, the Lithuanian Mekas and his brother Adolfas had pioneered the new filmmaking, partly inspired by such 'first-wave' exemplars as Hans Richter, now living and teaching in New York. With his sympathies at first drawn to the New American Cinema of independent documentarists, who like the artists exploited the hand-held 16mm camera to catch life on the run, Mekas soon shifted his main allegiance to the vibrant film poems or 'cinema of mistakes' now emerging. His own film diaries, shot from the 1940s but often edited much later, are plangent revelations of refugees 'thrown into the world' of a new city, and of the casual intimacy of daily life in New York's lofts and studios. At Deren's funeral in 1961, the film community was inspired by Mekas to form a Film Cooperative, still extant and much emulated, to pool the distribution of their films on a no-censorship, equal-shares policy.

The Underground had a distinctly American flavour, close to Pop art in its use of mass imaging, but also to US rock music with its African-American heartbeat and roots. The dynamics of US pop culture spread the Underground internationally, where it joined up with similar but independent manifestations in Western and Eastern Europe and Japan. The Fluxus group of the 1960s, led by George Maciunas, was an example of this, with anti-art performances partly based on the Zen anarchism of John Cage and a host of experimental films by Yoko Ono, Paul Sharits and many others. By then, Europe had forged its own experimental film culture, in the wake of postwar reconstruction. Just as dada grew in the shadow of the First World War, so other movements led by young iconoclasts, especially in Austria and France, challenged the traditions of a culture seen to be dead in the ruins of 1945. In the postwar austerity of war-torn Europe, new forms of art (or anti-art) emerged slowly.

Peter Kubelka, soon to be the key advocate of 'metric film', made his semi-underground *Mosaik in Vertraeun* in 1955, a found-footage collage of disasters (car crashes) and fragments of acted scenes with out-of synch dialogue. His first two major, if extremely brief (60–90 second), films followed quickly. Both were 'diverted' adverts, originating as commissions from a dance-café (*Adebar* 1957) and a brand of beer (*Schwechater* 1958). In each, fragmented shots of movement (such as dancing couples, or a hand reaching for a glass) are subjected to strict repetitions and inversions, modelled on the serial music of Arnold Schoenberg, Anton von Webern and the prewar Second Viennese School. The soundtracks (African chants, electronic beeps) are similarly looped, to match the editing structure. Acknowledging Len Lye, and Dziga Vertov, these films rethink 'visual music' from a new angle. *Arnulf Rainer* 1960, named after the Austrian painter of monochrome graphic portraits, is composed of alternating clusters of black and white frames and of raw sound ('white noise') and pure silence. It follows a predetermined score, an idea explored in Marc Adrian's experiments with mathematical and computer-based films in 1956–7. By contrast, Kubelka's *Unsere Afrikareise* (*Our Trip to Africa*) 1966, is another example of 'détournement'. Commissioned by wealthy tourists as a document or travelogue of a safari, the film turns the antics of the leisure-class against them through contrast with the people and landscapes that they exploit.

Also in Austria, Kurt Kren made serial or system films of a different kind, broadly divided into two classes. The first were cool but intensely engaged observations of gesture, space and the natural scene. A whole landscape is gradually composed out of a network of matted overlays, by winding and rewinding the film (*Asyl* 1975).

Peter Kubelka
Adebar 1957
35mm film, sound

Faces from a psychology association test are edited so as to flow in and out of each other (*2/60: 48 Faces from the Szondi Test* 1960). Bare branches make up an interlaced matrix from single-frame shots of dozens of trees (*Trees in Autumn* 1960). A few shots from a café next to a harbour are permutated dozens of times to form new connections (*TV* 1967). In each film, Kren used a predetermined score to minimise the personal choice of the maker and to allow nature or an event to reveal itself objectively through the camera and the score. As with Warhol, each film is the length of a standard 3-minute roll of 16mm film. In a second category of works, Kren records (and transforms) the often gory and provocative art of Otto Muehl and Gunter Brus of the Viennese Action Art movement. But his approach is counter-intuitive, in that the more frenetic and dadaist performances of Brus are seen in longer and cooler shots, while the extended quasi-narrative performances of Muehl are depicted in rapid montage.

The Austrian metrical film often held emotive content in check through the use of a strict system (George Braque's 'rule that corrects the emotion', in a new context), just as the use of found footage challenges authorial power. In France, new groups in the wake of Surrealism invented similar techniques but with a different impact. Here, cool treatment by reduction to black and white frames, or remixed commercial footage, worked to heighten the content and give it a quasi-political dimension. First to do so were the Lettristes, an avant-garde group of neo-dada poets led by Isidore Isou, with a 1952 manifesto of counter-cinema and his *Treatise of Slobber and Eternity* (at 175 minutes cut from an original four-and-a-half hours). Like Maurice Lemaitre in the aptly titled *Has the Film Started Yet?* 1951, Isou re-edited feature films and other footage to turn cinema on its head. Yet more extreme was Guy Wolman, whose 1952 film *The Anti-Concept* consists of strobe-like holes punched in the empty black frame of the film, while the poet screams and chants polemical sound poetry in a literal reduction of cinema to absurdity. At the same time, the young Guy Debord made *I'm Screaming About De Sade* 1952, featuring long black sections of silence punctuated by white screen and a collage of spoken words. Some are cited from literary sources or film soundtracks, others are 'quotidian banalities' (the critique of everyday life was later a chief aim of the International Situationists, formed by the politicised Debord in 1957). The final 24 minutes of the film are black and silent. His later films are also largely collaged from commercial cinema and television. *Society of the Spectacle*, the 1973 film version of his famous book, adds documentary footage, ads and surveillance-type images to a relentless denunciatory montage and a voiceover reading of the text. Debord finally withdrew his films from circulation, but they survive 'underground' in video copies, on the Web and now on DVD, their circulation ironically ensured as the spectacle proliferates.

The Lettristes invented many of the techniques of the underground film ten years ahead of their time (as did Norman McLaren in the black screen of *Blankety Blank* 1955).These included the projection-event, hand painting and scratching the film, cut-up images and non-synch sound. But it was a very different context. For Isou, as later for Debord, the main aim was to attack the cinema as a whole, not to create a new art form within it. Isou believed that the language of cinema, developed over a half-century, must now be 'chiselled' and interrogated. Debord's 1952 film was, said Isou, 'the end of cinema in its insurrectional phase'. Their main target was the classic and arthouse film, and later TV. The French activists did not intend to construct a new cinema modelled on the visual arts, and certainly not one concerned with individual self-expression. But in the US, a decade later in the 1960s, the battlefield was more cultural than political, although the heightening of the war in Vietnam and the Civil Rights issue at home were to change that.

This period saw the flourishing of the Underground film across the coasts. The goal of visual music was revived, with Oskar Fischinger (who died in 1967) as the acknowledged ancestor of Jordan Belson and other West Coast abstractionists. Like

Bruce Bailie
Castro Street 1966
16mm film, sound

Robert Breer (who reinvented avant-garde animation), Belson was a painter who first turned to film in the late 1940s and early 1950s. In 1957–9 he worked on the celebrated Vortex multi-media concerts. For Belson, and the Whitney brothers, the goal was less to film specificity than to an 'expanded cinema', as it was called in a seminal 1970 book by the twenty-six year old Gene Youngblood. Not surprisingly, they are the direct ancestors of computer-aided graphics and digital imaging. Along with post-psychedelic abstraction, there flourished the colour-lyricism of Ron Rice and the optical colour films of Bruce Baillie, Chick Strand and Pat O'Neill, who turned the everyday scene into vibrant and visionary cinema through the use of colour printing and filters. But the main force was felt by the New York filmmakers, who had witnessed a rapid turnover of ideas between 1962 and 1966, partly through the impact of Andy Warhol. Warhol entered the ring in 1963 with some stunning single-take films that defied the modes and conventions of the avant-garde cinema, and was acclaimed for it by the Co-op's chief animateur, Jonas Mekas.

By this time, roughly between Deren's last film (1959) and Warhol's first (1963), a new group of major authors had arisen, notably Stan Brakhage, Ken Jacobs and Gregory Markopoulos. Waiting in the wings were figures who led the next generation, Michael Snow and Hollis Frampton. Of these, Brakhage was the dominant figure until his death in 2003, and his films and legend are still powerful influences. A huge output of films, ranging in length from a few seconds to over five hours, emerged from his mountain retreat in Boulder, Colorado (and latterly Canada). They include the vivid 'birth film', *Window Water Baby Moving* 1959, his lyric poem of a dead dog returning to nature as carrion, in *Sirius Remembered* 1959, and his epic or creation myth *Dog Star Man* 1964. After *Anticipation of the Night* 1958, he had shaken off the narrative coil and abandoned the psychodrama or trance film. Instead, Brakhage began to explore the film surface, the lens and the printing process as direct material outlets for his abstract expressionism, free of constraint to anchor the film in any other subjectivity than his own. In so doing, the material world returned as direct presence, notably in a key film (*Mothlight* 1963, overleaf) made entirely by pasting grass, pollen and insect wings on to the film surface. His later hand-painted films of the 1980s and 1990s such as *Roman Numerals* treat 'inner vision' in the form of colour pulsation. In between came autobiographical films and then – after years of silent films – intense treatments of the acted drama in performance, the fragmented spoken text and the dramatic landscape, as in the *Faust* series (1987–9).

Despite hymning the visual imagination, Brakhage's romantic poetics also acknowledge such modernist authors as Ezra Pound, Charles Olson and Gertrude Stein. Equally drawn to classic texts of high culture, in his case to the Greek myths that he associated with his own family heritage, was Gregory Markopoulos. By cutting to the single frame and the sound syllable, as a stuttering accompaniment to shots in short bursts, Markopoulos exploded the psychodrama from within, in a staccato of Eisenstein-like montage rhythms. Films such as *Twice A Man* 1963 are neo-narrative quest-myths reduced to intense moments of furious frame-cutting, but paradoxically spun over time. His disenchantment with the American scene led him to abandon the USA for Europe in 1967, and then to withdraw his films from distribution. After that, until he died in 1992, his films – radically recut into yet more elliptical patterns – were only shown in a small Greek village, in the open air, once a year. Today, his partner the filmmaker Robert Beavers is making this extraordinary body of work available to new audiences for whom it has become legendary (because unseen) in a way different from its author's intentions.

Much more visible, down to the present, is the extensive work of Ken Jacobs, which in this period spans several phases from the Underground – as in *Little Stabs at Happiness* 1963, starring Jack Smith – to neo-minimalist structural cinema in

Stan Brakhage
Mothlight 1963
16mm film, silent

Andy Warhol
Screen Test: Jane Holzer
1964
16mm film, silent

Tom Tom the Piper's Son 1969. A prolonged meditation on an eponymous comic film of 1905, it slows and freezes the original crowded scene to focus on the interstices of motion and gesture, expanding it from five minutes to feature length. He later developed his films in a live context of 'Nervous System' performances, creating minimal (but sufficient) motion from adjacent frames on two filmstrips, projected as overlapping stills through a fan used as a primitive shutter device. The subject matter ranges across early found footage from landscape and comedy to (more controversially) pornography. Other underground filmmakers explored the city scene with hand-held cameras, as did Brakhage in his study of the New York elevated railway, *Wonder Ring* 1955 (funded by Surrealist artist Joseph Cornell), as did his older mentors Marie Menken and Rudy Burkhardt, and urban poets of dailiness like Peter Emanuel Goldman. Painter and sculptor Michael Snow's first experimental film in New York (he had started his artistic life as an animator on the commercial fringe in Canada), a loosely constructed tale of crossing the race barriers, has a soundtrack of avant-garde free jazz (*New York Eye and Ear Control* 1964).

Partly because of its Underground ethos, and even as it became part of an international cultural revolution in free-form art and music, the Film Co-op led by Mekas seemed (in Michael Snow's words) 'grungy' and 'Beat era' to the most advanced New York artists in the run-up to Conceptual art and Minimalism. This was to change with the advent of Warhol, already a rising star in painting and graphic media, who produced a massive output of films from 1963 to 1966. Deliberately turning the underground on its head, he put the camera back on the tripod, from which Brakhage had most notoriously freed it for his hand-held balletic camerawork. Warhol also eshewed montage, the hallmark of radical film from the Soviet cinema through to the 1960s. Starkly shot, with each roll of film simply joined to the next, Warhol's films focus on the simplest acts (*Eat* and *Sleep* are typical titles) and often attain great length (as in the eight hours of *Empire* 1964). Many are portraits, as in *13 Most Beautiful Women* 1963, akin to the films shot as records or 'Screen Tests' for his Factory studios, but often more nuanced and subtly lit. Along with his home-made stars, Warhol's film galaxy includes artists from Salvador Dalí to Robert Indiana, while *Chelsea Girls* 1966 features Menken, Taylor Mead and the chanteuse Nico from the Velvet Underground.

Warhol's films impacted directly on the arts scene, just as they arguably continue to do as an influence on the long-take portrait videos of Gillian Wearing (*Sixty Minutes Silence* 1997) and Sam Taylor-Wood (*Beckham* 2004). However 'Pop' and even Underground in content and mood, Warhol's films also appealed at the time to the growing Minimalist movement. This was due to Warhol's formal

Hollis Frampton
Zorns Lemma 1970
16mm film, sound

strictness, a lack of overt drama and a relentless articulation of time as duration, so that film viewing gained a new experiential aspect. Perhaps not surprisingly, the torch was passed to two artists who were able to cross the barrier between the Filmmakers around the Co-op and the new artists gathering around the Judson Church and the loft culture of New York. These border-hoppers were Michael Snow – whose films were praised and shown by Philip Glass, Steve Reich and Richard Serra – and Hollis Frampton, a close friend (and photographer) of Carl Andre and Frank Stella. A long, intermittent zoom through a loft is punctuated by sparse and ironic 'action' in Snow's *Wavelength* 1967. It explores a space that is epistemological, because open to the viewer's scrutiny and participation, but also rigorously shaped by the passage from depth to flatness (a photograph pinned on the far wall finally fills the screen for the closing moments). A painterly film, its sculptural counterpart is *Back and Forth* 1969, where the swinging camera in a bare schoolroom constructs fluid space in time at the extremes of blur and focus.

Snow went on to make two very long films, up to four or five hours each. The landscape-based *La Région Centrale* 1971 was shot with an electronically controlled camera to swoop and curve over snow and mountains. By contrast, *Rameau's Nephew* 1974 is urban, linguistic and game-playing, deconstructing sound and vision by using encyclopaedic stratagems from puns to reversed speech and non-synch noise. Snow continues to explore many media, including digital video. Some works such as *So Is This* 1982 are wholly made of texts that directly address the viewer. As a mixed-media artist, he is one of the few from this orbit to attract serious attention from the gallery world and its critics, notably Thierry de Duve. Snow's friend Hollis Frampton's career was cut short by his early death in 1984, by which time he had acquired a formidable reputation as a filmmaker and writer, who expressed his complex ideas in a series of highly articulate interviews and lectures that were playful, witty, allusive and uncompromisingly intellectual. His early films parallel those of other artists like Serra, Robert Morris and Yvonne Rainer, who used film to explore spatial and other concepts. They include graphic abstracted collage in *Heterodyne* 1967 or *Palindrome* 1969, based on Webern-like tone rows, and the pulsating *Critical Mass* 1971, in which staggered cuts emulate the 'breakdown' acted out by two angry protagonists. *Nostalgia* 1971 is another conceptual game, in which a series of photographs are burnt, while a voiceover narration (spoken by Snow but in the persona of Frampton) tells an autobiographical story about the next as yet unseen image, to engage the viewer in self-aware acts of memory and anticipation.

Although Frampton left extensive footage for a massive late project, *Magellan*, based on the cycles of the year, his magnum opus is *Zorns Lemma* 1970. This film weaves permutations of Manhattan street and shop signs, each shot lasting one second and in alphabetical order. Gradually the words are replaced by sequential and cyclical images of everyday actions or natural scenes. The film is an abstract narrative of the passage from word to picture, from culture to nature (city to countryside) and from the still image (photography) to motion (cinema). Along with Paul Sharits and George Landow, the one through abstraction and cut-ups, the other through ironic anti-narrative, the films of Snow and Frampton led to the influential critic P. Adams Sitney positing, in 1969, a new genre that he called the 'structural film'. Disliked by most of the filmmakers themselves, just as the term 'Cubist' was by painters of the period, the phrase nonetheless caught on. Structural films were 'defined by their shape', and typically employed devices from loop-printing to flicker or surface scratches (though few of them had the same repertoire and some had none of these features). Sharits moved from intense structural psychodramas, anxiety dreams culled from images in mail-order catalogues, to pure but also visceral abstractions that spread to multiple screens and into epileptic flicker patterns. Landow's brief metafilms include the literalist *Film in Which There Appear Edge Lettering, Dirt Particles, Sprocket Holes, etc* 1966,

or the rebus-like *Remedial Reading Comprehension* 1970. These comment on the film illusion and its lack of transparency to meaning. It was at this time, significantly, that the more aspirational 'Avant-Garde' replaced the looser term 'Underground' to describe these films. Sitney's major book *Visionary Film* appeared in 1974, and there was extensive writing on the structural film and Brakhage in *Artforum* by way of its film editor, Annette Michelson. A former champion of the French New Wave, she had had been converted to the new artists' cinema of Snow and his peers.

The energies of the US avant-gardes encompassed the conceptual art of the structuralists, the colour abstract lyricists of the west coast, and the dadaist montage of found-footage in the films of sculptor and assemblage artist Bruce Conner. From the mid-1960s onwards, artists in other media from Bruce Nauman to Robert Smithson were also impelled to make films and video (and are discussed elsewhere in this book), and film entered the critical vocabulary of modern and postmodern art. By way of international festivals and film tours, in journals like *Film Culture*, and by exchange of films through the now international Film Co-op movement, the North American avant-garde dominated the public face of the Underground. It showed, as Deren and her allies had hoped, that film could be an art medium in its own right. Meanwhile, other avant-gardes across the world were gathering too, in the late 1960s and through the next decade. A considerable movement grew in Japan, with Taka Iimura, in Germany with groups like X-Screen led by Wilhelm and Birgit Hein, and in Poland with the proto-conceptualists of the Artists' Film Workshop at Lodz, an alternative to the norms of the famous Film School that had produced the radical realism of Roman Polanski and Jerzy Skolimowski.

The Polish group formed an 'arts lab' to investigate the basic properties of film and time-based art, and to experiment with the audio-visual language of sound, text and image. They re-invented the investigative spirit of 1920s modernism, but in a new conceptual framework. While Zbigniew Rybczynski produced lavish colour animated optics (with minimal means), others like Wojciech Bruszewski, Ryszard Wasko and Josef Robakowski focused on 'elementary' issues. In Bruszewski's *Matchbox* 1975 two alternating shots of a hand rapping the box on a table are slowly put out of synch, decoupling sound from its source in the image. In *Yyaa* 1973 he creates a continuous yell from a series of distinct shots of himself screaming, recalling the raw impact of dada noise-art. Unusually working in 35mm (a legacy of their film-school base), these artists also took part in the rising art of video. Video art was also medium-specific in its early days, exploiting direct playback as well as interference with the electronic signal (most famously with Woody and Steina Vasulka). But video also had sculptural concerns, modelling a new sense of space in the rotating cameras of Peter Campus and the Vasulkas, or

David Hall (in collaboration with Tony Sinden) *101 TV Sets* 1972–5 Video installation, Serpentine Gallery, London 1975

entering the gallery as installations with David Hall and Tony Sinden. From the late 1960s, Gerry Schum in Germany created his 'video gallery' for television (with new work by Richard Long, Gilbert & George and Keith Arnatt). In the UK David Hall created 'TV interventions' (from 1971) in the form of short and often elliptical commissioned works designed to be shown unannounced and at random to interrupt the standard programme flow. Throughout this period, video was an alternative to the more iconic film medium, exploring direct playback and multi-monitor installation for gallery rather than cinema space.

While German TV commissioned experimental films by such diverse filmmakers as Straub-Huillet, Mekas and Stephen Dwoskin, other German artists turned to projection art and live performance. Wolf Vostell, Peter Weibel and VALIE EXPORT explored film as a Fluxus-like art event for street and gallery, while Birgit and Wilhelm Hein reduced the film surface to crude data, replete with rough-edged reprinting and hand-scored collage, in their aptly named *Raw Film* 1968. More minimalist (but also lyrical) filmmakers such as Karl-Heinz Emigholz and Klaus Wyborny focused on landscape, structured (as with Kren) by a system, but at greater length, as in Wyborny's *Pictures of the Lost Word* 1974. Wyborny also shot in 8mm with a computerised frame-counter, so as to construct in-camera flicker-edits between distinct places from European cities to African islands. His *Unreachable Homeless/Sonata on Film* and *6 Little Pieces on Film* (1977–8) invoke a musical presence in the titles although the films are silent, asserting their musical content through visual pattern and rhythms based on piano music by Alexander Scriabin and Schoenberg.

By the 1970s, the UK was also the centre of a unique kind of structural film, the 'structural-materialist' brand associated with Peter Gidal and Malcolm Le Grice at the London Film Makers' Cooperative, and which emphasised the politics and process of film perception rather than film's aesthetic form or material. Before that, John Latham, Margaret Tait and Jeff Keen had independently made abstract and experimental films by 1965, but the main event was the founding of the LFMC in 1966. It began by showing films at the avant-garde Better Books and then continued at the Arts Lab in Covent Garden (with David Curtis as lead programmer), but by the early 1970s it had built its own film-printing facilities and a workshop. This massively expanded the ability of artists to make films cheaply and directly. While some of its members like Dwoskin and Gidal brought from the US a flavour of the Underground and Warhol's Factory, most LFMC filmmakers came from an art-school background without much influence from either the mainstream cinema or avant-garde film. This was also the case for artists who made occasional films at the fringes of Conceptual art (such as John Stezaker or David Dye), and for mixed-media artists who used film and video as diary forms (notably Ian Breakwell). They approached the medium as artists exploring new ways to record, depict, print and project the time-based image, although the specific means by which film could do these things were in time to dominate this 'process-based' tendency. Throughout the 1970s (and until it merged with London Electronic Arts, to form the Lux in 1997) the LFMC occupied a series of former industrial buildings in north London – an old dairy, a piano factory, a laundry. That austerity perhaps fostered a reductive and pared-down materialism in the work, but the films were also capable of intense lyricism and visual poetry, as in the landscape genre explored by Chris Welsby and William Raban.

A group around Le Grice at St Martins is known today (though not so much at the time) as 'Filmaktion' because of occasional screenings under this name. William Raban had come to film from experiments with direct prints from nature, such as wrapping canvas round trees to make an image. His early films explore direct abstract sound and image made from projector-gate light (as in the three-screen *Diagonal* 1973), often with a performance element. *Take Measure* 1973 is based on a walk from screen to projector as the film unwinds. He also recorded

successive audiences in films that were processed and printed for immediate screening. Studies of light and space in rooms, or of simple actions that were recut against the flow of time, led to more elaborate observational films, some in collaboration with Marilyn Halford and one (*River Yar* 1972) with Chris Welsby, who concentrated on landscape imaging in time-lapse to reveal the hidden aspects of light and form. Like Le Grice, Raban and Welsby practiced 'expanded cinema' – or 'making films with projectors' (David Curtis) – to merge the gallery and the cinema space. This performative aspect is also seen in the films of Gill Eatherley, some of them made with a light-pen to trace the shapes of objects in the dark, and in the film-events of Annabel Nicolson, such as reading a text about light by striking single matches in a blacked-out room. Projection – or perhaps diffusion, since they also used TV screen light in *60 TV Sets at Gallery House* 1972 – was also an aspect of the collaborations between David Hall and Tony Sinden. Their separate work was based on multi-projection (Sinden) and time-lapse video (Hall), to deconstruct or expose illusionist space. At Maidstone, their students included young artists who later impacted on the electro-acoustic intermix of the 1980s and 1990s, such as David Cunningham (musician), Stephen Partridge (video artist) and Rob Gawthrop (audio-visual media).

In film, the key figures of the era were Le Grice and Gidal, not only for their prodigious and distinctive output of films, but also for their polemical and intellectual stance. Le Grice's early work was often also performative. A bare bulb flashes in front of a screen to wipe out the image (found documentary footage) in *Castle 1* 1966 while in *Horror Film* 1970 Le Grice recreates optical mixture by

Chris Welsby
Colour Separation 1974
16mm film, silent

Malcolm Le Grice
Berlin Horse 1970
16mm film, sound

standing in front of three overlapping projectors, each with a strip of colour film. His most famous film is perhaps *Berlin Horse* 1970, with sound-loop by Brian Eno, a textured and lyrical piece that includes 8mm raw footage, rephotography from the screen, direct colour printing and archive footage from 1896. As well as numerous 'landscape' films, he explored narrative structure and the 'family romance' in the late 1970s before returning to an early interest in computer imaging and abstract art in digital form. Like David Larcher, another UK underground pioneer latterly turned to video and digital media, Le Grice's later mythopoeic films such as *Chronos* 1994 have elements of autobiography, text and diary.

Gidal, by contrast, retains the strict ethos of his earlier *Upside Down Feature* 1972 and *Room Film 1973* 1973, which attack representation and metaphor through a series of camera strategies such as variable focus, hand-held motion and zip-pans. These are made more complex by successively reshooting or reprinting the same scene, often a room or a small portion of a landscape, to question the given and 'already-seen' aspects of the moving image. Other films include still photographs that are shot as real scenes or landscapes to interrogate the reality-effect of cinema. Gidal's rigour, and his refusal to concede to any form of unmediated presence in film, has yielded a substantial body of work that in fact is richly visual and associative while also being critical and 'apperceptive'. It compels the viewer to reflect on and question his or her own experience in the process of watching the film. A major theorist of 'materialist film', he has written extensively about Samuel Beckett, Gerhard Richter, Andy Warhol and Thérèse Oulton.

The period emblematically ended with the exhibition *Film as Film* in 1979 at the Hayward Gallery, along with a major film festival of new avant-garde work. *Film as Film*, based on an earlier show in Germany by the Heins and the curator Wulf Herzogenrath, was a celebration of the 'formal film' going back to the 1920s. Its very definition caused controversy, by excluding the broader Underground, but also alienated women filmmakers when they were refused a space of their own in the gallery. Their walk-out left some blank spaces in an otherwise radically transformed Hayward, vividly lit by experimental films on loop projectors. That year, Lis Rhodes – one of the protestors – showed a stunning new film, *Light Reading*, that heralded a new sensibility. This was more personal, allusive and explicitly feminist than her abstract two-screen *Light Music* 1975, an audio-visual work of expanded cinema made directly on the filmstrip with a graphic vitality akin to the light-projections of Anthony McCall (an LFMC filmmaker before his departure to the USA).

Many filmmakers of the later 1970s took up this more personal stance, a direction also seen in the early films of Patrick Keiller, John Smith, Jayne Parker and Tina Keane. Some filmmakers used the home-movie 8mm format to explore subjective vision in an even more direct way, as with Derek Jarman and the 'new romantic' filmmakers who emerged at this time and into the early 1980s (including Cerith Wyn-Evans and John Maybury). The Festival of Expanded

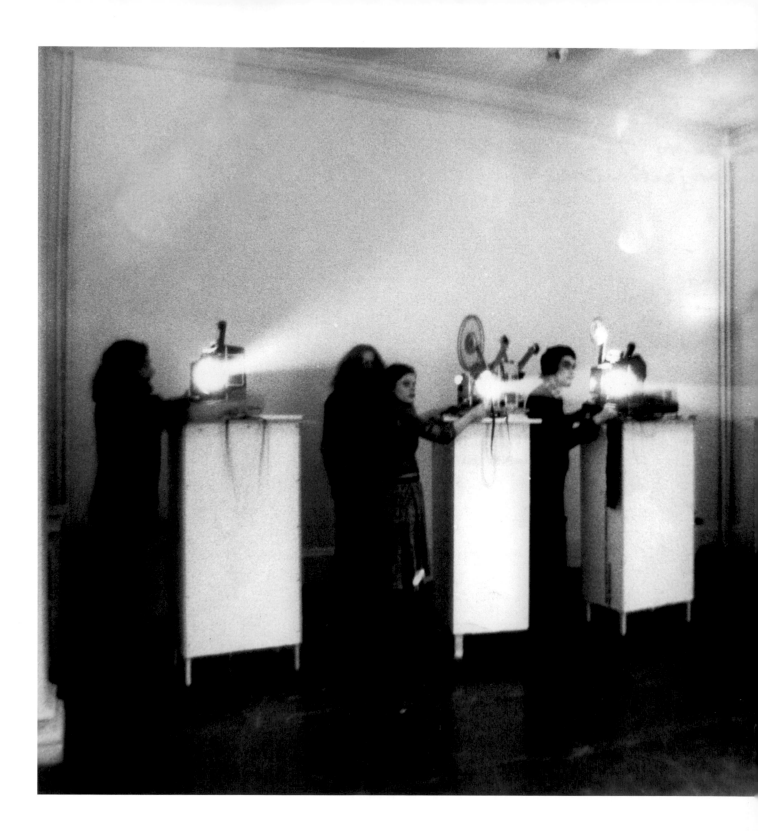

Filmaktion group performance,
Gallery House, London,
March 1973.
Left to right: Malcolm Le Grice,
John Blandy, Gill Eatherley,
William Raban

Lis Rhodes
Light Reading 1979
16mm film installation

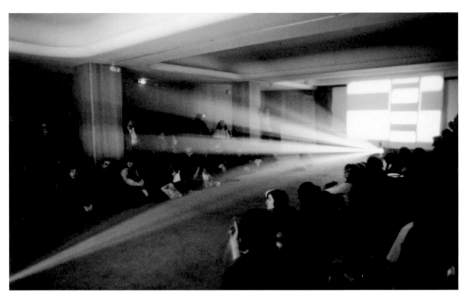

Cinema at the ICA in 1976 also featured work by a younger generation who made multi-screen, installation and site-specific cinema, such as Guy Sherwin, Nicky Hamlyn and Steve Farrer.

Since the late 1970s, both older and newer filmmakers associated with the LFMC or the Circles group of women film artists have continued to make films for screen, television and the gallery (notably John Smith and Jayne Parker). They comprise a group or tendency distinct from later video gallerists (since the 1990s), although it is not the medium or the technology that marks the change. Few of the 'filmmakers' active since the 1970s in fact now work exclusively with film, and most have turned to video or digital media. Their US contemporaries include Ernie Gehr, Nathaniel Dorsky, Leslie Thornton and Peter Hutton. Their collective difference from gallery video artists is based less on style or even subject-matter than on an interrogative and critical approach to the time-based image. Looking back at the 1960s, Michael Snow also remarked that 'there was at that time and still is a separation of communities between those involved in the painting and sculpture world in whatever capacity – artist, dealer, critic, collector – and those involved in experimental film'. By this he meant that experimental film lacked 'glamour'. The rise of current projection art in the gallery – which is far from lacking in glamour – comes by and large from a very different direction that rarely acknowledges, and perhaps does not even know about, the films, groups and experiments outlined here.

Originally, that difference opened up a dialogue. As a student at the Courtauld Institute in London (1970–3), Jeff Wall recalled in 2001 that he:

> spent a great deal of time looking at film ... I went to the film clubs, the ICA, the NFT, and everywhere I could see the things I wanted to see – which were experimental and art films, from Peter Gidal and Michael Snow, to Jean-Marie Straub, Fassbinder, Robert Kramer, or Godard ... I remember liking very much going to places like the Filmmakers' Co-op. It wasn't a cinema in the standard sense. The films might be very short or very long, any length, so there was no set interval for the replaying of the recording. You could also walk in and out more easily ... the audience was more detached, mobile and intermittent than they are in the normal cinema. They aren't there to see a play, but to contemplate some instance of motion pictures, formed in some other way. It is more like going to an art gallery and encountering this or that work, each different in scale, medium, etc.

In this sense, today's gallery video projection is a return of the repressed, but in another aspect some of its radical antecedents make up a hidden and still suppressed history within the rise of artists' video from margin to mainstream.

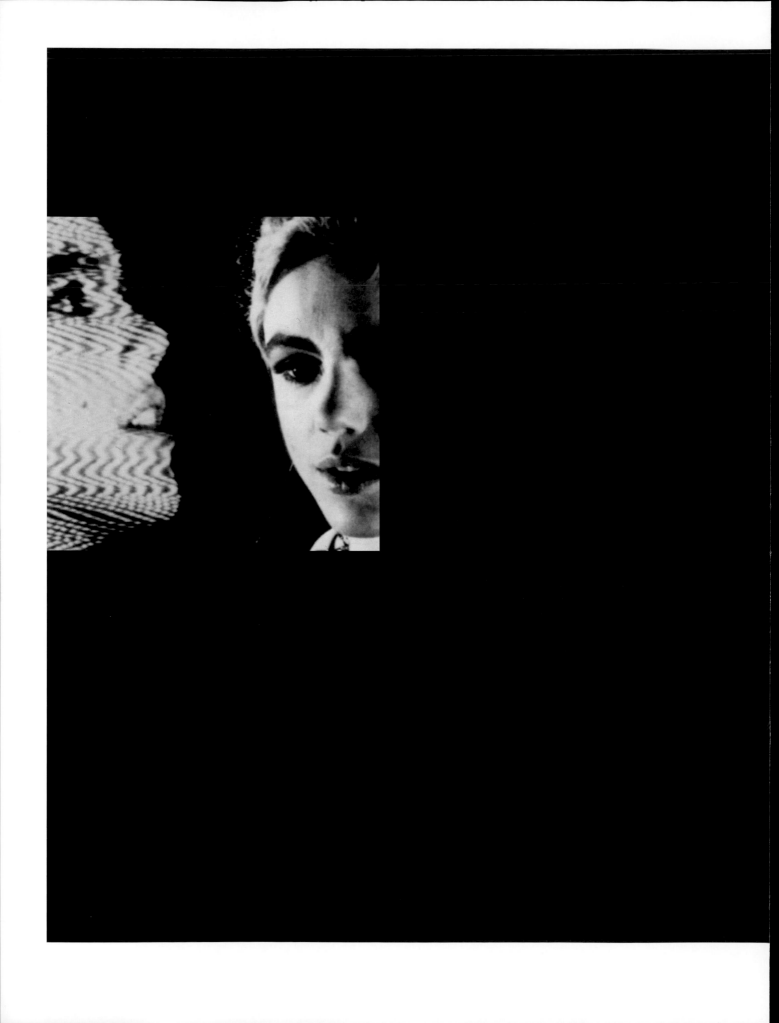

Christopher Eamon

AN ART OF
TEMPORALITY

As captured in Hans Namuth's famous 1950 film of the artist at work, Jackson Pollock's method of painting involved moving his entire body across the canvas from all directions. Building up layer after layer of paint through drips of colour, Pollock made a record of his body's action over time. It was perhaps this element of time inscribed into the work, in addition to the involvement of the artist's entire body in the process, and the resulting total immersion of the audience in the large-scale, 'all over', seemingly frameless images, that led Allan Kaprow to announce a new form of artistic practice in a text that is now seminal for the history of Happenings, actions and performance: 'The Legacy Of Jackson Pollock' (1958).[1] Yet Kaprow did not trace a direct link from Pollock to 'Happenings', a term coined by the Fluxus artist Dick Higgins in 1957. His formulation comes by way of the music and compositional ideas of John Cage. The incorporation of temporality into the artwork by way of the ephemeral and temporary conditions of music suggests a multidisciplinary past to the video, film and intermedia works that were to flow out of Happenings and Fluxus by the early 1960s. And it is this multidisciplinarity that should be explored in relation to the film and video art of the next three decades.

By the time Kaprow wrote his homage to Pollock, he had, along with Dick Higgins, Al Hanson and George Segal, attended a composition class at the New School for Social Research with Cage. By the mid-1940s, Cage had experimented with new musical forms – synthesisers and electronic sounds, record players and magnetic audiotape – and by the early 1950s, he had begun to develop a Zen-inspired theory of music that was more open-ended in terms of who could or could not produce it than had previously been known in music. His compositional approach was not only open to, but based upon, chance phenomena – a central idea in his newly developing and influential aesthetic theory.

In 1952, Cage created one of his best-known works, *4'33"*, which requires a pianist to arrive at a piano, close the lid and rest in silence for a period of time and then open it for a moment, close it again, and remain motionless for the same amount of time. This act is repeated once more over the duration of the piece, to a total of 4 minutes, 33 seconds. Of course, there is no such thing as silence, and thus the piece involves the ambient sounds of the room, the shuffling of the audience, and the occasional cough. In *4'33"* Cage admits into the compositional canon uncontrollable and chance activities. By giving equal weight to non-musical sounds, he also radically overturns a conventional hierarchy in the making of music held onto for centuries. The singularity of the musical event was also underscored: no subsequent performance of this piece would, or indeed could, be the same. These central ideas – the lack of hierarchy between musician and audience, and the collapsing of the cultured sphere of notes and the Duchampian realm of the everyday into a singular non-repeatable experience of art – would wield a crucial influence on contemporary art for decades to come. Indeed, Cage's thinking produced an incomparable framework for the film and video art that was to grow amidst the radical dissolution of boundaries and art forms characterising much of the art of the 1960s and 1970s, since by the time these ideas caught on in performance, Cage-inspired actions came to include the time-based, recordable and projectable medium of film.

Cage's first event to incorporate multidisciplinarity and chance into a single work, later called *Theatre Piece No. 1*, was performed at Black Mountain College in North Carolina in 1952. Often described as a proto-Happening, which in itself renders it the core of much film and video art, *Theatre Piece No. 1* took the form of a 45-minute piece divided into 15-minute segments for which others at the college were invited to 'fill up the time' with actions of their own. Participants included poets Charles Olson, Mary Caroline Richards, painter Robert Rauschenberg, musician David Tudor, choreographer Merce Cunningham, several dancers, slide

and film projections and, reportedly, a dog.[2] Cage conceived the form of the event as 'purposeful purposelessness'.[3] In other words, it involved a structure within which indeterminate elements could be carried out without the control normally ascribed to composers, choreographers or directors.

The related works of Kaprow took a primarily visual approach, through the employment and creation of environments and assemblages. His background was as a painter. In 1959, the Reuben Gallery in New York was christened with the unveiling of his *18 Happenings in 6 Parts*. Claes Oldenberg, Robert Whitman, Lucas Samaras and Robert Watts all came to be involved in the Happenings during the late 1950s and 1960s, as did those (more musical) artists who were later associated with the group known as Fluxus, such as George Brecht, Dick Higgins and Al Hanson. But at this early stage Whitman demonstrated the greatest interest in the projected film image, especially in relation to live action. Of those who incorporated film image into live action, it was Whitman who extended his interrogation the furthest, becoming one of the first artists to use the projected film image in stand-alone installations as works of art. From the well-known and oft-cited *American Moon*, performed in 1960, to *Prune Flat*, presented at Jonas Mekas's New York Filmmakers' Cinematheque during the Expanded Film Festival in 1965, Whitman prominently introduced the use of the film image within a performance environment.

In *Prune Flat*, film images are screened on the background of the performance area, while two female figures move into the frame of action, at times almost entirely camouflaged by the images projected onto their white smocks and head coverings. When the same figures appear in the film, their scale is much larger than that of their live doppelgangers, until the lens widens, causing the film image to coincide almost completely with the live figures. This endows the latter with the materiality they lacked when projected onto as screen. A sort of *trompe l'oeil* occurs when the filmic image of one figure pivots, jump cuts and her white dress changes into a red one and then becomes blue. This filmic play of the immaterial figures bestowing solidity on the live performers reverses the assumed logic of projected figure and ground. This play continues through a series of actions that are either mirrored in the film or presaged by it, also experimenting with the temporal order of the performed action *vis-à-vis* the recorded. Nearly halfway through the piece, the pouring of water over an illuminated light bulb suspended centre stage causes it to explode. Providing not only a shock to the audience, but also an explosion of the real into the dream-like, the work teeters on the brink of the surrealist and ritualistic. This idea of incorporating into the live action a film made with the participants and treated as another actor in the drama would later be found in much video installation art.

Whitman's 'Cinema Pieces', *Window* 1963, *Dining Room Table* 1963, *Shower* 1964 and *Bathroom Sink* 1964 (also known as *Sink*), are four of the earliest works to employ projected film in freestanding installations, as opposed to elements in a performance. In *Shower*, water is pumped through a nozzle in a shower stall, while an image of a woman showering is rear-projected onto a semi-transparent screen replacing the back wall of the stall, and viewed through a clear plastic curtain. The coincidence of real and projected, as in *Prune Flat*, becomes a form of *trompe l'oeil*, a sort of convulsion, in Surrealist terms, of the representation of art into the reality of the object. When the filmed water changes into paint, the projected nude becomes bathed in the primary colours, referring both to painting and to cinema in a way that is not dissimilar to the concerns of the contemporaneous Pop artists, such as Andy Warhol and James Rosenquist, who were making paintings in a cinematic mode. The use of everyday objects such as a window, sink or shower, was also central to Pop art.

Whitman's incorporation of temporality into the conventions of visual arts practice, at a time when dance, music, painting and sculpture were still very

Robert Whitman
Window 1963
16mm film loop
transferred to DVD,
silent

separate disciplines, announced the dissolution of boundaries between genres that came to be a defining characteristic of Happenings and Fluxus events worldwide. The term 'intermedia' was coined for such related activities.[4] Intermedia would become increasingly germane to the development of film installations and video art in the decades to come, much of which were explicitly connected to actions, performance and the dematerialisation of the art object – the most influential ideas of the next two decades. The time-based and the ephemeral became the core experience during a time of political upheaval, change and deep questioning of the role of art in everyday life.

Fluxus, a notoriously difficult-to-define international movement, represents another, arguably more direct, link between electronic musical composition and film and video art. The term, coined by the Hungarian émigré George Maciunas in Germany in 1961, was used loosely in the United States, where artists associated with Fluxus included George Brecht, Dick Higgins and Al Hanson, who also took part in individual Happenings at George Segal's farm in New Jersey. In Europe, Fluxus has a long and involved history. From the earliest time, it was associated with electronic music. Joseph Beuys described this history in a 1982 interview: 'The original Fluxus concerts were organised by people whose interest was in sound rather than in painting or sculpture. Hence the link with John Cage, La Monte Young, and even Stockhausen and those concerned with electronic music. But their attitude was a revolutionary one and went against the traditional idea of the concert.'[5] Perhaps due to these roots, many of the works of artists associated with European Fluxus, including Beuys, Wolf Vostell and Nam June Paik, invoked music or involved musical instruments. These included Beuys's first two public actions *Composition for 2 Musicians* and *Siberian Symphony, 1st Movement* 1963 – the former a composition for piano, the latter for piano, blackboard and dead hare – and Paik's *Opera Sextronique* 1967, where Paik's body was 'played' by long-time collaborator and concert cellist Charlotte Moorman. The time-based nature of experimental music, along with the electronic element, was to lead to Paik's and Vostell's work with electronic images.

Vostell is believed to have created the first European Happening, in Paris in 1958, which, as in Kaprow's early works, involved a series of assemblages. The series entitled *Black Room Cycle* 1958–63 includes a piece known as *German View*, which incorporated newspaper clippings, burned wood, bones, a child's toy, barbed wire and a television set on which a programme was playing. Vostell's work from this period evolved from his interest in the use of the 'everyday' in art. He did not collage newly combined materials, but rather used what is already combined in the world around us, an idea he called 'dé-collage' and from which numerous assemblages and environments were derived in the coming years. These included a six-television environment entitled *Television Dé-collage* 1963, first exhibited at the Smollin Gallery, New York, and *Electronic Dé-collage, Happening Room*, shown at the Venice Biennale in 1968, which involved six televisions with programmes playing, broken glass, electronically motorised found objects and a computer programme that controlled the movement of pieces of the assemblage in response to the presence of viewers. It has been argued that this use of televisions in assemblages marked the birth of video art. But the television set was used in such works as a material in its own right, rather than for purposes of documentation through videotape. At this time, the new medium of television was rapidly achieving cultural dominance, and artists were beginning to investigate its particular visual qualities.

Vostell may have had an influence on Paik in the use of the television set, closed-circuit video cameras and, later, videotape, which would not come into common artistic use until the late 1960s. Yet this influence is uncertain, since Vostell's first television works, shown in 1963, were exhibited after Paik's *Exposition of Music – Electronic Television* show in Wuppertal in the same year.

Nam June Paik
Zen for Film 1964/5
16mm film, silent

What is certain, according to Vostell, is the influence of the first Dada retrospective in Germany on many of the artists who would come to participate in Fluxus internationally, including Nam June Paik and Karlheinz Stockhausen in Düsseldorf in 1958.[6]

Paik had immigrated to Munich from Korea in 1957, where he took courses with Cage, Stockhausen and David Tudor. After immigrating to the United States, he created a much-lauded Fluxus work entitled *Zen for Film* 1964, undoubtedly inspired by Cage, in which the artist ran blank leader through the film projector while he positioned himself in the square of projected light, producing minimal movements within the frame. His actions become the subject of the 'film'. As in Whitman's *Prune Flat*, the work is about the link between the frame of light and the body, and needs the performer for completion. Paik may also have been aware of the well-known and scandalous film by Situationist theorist Guy Debord, made completely of blank film leader in 1952, entitled *Hurlements en faveur de Sade* (Howls in Favour of Sade).

Although these works by Paik and Vostell have been called the earliest examples of video art, most did not actually employ videotape. The images in Vostell's works were from live broadcast television, similar to Cage's composition for twelve live radios, *Imaginary Landscape No. 4* 1953, and Rauschenberg's paintings incorporating working radios. The use of live television and radio appears again and again over the next two decades, and closed-circuit television was employed by Post-minimalist artists in the late 1960s and early 1970s. By the mid-to-late 1990s, technological advances gave rise to new forms, such as interactive digital environments. The live component of these evolving experiences continues to emphasise temporal specificity. This condition was important to artists at this time, and could be said to derive from a desire to incorporate democracy into their work, or, at least, to abolish traditional hierarchies, for these works demanded an immediate response from viewers that could not be replicated. The completion of the work was reliant specifically on viewers in the exact 'here and now' of the work.

A parallel history of time-based media that was to contribute to the development of film and video art can be traced from early film experiments begun in the 1940s. This different strand, found in the films of Maya Deren, Kenneth Anger, Harry Smith and Bruce Conner, revived those of the Surrealists and Dadaists of the 1920s and 1930s. These works came to form the beginnings of the independent and experimental film scenes in New York at the Filmmaker's Cooperative, founded by Jonas Mekas in 1962, and, on the West Coast, at Canyon Cinema, established in San Francisco in 1960. Deren began as a dancer, and this connection to temporality in art may have prompted her to take advantage of the new 8mm camera, developed in the 1930s for home use, and later 16mm film. She chose to make works incorporating movement, elements of narrative and a decidedly Surrealist vision. Deren, and no doubt Anger, whose first film *Fireworks* was completed in 1947, would have been exposed to the art-film clubs that had been springing up in several American cities since the early 1930s. Deren's exposure to the Surrealist films of Luis Buñuel very likely occurred at the Film Guild Cinema in Greenwich Village, the first modernist cinema in the United States, designed by the visionary architect Frederick Kiesler, and for which films such as *Un Chien Andalou* 1929 and Fernand Léger's *Ballet Mecanique* 1924 had been mainstays ever since its opening in 1929.

In her second film *At Land* 1944, Deren winds her way over dunes on the seashore. When she reaches the top of one of them, she seems to pull herself up through a trap door and emerges in a wooden construction, a room inhabited by men dressed in black and wearing fedoras. In this work, Deren reinvents the cut, deliberately intending to produce discontinuity between takes as opposed to minimising the viewer's awareness of editing in the interests of narrative

continuity. Her method harks back to Surrealist European film, reintroducing experimentation with the medium in a US film scene that had become thoroughly commercialised and standardised by the 1940s. The influential works of Deren and Anger, which laid bare not only the cut but also other aspects of the filmmaking apparatus, such as exposure, speed, focus and celluloid itself, became the technical paradigms for the New American Cinema, which rose to influential heights in the 1960s. The worlds of the experimental filmmakers and those of the video and performance artists were essentially quite different, since the paradigm against which these filmmakers placed themselves was that of the film industry and not that of art history like so many of those involved in video and performance art in the 1960s and 1970s. Having said that, there were overlaps between individual practices, and by the early 1990s, the full extent of the rich explorations of the moving image by both groups came to influence new generations of video artists, such as Stan Douglas and Douglas Gordon, among many others.

A decade later, it would take a Lithuanian émigré living in America to reintroduce the experiments of the Europeans to Europe. As editor of the journal *Film Culture* and through his column in the *Village Voice*, Jonas Mekas gave great critical attention to experimental cinema in the United States from 1960 onwards. A prolific filmmaker himself, he was a tireless advocate of this new brand of artistic freedom in filmmaking. He founded the New York Cinematheque and the Expanded Cinema Festival in New York, which became venues for a rich interplay of artists, movements and interests. Not only did some of the Happenings artists participate in this arena, but so did painters and performers such as Carolee Schneemann, Robert Morris, West Coast filmmakers like Stan VanDerBeek, and Judson Gallery-affiliated filmmakers Jud Yalkut and the USCO collective.

The most influential filmmakers associated with the New American Cinema in the 1960s were Stan Brakhage and the Canadian artist/filmmaker Michael Snow. Along with Paul Sharits and Ken Jacobs, they theorised and realised a practice that had a great impact on film artists both in the US and in Europe. Structuralist film, as it was called in the US, evolved globally in different forms. Its approach revolved around the material aspects of film – the qualities inherent in film itself – and became extended to the entire filmmaking apparatus. In the UK, the term 'materialist film' was coined by Peter Gidal to describe this evolving project.

The definitive Structuralist film is Snow's *Wavelength* 1967, which comprises an apparently continuous (but in fact edited) zoom that starts with the widest-angle view of a Soho loft and narrows in on a small picture hanging between two large windows at the end of the room. When the contents of this black and white picture of a choppy sea entirely fill the frame, the film ends. On the soundtrack we hear an aural equivalent to the zoom lens shot, a sine wave that steadily increases in pitch from its lowest frequency to its highest. Duration is the subject of this film in many respects, and, in the course of its 45 minutes, several aspects of the material qualities of the film are explored. Translucent, coloured gels are applied, and the film appears at times in negative. Interestingly, narrative elements creep in. Under the disinterested forward momentum of the zoom, film writer Amy Taubin enters and exits, a staged murder takes place, as well as various other actions that alert the viewer to how 'story' dominates filmmaking within conventional narrative cinema.

In 1967, the International Experimental Film Festival in the Belgian seaside resort of Knokke became as lively a venue for discussion and exchange between filmmakers and performers as the Expanded Film Festival in New York had been. It was here that artists from around Europe saw for the first time the famous *Wavelength* that they had until now only heard of. During this troubled time, many Europeans – opposed to the US intervention in Vietnam – criticised American Structuralism for its formalism, which appeared to them apolitical. Particularly confrontational were the Austrian filmmakers Peter Weibel, Otto Muehl, Kurt

Michael Snow
Wavelength 1967
16mm film transferred to
DVD, sound

Kren and VALIE EXPORT. Their approach derived from experiences with the Viennese Actionists, whose public performances were at times ritualistic and almost always abject in their use of bodily fluids, blood and mud on and in relation to their own bodies.

The work of the Viennese filmmakers stood in stark contrast not only to American Structuralism, but also to European Structuralism. While the German husband-and-wife team Birgit and Wilhelm Hein, for example, were experimenting with a hand-held camera to produce abstract images in relation to found and commercial ones, Weibel and EXPORT infused their work with interactivity, emphasising actions over illusions, the real over the image. In *Touch Cinema* 1968, for example, EXPORT took to the streets wearing a small model of a cinema as a bra. Weibel used a loudhailer like a fairground barker, inviting passers-by to put their hands inside the model through a miniature curtain and to touch EXPORT's breasts.

Probably since there had been no female Actionists with whom to identify, EXPORT felt free to develop her own practice in several different directions. Not only did she employ mass-media tactics such as treating her name and body like a product logo in order to deconstruct gender stereotypes, she also developed an 'expanded cinema', an experimental film style that explored human perception through the fragmentation of the moving image, similar to the early film works of Dan Graham in the late 1960s and the later freestanding works of Gary Hill. In *Hearing Sound/Seeing Sound* 1973–4, for instance, she employs a split screen. On one side, she can be seen in her Vienna apartment from one point of view and depth of field; on the other, the same scene is filmed from a different position. Shown simultaneously, the two sides never match and are never completely commensurate with a monocular view. In human vision, images are fused together in the brain, and in this sense the unity synthesised in the mind is a fiction. To stress the activity of seeing, the soundtrack is a mix of electronic sounds, like reverberations in the air that have not yet been blended in the cerebral cortex.

This focus on the fallibility of the perceiving consciousness and our over-reliance on conventional ways of thinking reveals EXPORT's deep interest in protest and revolt. Subsequent video works further examine these issues, pre-dating the numerous investigations into perceptual phenomena examined in later film and video art – an analysis for which film and video prove adept tools. They anticipate, for example, Gary Hill's *Core Series* 1991 and other perceptual apparatus works of the 1990s.

In *Adjunct Dislocations* 1973, EXPORT dissects point-of-view as a synthesis of diverse phenomena by filming with three different 16mm cameras, two attached to her body – one on her front and one on her back – and a third hand-held by another person. As in the earliest three of Dan Graham's 1969 series *Sunrise to Sunset*, EXPORT chooses landscape, the most natural and 'given' environment, as a setting. Swinging around along a vertical axis and later in a to-and-fro movement along a horizontal one, she attempts to reintegrate her movements into a technically reconstructed whole. The finished piece is a triple-screen film installation where the image from the hand-held camera is projected in large form on the left, while the films from the remaining two are projected at half size, one atop the other on the right.

A divergent group of American and Europeans gathered at Knokke, leading to a high level of cross-fertilisation on an international scale, where Fluxus elements overlapped with the actions of Weibel and EXPORT, and the respective languages used to describe their works and motivations were contested by and communicated to a network of diverse though like-minded artists.

In the US, one of the most important and enduring figures to come out of the New York Experimental or Underground film scene was Andy Warhol. A frequent attendee of screenings at the New York Cinematheque, Warhol was particularly taken with the freedom exercised in the films he saw. The introduction of 16mm film camera for home use was the most significant technical innovation for the emergence of moving-image art, both in the visual arts and filmmaking communities. For Warhol hinself, Jack Smith was particularly influential. An icon of the New York Underground in both filmmaking and performance during the 1960s, Smith routinely subverted the use of these media with films and events that contested the limits of conformist middle-class culture. The history of film and video art has always been marked by interdisciplinary work, and Smith's is no exception. With more than a hint of camp, his films of the mid-1960s were like fantasies made real. His use of colour and his style of editing were anti-conventional on many simultaneous levels. His technique, though seemingly freeform and hallucinogenic, was rigorously thought through, as was his use of costume. Smith's scandalous *Flaming Creatures* 1961 is legendary in the filmmaking community. Although it appears tame by today's standards, at the time it attracted the attention of the vice squad, who raided a downtown screening due to its lurid content of topless women and transvestites in a harem-like situation presided over by Smith himself. His freedom, not only with focus, editing and point of view (the film was shot from above), but also with content – free love and gender fluidity – attracted Warhol, who actually appears in *Normal Love*, Smith's opus of 1963, as one of the sheet-clad maidens gathered in a golden clearing on an upstate farm. His interest in participating as opposed to taking a disinterested, observational stance in this instance is highly unusual and suggests a greater than ordinary investment in the work of another.

Smith's blurring of gender and social strata adds yet another level to the Fluxus hybridisation of genres and the breaking down of difference between audience and performer. This may have been what intrigued Warhol in Smith's works. He began to make films himself, in which the collision of 'cultures' can be seen as a political element: he combined downtown and uptown, gay and straight, bohemian and bourgeois. For four years, Warhol pursued his new-found interest obsessively, shooting 500 reels of film, as well as 800 single 100-foot reels of *Screen Tests*. Perhaps this was due to his interest in the serial qualities of film. Like his paintings of screen legends, where Warhol repeated the image over and over, perhaps in an attempt to make his subjects live again, the subjects of his *Screen Tests* appear to be living in a continuous present.

The earliest of Warhol's films have been called 'minimalist', even though they bear little relation to Minimalist art, coincidentally emerging at the time. *Sleep,*

VALIE EXPORT
Adjunct Dislocations 1973
16mm film, sound.
Photograph by Hermann
Hendrich of the work
being produced.

Andy Warhol
Outer and Inner Space
1965
16mm film,
double-screen
projection, sound

Hair Cut and *Blow Job* (all 1963) and *Empire* 1964 are amongst the first. All were shot with a fixed camera over a long period of time, and are unedited, except for *Sleep*. For this seven-hour film of John Giorno sleeping, Warhol organised the reels into a complex sequence, and projected them in a multi-screen presentation that fragmented linear events, producing a temporally complex order in which before and after were no longer relevant. The films were projected at the silent-film speed of 18 frames per second, though they had been recorded at 24 frames per second, which rendered the image dreamy and de-realised. Warhol commented that *Sleep* was satisfying to him because of the way in which the image continually repeats. Repetition in relation to the non-repeatability and ephemerality of the event enter into a dialectic, as they had done in the film installations of Robert Whitman.

While Paik was the first American video artist to exhibit in a commercial gallery – his work with television sets of 1963 – his earliest videotaped works were not made until 1966. Warhol can therefore be considered the first to use videotape, which he did in *Outer and Inner Space* 1965. This recently discovered hybrid videotape/film was inspired by a loan from Norelco of a non-portable video camera and tape deck, given to him in the hope that he might produce something useable for marketing purposes. With this very new apparatus, Warhol taped a close-up of Factory regular Edie Sedgwick, in profile and apparently talking to someone off screen to her right. Subsequently, he positioned her beside a large monitor that showed her roughly life-size taped image, and filmed her again on 16mm film, talking to someone to her left. The two reels of resulting film footage, each 33 minutes long, were then projected on a double screen. Warhol's plastic way of manipulating time in this piece is paralleled by his manipulation of space, since when viewing the work, not only do we see four simultaneous images of Sedgwick arranged from left to right (two portraits on two screens, reminiscent of Warhol's multiple painted portraits of the early 1960s such as *Portrait of Ethel's Skull Thirty-Six Times*, 1963), but we also see two different types of space alternating with each other: the filmed space and the taped space of the monitor – 'outer and inner' spaces. The effect, in time, is that we perceive Edie to be in a kind of inner dialogue with herself.

Warhol's movies had a profound influence on the experimental film community, who regularly turned out, and still turn out, for screenings of his works, as well as on a diverse array of Post-minimalist film artists. Birgit Hein, for instance, noted that her Structuralist approach was more akin to Warhol's cold, distanced filmmaking than to Brakhage's, which was already being discussed as romantic and diaristic in comparison.[7] Later artists using film, such as Mel Bochner and Dan Graham, acknowledge the influence of Warhol's films on their own developing practices.

The cross-fertilisation that characterised much of the time-based or moving-image art of the 1950s and 1960s continued well into the 1970s. And, like Fluxus, few of the movements that emerged at this time held together in a strict fashion, certainly not as tightly as did the New American Cinema. But in the early 1960s, a particularly intriguing crossover between electronic music, experimental film and the performance of the everyday took place at the Judson Church in Greenwich Village, New York, which, from the late 1950s onwards, made space available for exhibitions, rehearsals and performances. Not only had intermedia and assemblage art flourished at the Judson Gallery founded by Kaprow in 1959, but also the use of everyday movement was seeping into dance, in the work of Yvonne Rainer, Trisha Brown, Steve Paxton and others who formed Judson Dance Theatre in 1962. This transfer of ideas from Happenings into dance, via Cunningham and Cage, brought about a challenge to traditionally conceived dance through its use of amateur performers and incorporation of non-dance movement and improvisation. This group, later to work as the company Grand

Union, has made a lasting impact on both dance history and, arguably, the history of the moving image as well.

Rainer, Brown and Paxton worked with the Martha Graham Company in the late 1950s and attended Anna Halprin's workshop with Judson Dance Theatre co-founder Simone Forti in 1960, followed by classes with famed choreographer Merce Cunningham. Later, they began developing their own form. In 1967, perhaps due to a concomitant interest in the cinema, Rainer made the first of her films that took movement as a subject. Shot by a variety of cinematographers, films such as *Volleyball (Foot Film)* 1967 or *Hand Movie* 1966, presented movements that looked nothing like dance in the conventional sense. They would focus, for example, on the artist's foot gently kicking and rolling a volleyball into the corner of the room, or on the movement of a hand against a blank white ground. Although shot on film, they can be considered examples of the very earliest video art, since they significantly influenced the way in which video would be used internationally over the next decade by Vito Acconci, Ulay and Abramovic, Peter Campus and Joan Jonas, to name just a few. Central to all their practices was the presentation of the artist's body in movement, isolated for the camera, in what would come to be called 'performance video'.

Two of Rainer's films, *Line* 1969 and *Hand Movie*, were included in a 1969 programme of films at the Paula Cooper Gallery, which had come to the fore in the 1960s for its focus on Minimalism, routinely exhibiting the works of Donald Judd, Sol LeWitt and Carl Andre. Entitled *Coulisse*, and also featuring films by Bruce Nauman and Richard Serra, this screening had a lasting impact on what we think of as video art today. Serra, who at the time focused on temporality and process in his sculptural works by splashing molten metal into the corners of rooms or against barriers, remembers being impressed by the simple purity of action in Rainer's *Hand Movie*. He made four of his own 'hand' films such as *Hand Catching Lead* 1968 in response.[8]

While, on the East Coast, Rainer was incising the staged with the everyday, on the West, a young artist who was still a graduate student at the University of California at Davis was having his world opened up to performance and Conceptualism. By 1966, Bruce Nauman, along with his collaborator William Allan, embarked on a project to make work that was as 'pure' as possible.[9] By then, a Conceptual environment was already in place that valued actions or process over completed objects. Their first work was an incomplete film called *Uncovering a Sculpture* 1965, which showed the process of producing a wedge-like structure. In their second film *Span*, the two built a structure with plastic draped over rope to span a stream in the Muir Woods north of San Francisco. Swayed by the wind, the structure was left to its own devices with no audience as witness, save for viewers of the resulting film; the focus of the work was not the act in the forest, but the time-based film.

The dissolution of boundaries between disciplines and the element of time moving into art via the model of music and dance was due in no small part due to Halprin's studio in Northern California, which attracted like-minded performers on the West Coast. Nauman recalls in a 1970 interview having met the vocal performance artist Meredith Monk at Halprin's studio. This prompted him to think of sound as an element in his work. His film works were almost always distributed in the form of video due to the ease with which videos could be shown and disseminated. In his works of 1968, known as the 'studio films', Nauman, like Rainer on the East Coast, frames himself performing solitary acts of everyday simplicity such as bouncing a ball, or walking on the perimeter of a square. In these works, Nauman does away with objects. Like other Post-minimalist artists, he also began to turn from an interest in the temporal and event-based aesthetics of Cage towards an exploration of human perception and the possibilities of disrupting it.

In common with many other artists of the time, including Jonas, Campus and

Acconci, Nauman acquired his first portable video equipment in 1969. The unique properties of video, and specifically the Portapak, introduced in 1966, had up until this point rarely been investigated. Unlike images shot on film, those made on portable video are immediately available for viewing. Furthermore, they can appear on a monitor while simultaneously being recorded. This reflexive quality of the video camera in relation to performed activity was exploited by each artist in different ways. It allowed for an investigation into the complex schism between live and recorded image, between illusion and reality, raising disquieting ontological questions: Am I there or here? Is this me now or then? The camera-monitor-circuit acted as a kind of mirror; it turned practices inwards, involving at least one degree of removal. Nauman took advantage of this to create an antagonistic or at least disquieting effect on the audience, as in his works with disembodied voices or bodiless heads.

One of Nauman's first video works extends his studio actions. In the 1968 *Walk with Contrapposto*, he comically attempts to walk through a narrow corridor while maintaining the 'contrapposto' poses of figures in Classical and Renaissance sculpture. When he showed the work in the Whitney Museum of American Art's 1969 exhibition *Anti-illusion*, he screened it in a replica of the same corridor, thus

Richard Serra
Hand Catching Lead
1968
16mm film, silent

Bruce Nauman
Walk with Contropposto
1968
Video, sound. Digital
beta created 2004

mimicking and doubling the space of the corridor and the recorded space of the videotape. His use of live and pre-recorded videos in corridors became key to his practice in 1969 and 1970, and corridors dominated his work throughout the early 1970s. Video's performative and mirroring qualities ensure that viewers are caught up in an invisible electronic circuit, where they are participants in the work, a twist on the inclusiveness of Fluxus and Happenings.

This closed circuit of electronic media was also investigated by Acconci in works such as *Centers* 1971 and *Face Off* 1972, by Jonas in *Vertical Roll* 1972, and in several works by Peter Campus. The latter's explorations such as *Double Vision* 1971 and *Interface* 1972 used both live and recorded video, and expanded into a highly influential form of video installation in the early 1970s. In *Interface*, the viewer enters a darkened chamber. In the centre of the room hangs a piece of glass in which the viewer perceives a faint reflected image of him/herself. Shortly afterwards, a live image of the viewer captured by the camera from the other side of the glass is projected onto the glass, which now acts as a screen, and presents the image from the opposite point of view, flipped in relation to the earlier reflection. The use of glass as a real mirror and as a surface onto which is projected the viewpoint of another 'eye', not only exploits the mirror-like aspects of the electronic image, but invokes a question about the continuity of the circuit in real time, calling one or both of the live images into question.

This rupture in the fabric of time marks much of the video art of the early 1970s. To greater or lesser degrees, Bill Viola's first three video installations, for example, can be traced back to this work. In these early pieces, Viola immerses the viewer, taking his investigation to a metaphysical level. In the second of three installations begun in 1974, *He Weeps for You* (p.84), Viola combines the projected image of the viewer with audio and physical components. While a drop of water slowly forms at the end of a copper pipe, the image of the drop is projected in large format on a distant wall. The viewer and the room can be seen reflected in the magnified image. When the drip falls from the pipe under its own weight onto a large drum fitted with a microphone, a loud crash is heard in the space. The inverted image of the viewer evokes a spiritual introspection, and is reminiscent not only of Campus's projected glass pieces, but also of his later series employing the live projection of viewers inverted on a distant wall in a darkened space. In both cases, the viewer is reminded of the fragility of the image, and perhaps, by implication, of his or her own mortality. Temporality remains central, since

the audience's movements and acknowledgement of what occurs in the space is crucial to their experience and understanding of the work.

By contrast, Dan Graham moves the investigation in a completely different direction, towards a critique of the entire social apparatus of the televisual and its invisible circuits. His early works are more concerned with the viewpoints of audience and camera, in a way similar to Snow in *Wavelength* and *Standard Time* 1967. By the early 1970s, Graham was using 8mm and 16mm film in works such as *Sunrise to Sunset* 1969, *Roll* 1970 and *Helix Spiral* 1973. *Sunrise to Sunset* emphasises the position of the viewer in relation to that of the filmmaker, and extends this into the surrounding, filmed environment. As in a number of Snow's early works, the camera turns around a central axis, spiralling upwards to the sky and then down again to the horizon. Graham acknowledges that he was influenced by Snow, and by the subtly graduating colours of early paintings by Robert Mangold. His aim in these works is to take up the ideas put forward by phenomenological psychology regarding the position of a perceiving consciousness in relation to its horizon. In *Helix Spiral*, these relationships are expanded to involve another person with a camera performing the 'helix' while Graham, also with camera in hand, performs the 'spiral', thereby heightening the possibilities for interaction.

The investigation of self in relation to other is still very much present in Graham's current investigations. His interest in the field of perception has expanded to include processes outside the artwork and its immediate experience. His live performances involving mirrored rooms, video and audio equipment, and constructed barriers all invoke the duality of seeing and being seen. In a piece entitled *Opposing Mirrors and Video Monitors with Time Delay* 1974, our view of ourselves represented in an array of images both live and on time delay, in mirrors and on monitors, directly undermines the self-assuredness of the perceiving consciousness. Two cameras capture one's image on a pair of opposing monitors, both of which face towards mirrored walls. One sees oneself not only multiplied within the *mise-en-abyme* of the mirrors, but also in that same *mise-en-abyme* multiplied in the monitor images. A time-delay mechanism complicates the experience. The direct image of oneself in real time is accessible only by looking across the room at the reflected image of the distant monitor as reflected in a mirror. Unable to understand the exact process of representation, one experiences a complete lack of control over the images. This work prefigures Graham's work with glass and mirrored outdoor pavilions and the idea of viewing or being viewed as a system that implicates power. The power of seeing over the related impotence of being seen was rigorously investigated by Graham in the early 1970s, presaging several decades of thinking and writing about the social and philosophical implications of surveillance, and the mistruths inherent in the structure of the live video image.

This idea was taken up and expanded in a completely different way within a few years by Graham's colleague and frequent collaborator Dara Birnbaum, who expanded the notion of communication to the realm of mass media. In Birnbaum's images appropriated from popular television, the ethos or myths underlying such images is teased out, reauthored and hence re-mythologised. In *Technology/ Transformation: Wonder Woman* 1978, the 1970s television series 'Wonder Woman' is appropriated and certain aspects of its representation of women are ferreted out. Focusing on specific sequences of material, she cuts, repeats and lays down track after track, accompanied by a hyper-sexualised disco soundtrack based on the television show. In this way, Birnbaum emphasises the deployment of female sexuality in the media. Both ironic and humorous, the work attacks and disarms the unacknowledged myth-making process inherent in the narrative. These early video appropriations or 'deconstructions' were often exhibited as sculpture, sometimes on monitors set into large travel cases (such as those used in the transfer of professional equipment), as in the original version of *Kiss the Girls* 1979.

Bill Viola
He Weeps for You 1976
Video/sound installation:
water-drop from copper
pipe, live colour camera
with macro lens,
amplified drum, video
projection in dark room

Viola, Birnbaum and Graham, along with other artists, all adopted dual practices, investigating installation while at the same time making single-channel works for distribution as an antidote to mass culture and the dominance of network television. Their work contributed greatly to the development of video installation art in the 1980s, which involved performances that incorporated film and video images, projected or on monitors, and freestanding film or video installations, particularly the works of Gary Hill, a major figure of this generation.

Hill worked initially within the newly formed genre of performance video. In 1974, he made *Hole in the Wall* at Woodstock Artists' Association, which entailed cutting a hole in a wall, videotaping the action in the next room, and then playing it back on a monitor placed in the same hole. In many of his subsequent single-channel works, Hill began to draw on theories of language in his work, especially in relation to the body and to sight. His works of the 1970s such as *Electronic Music: Improvisations* 1972 and *Soundings* 1979 contributed uniquely both to the history of video and to his own video-installation art in the decades to come. *Soundings*, like many of his works, is about the 'infra-slim' membrane between words and things. In it, the sound of Hill's voice is heard over the image of the speaker from which it emanates, capturing the physicality of the words through vibrations visible on its 'skin'. Over time, Hill covers the speaker with sand, drives a spike through it, sets it on fire and douses it with water in an attempt to alter the sound. The connections and differences between vision, sound, words and objects are highlighted.

Viola, Birnbaum and Hill continue to make major contributions to audio/video installation art (see Hill, pp.152–3). Their roots in live events and their investigation of the apparatus of the video mechanism have been transformed and disseminated through new networks created for the distribution of single-channel tapes. Their contributions created for the first time an archive that could be drawn from when, in the 1990s, installations regained prominence.

The time-based and ephemeral works of Happenings, Fluxus, performance and intermedia artists are crucially germane to the history of video art: they altered art-making practices, undid boundaries between artistic disciplines and emphasised temporality and even the disappearance of the event over the art object. The shifts in approach, ideology and interest necessary for the emergence of works using the moving image can only be understood through the traces of these previous histories. From electronic sound to the electronic image, from the experimental score to the Happening, from movement and dance to the everyday action, and from the static image to the video/monitor circuit and beyond, the nuances of this history have only just begun to be mined.

1 Allan Kaprow, 'The Legacy of Jackson Pollock' in *Essays of the Blurring of Art and Life*, Berkeley and Los Angeles 1993.

2 Richard Schechner and M. Kirkby (eds.), *Tulane Drama Review*, vol.10, no.2, Winter 1965, pp.50–72.

3 Michael Huxley and Noel Witts, *The Twentieth Century Performance Reader*, 2nd ed., London 2002, pp.135–45.

4 Dick Higgins, *Horizons, the Poetics and Theory of Intermedia*, Carbondale 1984.

5 Joseph Beuys, *Joseph Beuys in America: Energy Plan for the Western Man*, New York 1993, p.128.

6 'An Interview with Wolf Vostell: Fluxus Reseen', *Umbrella*, vol.4, no.3, May 1981, p.1.

7 Gabriele Jutz, interview with Birgit Hein in *X-screen*, Matthias Michalka, ed., Vienna 2004, pp.118–29.

8 Annette Michelson, 'The Films of Richard Serra: an Interview (1979)' in Hal Foster and Gordon Hughes (eds.), *Richard Serra*, Cambridge and London 2000, pp.26, 56.

9 From a conversation between the author and William Allan, Spring 2005.

Michael Newman

MOVING IMAGE IN THE GALLERY SINCE THE 1990s

In the first decade of the twenty-first century, it has become practically impossible to walk around the gallery district of a major city, or visit a biennial, triennial or art fair, without seeing a large number of artworks consisting of images that move. Often in these works, an image-sequence made in one medium is taken up in or converted to another: for example, it might be shot in film, edited in digital and then shown as DVD. This 'remediation' is facilitated by digitalisation where the image is easily transferred across different platforms – monitor, projection screen, TV.[1] It is largely the shift in the nature of remediation brought about by digitalisation that justifies us in speaking currently of the 'moving image' rather than film or video.[2] Moving images today are not only ubiquitous, but also infinitely transformable.

Moving image is an art that implies both time and a spatial display in the gallery. This may involve the enlargement of the screen of projection to a whole wall from floor to ceiling, or drawing attention to the screen as an object, for example by tilting it, or by employing multiple screens. A bodily relation to the image may be established that is very different from that experienced by the spectator of cinema fixed to their seat and taken out of themselves, identifying with the image and engrossed by the narrative. Contrary possibilities are opened up by moving image installation: the freedom to move around the space may enable a more detached and inquisitive attitude towards the apparatus, or alternatively the multiplication of screens may induce an absorption into a panoramic spectacle. At stake in much moving image work is the possibility of a critical relation in a thoroughly mediated corporate global culture. The history of moving image art has in part been one of increasingly portable and accessible technology, to which has been added, through the internet, widely available means of distribution to a potentially vast audience. These open up counter-possibilities to the more repressive, controlling and commodifying aspects of global media.

Work using moving image since the 1990s has been extremely diverse – the result of a confluence of sources, varied technical possibilities, and different contexts of production – and this essay can only include a very limited and inevitably partial selection of the art that has been produced since the 1990s and deserves consideration. The rationale for the selection here situates the artists in relation to two key influences on moving image work: on the one hand, bodily performance in front of the camera, and on the other, cinema in its mainstream, avant-garde and experimental forms. In addition, TV has provided a model both of a different temporality – the illusion of immediacy and real time – and the possibility of a relation to a wider audience – a possibility that has been realised by the internet, although at the cost of audience fragmentation.[3] The confluence of these factors has set the parameters of embodiment and disembodiment, presence and absence, relation to mass culture and intimate experience, within which subsequent work in moving image has continued to develop, while taking new directions as the technological and cultural context changes.

Retrospect on cinema

An important gesture of 'moving image' art was to recontextualise cinema. In taking the projected image into the space of the gallery, moving image has returned to the early 'cinema of attractions':[4] the viewer is not physically fixed in place by a seat, and may therefore respond emotionally and directly, like the visitor to an attraction in a fairground booth before the advent of the more disciplinary set-up of the auditorium. While in a sense returning to the conditions of display at the origin of cinema, contemporary moving image art also introduces a new dimension of reflexivity because of the frame provided by the institution of art and its history.

The return to early cinema is evident in Stan Douglas's *Ouverture* 1986, which

Stan Douglas
Still of Nathanael
from *Der Sandmann*
(*The Sandman*) 1995
16mm film loop
installation for two
optical sound projectors

Rodney Graham
Vexation Island 1997
Video installation
(35mm film transferred
to DVD), sound

consists of a six-minute loop made up of sequences of archival footage, made by the Edison Company from 1899 and 1901, of a train journey through the Rocky Mountains, accompanied by a soundtrack of reworked readings from the opening of Marcel Proust's novel cycle *In Search of Lost Time* (1913–27). The linear train journey – co-extensive with the emergence of film as the registration of the linear vector of time – is transformed by the loop into a cycle of repetition, which in turn is shadowed by our knowledge that Proust's work has a circular structure, ending as the narrator begins to write the novel. The loop thus simultaneously exposes (through its negation of linearity) and traps (though its repetition) an unrealised utopian possibility—the 'promise of happiness' encapsulated in Proustian involuntary memory.[5] The connection of the loop with the memory of a stalled utopianism is more explicit in *The Sandman* 1995. The work was made at the former UFA studios, a centre for German film production in the 1920s. The location, in Bagelsberg near Potsdam, is also where many *Schrebergärten* or allotments are to be found. Douglas's film comprises two 360-degree pans through allotments that were reconstructed in the studio to show, in the first instance, how such a garden might have looked twenty years previously, and in the second, its transformation into a building site for new housing, as was the case with many of the gardens at that time. In both, an old man is shown working on a mechanical contraption. The two pans are combined in a single projection, with a seam down the centre, so that at first the past appears to emerge from and replace the present scene, while later the present emerges from and replaces the past. On the soundtrack, three voices read from adapted versions of the letters that open E.T.A. Hoffmann's story, *The Sandman* (1817), the tale of a man who throws sand into and steals the eyes of children who are not asleep, which Freud discusses in terms of the return of the repressed childhood memory of the fear of castration. In Douglas's film the two loops with the seam between them, each seemingly erasing the other, create an experience of the present moment divided between an uncanny return of the repressed and progress stalled in a ruin of redevelopment.

Re-siting cinema in the gallery in front of an audience with different expectations opens up the possibility of transforming its normally linear narrative trajectory, in particular through the use of the loop. The implications of this for the transformation of moving image's relation to time and space is explored by Rodney Graham in his 'costume film' *Vexation Island* 1997 and the two others that follow it to form a trilogy: *How I Became a Ramblin' Man* 1999 and *City Self/Country Self* 2000. All three films are conditioned by the form that gallery display most often imposes on the moving image: the loop – that is, the structure of recurrence – while pondering an event that is both conditioned by and exceeds repetition. On a sandy shore a man dressed in eighteenth-century costume, and who we guess is a castaway, is lying, apparently asleep, with his head on a barrel. *Vexation Island* begins with a parrot perched on another barrel calling for him to wake up. He wakes, sees a tree with coconuts, shakes it, one falls and hits him on the head, he falls back ... and the film repeats itself. Three 'flows' – bird, man, tree – intersect, and an event (what the Classical atomists called a *clinamen* or 'diversion') is generated. This event can give rise to many interpretations – the failure of humanity to dominate nature, a reworking of the story of *Robinson Crusoe*, or a disruption of the linearity of narrative in the adventure film – but in the end, partly because of its circular structure and repetition, the viewer is confronted with an enigma.

Returning to the unfinished business of cinema is one of the concerns of Pierre Huyghe. In *Blanche Neige Lucie* 1997, Lucie Dolène, who provided the French voice of Snow White in the 1937 Disney animation, sings 'Un jour mon prince viendra' (Some day my prince will come) in a high, girlish tone, while on screen she appears as an older woman, and tells the story of her lawsuit against Disney

Pierre Huyghe
The Third Memory 1999
Double projection,
beta digital, video on
monitor, sound

claiming the rights for the use of her voice in the French version of *Snow White*.
If here Huyghe can be seen to foreground a forgotten act of exploitation in
popular culture, in *L'ellipse* 1998, he fills a gap in the timeline of a movie. The film
'fills in' a jump-cut in Wim Wenders's movie *The American Friend* 1977. Some
twenty years after the movie was made, Bruno Ganz, who plays the central
protagonist in Wenders's film, walks from one location to another, crossing
a bridge over the Seine in the district of Beaugrenelle, which was beginning to be
rebuilt when the movie was shot. Apparently there to restore continuity, the
ellipse takes the form of a return that marks the difference between the real and
the fictional, where it is the former rather than the latter that becomes spectral:
Ganz is like a ghost revisiting his past, completing something that was left
incomplete. Huyghe's interest in restitution continues in *The Third Memory* 2000,
where John Woytowicz restages the robbery with hostage-taking that he
committed in 1972, which was the source for the movie *Dog Day Afternoon* 1975,
directed by Sidney Lumet and starring Al Pacino as Woytowicz. Now Woytowicz
can tell his story, as Dolène told hers. This is not a remake, but a reconstruction –
and if reconstructing a crime, would this crime be Woytowicz's attempted bank
robbery, the slaying of his gay partner by the police, or the exploitation of his story
by Lumet? Huyghe's installation stages memory not as a true representation of
the past 'as it was', which in any case could only be correlated with another
representation, but rather as a reconstruction that opens up an area of dispute.
Two recent projects combine the insertion of fictions into reality with an interest
in the relation between art and festivals or holidays, celebrations that are also
interventions in the economy of time. *Streamside Day Follies* 2003, a film shown
as part of an installation with moving walls at Dia Center for the Arts, New York,
invents a festival for the inauguration of a new suburban housing development;
A Journey that Wasn't 2005, in which the film relates to an installation and
a multi-media performance celebrating a voyage to an Antarctic island inhabited
by a previously undiscovered (and, outside the parameters of the film, purely
mythical) albino penguin. In both cases, moving image projection only forms one
element of a larger, open-ended project, whilst also functioning to create effects
rather than to represent reality.

At a cinema the audience cannot control the time of the film, which becomes
possible once film is watched as video or DVD. This new relation to the medium
is a condition inhabited by the work of Douglas Gordon. For *24 Hour Psycho* 1993,
Gordon removed the sound from Alfred Hitchcock's *Psycho* 1960, and slowed it
down so that the shower sequence, for example, lasts approximately half an hour.
Each moment of the film, including those that are marginal to the core narrative,
becomes monumental. The possibility of slowing the film to such an extent
depends entirely on the remediation of film through video. Another example of
the reworking of cinema is Gordon's three-screen projection *Déjà-vu* 2000, which
involves the transfer onto video and subsequent projection onto three screens

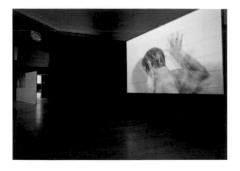

of Rudolph Maté's 1949–50 film noir *D.O.A.* (*Dead On Arrival*), where the first projection is at twenty-five frames per second, and the third at twenty-three frames per second, the middle one being at the 'normal' speed of twenty-four frames per second. Maté's film opens with a man reporting a murder at a police station: he has been poisoned, and in the time before the poison takes effect has managed to kill the man who poisoned him, so he is both murdered and murderer, subject and object of his own story – in a more extreme version of what had become possible for the everyday viewer of a film on video, Gordon has changed the 'timings' of a film that is itself about time and suspense.

An analysis of the rhetoric and syntax of cinema is the starting point for the work of Mark Lewis. Take, for example, the zoom combined with tracking shot which penetrates the broken window of an old office to close in on a spinning top in *North Circular* 2000; or his *Jay's Garden, Malibu* 2001 with its long, steady-cam shots along the winding paths of a landscaped garden in California, where every so often actors from porn films are encountered, fully clothed, as if enjoying a break from their work. One scene with glass grapes gives a clue to the artificiality of this Bacchic idyll, a mnemonic of painting's mythological portrayals of ideal scenes. If *Jay's Garden* is an attempt to outbid painting – to do as a temporal art what a static art cannot, two later works, shot in the Canadian wilderness of Algonquin Park were, rather, an attempt to slow film down to the extent that it might sustain the intense scrutiny that has seemed painting's right, while at the same time creating an event of disclosure that takes place between image and viewer, and that requires time. *Algonquin Park, Early March* 2002 begins with the screen filled with white light which the reverse zoom reveals to be ice, in a bay fringed by pine trees, on which we see skaters, the whole scene recalling Pieter Breugel the Elder's *Hunters in the Snow* 1565. *Algonquin Park, September* 2001 shows a canoe being paddled across the frame in front of what looks like an island in the fog, which only lifts at the end. The Algonquin Park films re-explore the tradition of landscape using the possibilities of zoom and camera movement offered by the movie camera in order to both to show the role of time in the desire to see, and bring the intensity of attention to the structure of what is seen that is the norm in the reception of the art of the still image to moving images.

Having made political films on aspects of policing in the black British experience during the 1980s, Isaac Julien found his form with *Looking for Langston* 1989, a film about the black, gay American poet Langston Hughes which included imagined scenes from a Harlem speakeasy, scenes set in 1980s London, fantasy sequences, and the photographs of Robert Mapplethorpe. Julien subsequently moved from work that grew out of the tradition of experimental filmmaking and was intended to be shown in cinemas, to sumptuous moving image installation.

Douglas Gordon
24 Hour Psycho 1993
Video installation,
Royal Scottish Academy,
Edinburgh 2007

Mark Lewis
Algonquin Park, Early March 2002
35mm film transferred to DVD, silent

**Isaac Julien and
Sunil Gupta**
*Looking for Langston:
Homage Noir* 1989
16mm film, sound

Most of his installations have the underlying narrative of a journey: the two cowboys in *The Long Road to Mazatlan* 1999; the young man who journeys from the Carribean to the UK and back in *Paradise Omeros* 2002; the black woman in *True North* 2004, who stands for the black explorer Matthew Henson who accompanied the explorer Admiral Robert Peary to the North Pole in 1909, and has only recently been credited with being the Pole's co-discoverer. All these installations are multi-screen – a technique pioneered by the filmmaker Abel Gance in *Napoléon* 1927 – and by panoramically extending the image, or creating parallels and cross-overs, explore complex spatial and temporal relationships between images with their implications of history, geography and otherness.

Another approach to the history of both cinema and video is taken by Clemens von Wedemeyer in works which draw attention to their own making. In *Occupation* 2002 we are shown a film crew and a number of extras in a field under floodlights at night, who are being directed by a production manager dressed in a grey anorak that looks like a uniform, signalling in ways that do not entirely seem to be understood by the extras. The whole thing appears rather pointless, something between a rock festival and the behaviour of the crowd in the film *Close Encounters of the Third Kind* 1977. Soundtrack music begins to play as the camera passes through the crowd; tracks are laid down for a dolly shot; white lines are painted on the grass as if for some sporting event; the extras form a square within the lines, and allow themselves to be organised according to these dispositions. After condensing in a group, the extras suddenly scatter to dramatic music as the lights are knocked over and extinguished, which concludes the film. Accompanying the large projection is a video on a monitor about the making of the film, so a film about the making of a film about making a film which reverses the sequence by beginning with the scatter. On reflection, it is possible to see the 'action' as linking the hierarchical and disciplinary structure of cinema, including Hollywood – with its arrangement of bodies – to the disposition of troops and followers in fascist propaganda film (think of Leni Riefenstahl's *Triumph of the Will* 1934), where the scattering of Wedermeyer's extras might be understood as the contrary assertion of a diverse multitude.

Tableaux of time and the untimely

If time can be technologically mediated, its experience is also profoundly affected by social and cultural factors. Sharon Lockhart's film *NO* 2003 shows husband and wife farmers in Japan evenly distributing piles of mulch and then spreading it on a field, which appears to be square. Filmed from a fixed viewpoint in a single long shot with a 16mm camera, it becomes clear, on reflection, that the physical structure of the field is organised for the point-of-view of the camera. The

Sharon Lockhart
Teatro Amazonas 1999
35mm film, sound

Tacita Dean
Disappearance at Sea II
(Voyage de Guérison)
1997
16mm anamorphic film,
sound

apparently 'real' is a spatio-temporal illusion created for the viewer, and the Japanese subject matter shows up the subject-centred perspective as a culturally specific Western mode. With her *Teatro Amazonas* 1999, we are presented with a twenty-nine-minute unedited take, shot from the stage, of a local audience in the theatre in Manaus, Brazil, which was the focus of Werner Herzog's film *Fitzcarraldo* 1982. They are listening to a live performance of a Minimalist choral work by Becky Allen, sung by the Choral do Amazonas, who are out of sight of the audience in the pit, and which, as it gradually reduces to silence, is replaced by the sounds of the audience of 308 people, who are a statistical sample of the population of Manaus. The film enacts a reversal of the traditional relationship of spectacle to audience, of director to performers, and of international art to local representation. Another moving image work that 'measures' time within a specific geographical and cultural context is Francis Alÿs's *Zocalo* 1999, where the flagpole in the square of that name in Mexico City functions like a sundial during the twelve-hour duration of the video's running time – the people who form a line sheltering from the sun become inadvertent performers in the public space that is also measured by the real time of the rotating shadow, implying an intersection of the historical memory embodied in the city square with the cosmic time measured by this impromptu sundial. The memory of the calendrical systems of native peoples and their accompanying rituals meets the traditional function of the town square as the locus of a clock from which time may be synchronised.

It is striking how much of the best recent moving image work draws on models that were established in the 1960s and 1970s, and technology that is obsolete. Robert Smithson's film *Spiral Jetty* 1970, about the building of his earthwork, was very influential, offering a multi-layered model of time that was simultaneously mythic, geological, and scientific. Tacita Dean draws the consequences of Smithson's emphasis on entropy and time's irreversibility: that the repetitive structure of moving image work is actually related to loss. Her films – and here the celluloid medium as an indexical registering of time, in all its fragility, is essential – become acts of salvage. In many of Tacita Dean's films, the concern with documenting something combines with a sense of the relation between what is being filmed and the historical situation of the medium. In *Disappearance at Sea II* 1997, Dean used the rotating lamp of a lighthouse as a platform from which to film. This recalls the way Michael Snow had a mechanism constructed for one of his films in order to achieve 360-degree pans in a mountain wilderness near Quebec for *La Région Centrale* 1970. Both works share a sense of desolation, but whereas for Snow this revealed a way of seeing that is specific to the camera, for Dean it connected both with the idea of the lighthouse as something that protects the sailor, and a sense of searching the far horizon for someone lost. We could see Tacita Dean's work performing a double act of salvage: on the material, and on the medium. The beached sailboat on the island of Cayman Brac of Donald Crowhurst, a child of colonialism and quixotic yachtsman who had faked his

part in a round-the-world sailing competition and committed suicide by jumping off his boat holding the chronometer, was the subject of Dean's film *Teignmouth Electron* 2000. In *Fernsehturm* 2001, which was shot in the rotating restaurant of the old East Berlin TV tower, a past vision of a future is presented by Dean in the combination of a sunset panorama and the conviviality of the diners, accompanied by pop tunes on an old synthesizer. In each case, film is associated with the analog measurement of time and inscribed with its own temporal and physical fragility as a medium at a moment in history when it is being displaced by the digital.

The position of the observer is destabilised and fragmented in the urban labyrinth of Matthew Buckingham's film installation *A Man of the Crowd* 2003, based on the story by Edgar Allan Poe that influenced Baudelaire's account of modern, urban beauty in his essay 'The Painter of Modern Life'.[6] Buckingham has a 16mm film projecting through an opening in the gallery wall onto a freestanding two-way mirror in the centre of the space, which both reflects and doubles the image that is also seen on the further wall. The glass reflects the viewer's image (a device borrowed from Dan Graham's installation rooms using two-way mirrors and time-delay), thus achieving the aim of much moving image installation, which is to physically implicate the viewer in ways that are impossible in the cinema auditorium. This set-up also reflects the topology of the film itself: as the anonymous latter-day man of the crowd is followed through the streets – in this instance, Vienna – we are shown reflections in café and store windows, creating a *mise-en-abîme* between the content of the film and the mirror-installation.

Stillness in movement and movement in stillness

Movement, when it concerns the image, is necessarily experienced in its contrast with stillness, a contrast mediated by technologies that have changed historically. Once it became possible to reproduce movement in images – rather than simply reflect it in a mirror or produce it ephemerally with optical devices – the meaning of stillness in an image changed forever. In a sense, the emergence of images that move in a fine art context that had been the province of immobile objects and still images reversed the situation.[7] Whereas for cinema, that the image moves is an *a priori* condition, once the moving image is placed in the gallery it is implicitly experienced in relation to art that does not move: painting, sculpture, and photography. The meaning of movement in the image, rather than being taken for granted as ubiquitous in everyday life, is once again thrown into question

If the moving image, in particular in film which comprises individual, still photograms, mementos of an absent, past moment which are made to move through the physiological effect of the after-image, conveys a sense of a re-animation, conversely effects of stillness within movement – whether freeze-frame, the filming of a still image, or some other form of stoppage – are often used to signify memory or death.[8] In *Untitled: Philippe VACHER* 1990, James Coleman extended a four-second clip of the eponymous French actor's portrayal of a doctor who seems to be keeling over onto his instruments until he turns to look at the viewer, into a 35mm film lasting seventeen minutes. The film gradually transforms from colour into black-and-white, as if reversing the history of cinema in order to reflect on film's role as the embalmer of time.[9] It is as if the slowing of the film is an attempt to discern the invisible: for example, the moment of transition from life to death in the becoming of each image, or a secret, like a murder – recalling the photographer's enlargements of his prints in Michelangelo Antonioni's *Blow Up* 1966 in order to try to detect whether a murder has taken place in a park where he happened to be photographing. Coleman's film is projected as a large image with a long throw – the scale of an auditorium projection – but in a gallery space where the viewer may walk up to the image and examine it closely, becoming aware of his or her own body in the space of the installation in relation to a clip which concerns precisely the medical gaze and the emergence of a certain relation between the body, knowledge, and power.[10]

The ontology of the image shifts in the transition from the grain of indexical celluloid to the digital pixel. David Claerbout uses the digital, supplemented by sound and silence, to condense multiple temporalities within single images. The most 'cinematic' of his works is probably *Bordeaux Piece* 2004, which presents a narrative of Oedipal rivalry, but the narrative is repeated, which seems to empty it, and in the course of the repetitions the viewer gradually becomes aware of the continuous change from day into evening into night (a process that takes about fourteen hours). When the viewer puts on the headphones, the dialogue becomes inaudible, but birdsong can be heard: behind the repetitions of a scenario of desire and Oedipal rivalry is the diurnal and seasonal time of nature. Elsewhere Claerbout works at the level of the pixel to introduce stillness into a moving image: in *Vietnam, 1967, near Duc Pho (Reconstruction after Hiromishi Mine)* 2001, the exploded plane is frozen in a fast snapshot as the wind-touched foliage moves gently and the light changes (although we should remember that a still image in video or DVD is actually moving). *Rocking Chair* 2003 comprises a two-sided projection: as the viewer enters a darkened room, he sees a black-and-white image of a woman sitting on a sunny porch, her eyes in the shade, gently rocking as if resting yet marking time; walking past the screen the viewer sees her from behind, and she stops rocking and turns slightly, as if to listen. In this encounter

David Claerbout
Vietnam, 1967, near Duc Pho (Reconstruction after Hiromishi Mine) 2001
Digital video, silent

between the viewer's reality and the virtual image, the gulf between them is felt all the more strongly. In *Shadow Piece* 2005, the point of view is positioned inside a modernist building, looking out through its glass wall and door; people approach the building and try to enter, but the door is locked – only their shadow is able to pass inside, as if to remind us that we, too, are excluded from the image which is a realm of shades, ghostly re-apparitions. *Sections of a Happy Moment* 2007 is a single-channel projected video comprising multiple 'still' shots from various points of view of a single moment in the life of a Chinese family. In a square surrounded by social housing a basketball has been thrown into the air and hangs suspended: this single moment is spatially fragmented and laid out in sequential time, and so the fleeting moment of familial happiness becomes monumental, and even suggests a *memento mori*, accompanied as it is by the generic, soothing piano music that might be applied to a family video.

Moving image is capable of both speeding time up and slowing it down. Using a fixed viewpoint and an uninterrupted take, Jeroen de Rijke and Willem de Rooij's *Bantar Gebang* 2000 shows the transformation brought by the coming of day to a walled shantytown built on a rubbish dump near Jakarta. It is a ravishingly beautiful film, but this response is unsettled by the viewer's knowledge of the circumstances in which people there have to live and work. One might consider this reflection on context to have been extended to the film itself when the ten-minute version was reduced to a three-minute 'trailer' for Art Basel 2000, as if it became an advertisement for itself. In *Untitled* 2001, the artists again exploit the rich detail produced by a static shot of a slowly-changing distant scene. This time, the setting is a graveyard, in which people appear, with the city of Jakarta in the background. The graveyard is the burial place of the wife of Indonesia's first President, which might be the reason for its preservation amid rampant development – this goes to show how the viewer's experience of a representation of a place is affected by their knowledge, or ignorance, of its history and politics.

The temporality of video – the possibility of a continuous recording of the present which may appear simultaneously with itself – distinguishes it from cinema. This is exemplified by Dan Graham's time-delay video installations of the mid-1970s, also using two-way mirrors. The aspect of surveillance – that video can just be left running or triggered by sound or movement – is taken up by Bruce Nauman in his installations, *Mapping the Studio I (Fat Chance John Cage)*, shown at Dia Beacon in 2002, and *Mapping the Studio II with color shift, flip flop, & flip/flop (Fat Chance John Cage)* 2001, both of which include video projections shot in the studio at night (Nauman just left the camera running with a motion sensor on) as well as multiple audio tracks of ambient sound. In a reworking of the genre of 'artist's studio' in which in this case the artist is absent, we can see on multiple screens and hear the infestation of mice, his cat, the movement of moths. This kind of untouched presentation of a segment of the world, when done in the context of an art installation, raises questions about meaning in such a way that the presentation becomes simultaneously 'full' or replete (we try to experience it as it is in the 'now' as we would a painting) and 'emptied' since it is a representation of something that is not present. We necessarily ask why the image is being presented in this context, what its meaning might be. It is at this point that it becomes allegorical.

Traces and dreams of history

At a time of rapid social and technological transformation on a global scale, artists have used the possibilities of the moving image to engage with history – both as it relates to personal narrative, subjective experience and fantasy, and to space and geography, as well as time. In William Kentridge's moving image work *Felix in Exile* 1994, drawings fly out of a suitcase and attach themselves to the wall in a

configuration that precisely resembles the way paintings were hung in Kasimir Malevich's 'Last Futurist Exhibition 0.10' in Petrograd in 1915. Kentridge creates a hybrid art, drawing on the history of painting – Francisco Goya, Max Beckmann, George Grosz – and the graphic tradition, especially William Hogarth, theatre, and early cinema. And in fact, the artist came to moving image art primarily from acting, directing and set design for the theatre, particularly a hybrid form of theatre including puppets and moving image projection. In *Johannesburg: 2nd Greatest City After Paris* 1989, the artist introduced the industrialist and financier Soho Ekstein and his younger, artist-intellectual double, Felix Teitelbaum: alter-egos, but with an Oedipal father-son relation also implied – the former was based on a photograph of Kentridge's grandfather, and the latter resembled himself. Here and in subsequent works, Kentridge established a highly ambivalent position from which to speak, that of the South African Jewish community, who are simultaneously exploiters and defenders of the black South African population. In a history – which stretches from the Holocaust to the South African Truth and Reconciliation Commission set up in 1995, and beyond – where bearing witness has become a public, political act, as reflected in his *Ubu Tells the Truth* 1997, Kentridge has developed an art using animation which plays on the relation between the trace and its erasure. The film becomes the memory of the drawing, which in the new stage replaces the old one, save for the traces of the erasure of the previous marks. The imperfection of the erasure is essential to Kentridge's art, and indeed distinguishes is from the utopian *tabula rasa* of the early Modernism on which he draws. While the particular representations of memory are subject to dispute, common to all Kentridge's work is his incorporation of the traces of the erasure of the trace, in other words, not just remembrance, but the memory of forgetting and the effacement of the oppressed.

With *Testimony: Narrative of a Negress Burdened by Good Intentions* 2004, Kara Walker turned to film as a development of her previous practice, in which she used painted silhouettes to present a phantasmatic history of slavery and sexual exploitation in America. The cut-outs she used for the film placed it between animation and shadow-puppetry. It begins with the depiction of a black female effigy, followed by the appearance of a dreadlocked black female protagonist who performs an inversion of history by enslaving white men, and ends with the screen filled by the whiteness of the fluid produced by the fellatio she performs on the lynched body of the leader of the white men. As if Walker were to American slavery what the Marquis de Sade was to the French Revolution,

William Kentridge
Ubu Tells the Truth 1997
35mm film transferred to video, laser disc, DVD: animation, drawing, photography, sound and documentary film.
Based on the 1996 play *Ubu and the Truth Commission* by Handstring Theatre Company.

Harun Farocki
Eye/Machine III 2003
Double-screen video,
sound

she shows history to be inseparable from the effects of sexual desire and the repetitive rituals of perverse pleasure.

Historical memory and collective trauma is also the subject of work by Tracey Moffatt, which she approaches with heightened artificiality and a stylised, generic mode of presentation. In films including the shorts *Nice Coloured Girls* 1987, *Night Cries: A Rural Tragedy* 1989 and the full length *BeDevil* 1993, she employs such devices as tableaux with painted backdrops as an 'art' treatment of popular culture that throws into question both objectifying representations of the Australian aboriginal people and the complicity of the viewer as a passive witness to atrocity and injustice. The context is the struggle for land rights, and retrieval of the history of the forced removal of Aboriginal children from their families. Moffatt equally uses the devices of avant-garde film – such as sound that comes from somewhere other than the image – to subvert linear narrative, allowing the interweaving of past and present, including the haunting of the present by the past, and the projection of an alternative future in which injustice can be held to account. Like those of Kara Walker, Moffatt's films deal with their troubling subjects with what Surrealist André Breton called 'black humour': the disruption – through excessive, grotesque and perverse pleasure – of dominant discourse.[11]

For filmmaker Harun Farocki, since the mid-1990s the museum installation has provided a site for reflection on the contemporary machines of vision as historic modes of visualisation, both as a means of power and control, and as opportunities for knowledge. *Ich glaubte, Gefangene zu sehen* (I thought I saw Prisoners) 2001 shows on a projection wardens shooting quarrelling prisoners in a yard, where the field of fire and of surveillance coincide. The double projections of the *Eye/Machine* trilogy 2001–3 deal with the loss of distinction between the photographed and the computer-simulated in the 'operational' images produced by missiles and other equipment in the context of the first Gulf War of 1991, and therefore marks the moment when the human eye is denied its role as a historical witness. Farocki's installations could be understood as an extension of montage – indeed the Eisensteinian dialectical montage – from the relation between shots or images in the film to the combination of simultaneity and sequence in his double projections. A different kind of work is *Deep Play* 2007, shown at Documenta 12, where Farocki presented the final of the FIFA World Cup soccer match between France and Italy being converted into a video-game over twelve screens – including commentary, game analysis and player statistics – so that viewers could witness the representation becoming a simulation.

The moving image engrosses the viewer in a spectatorial present in a way that is different from a still photograph, which is more like a relic of a past present – the moving image, whether in film or video, doesn't so much interrupt the time of the viewer, as take it over.[12] How then to indicate 'pastness' in the moving image? One way is through content – costumes, sets and so on; another is through obsolescence in the medium – insisting on celluloid for example, and putting the projector in the room with the viewer, or by retaining that same quality of image but contained within a later technology. But neither of these really prevents the viewer from creating a present of the action in the image through a process of self-insertion into the image-space. In *Third Generation (Ascher Family)* 2003 Mark Wallinger draws on both of these aspects, and adds a third, whereby recessive framing becomes an analogue for distance in the past, while at the same time drawing attention to the context in which the viewer is watching the film. Home movies of a Jewish family, probably from the 1930s, are being shown in the Jewish Museum, Berlin. We see visitors walking past the images of the family. This image is projected in a neutral space, which may be a studio, where we hear the sound of footsteps. Finally, Wallinger's film is projected onto a screen in the gallery. Thus the spatial recession of frames encapsulates three generations of image – we are seeing a film of a film of a film, as well as a remediation of Super-8 film

into DVD. Wallinger's installation simultaneously makes us feel the pastness of the family's films – and the loss inscribed in that history – while also making it possible to see what is normally lost in the viewing of a film, namely the context in which that viewing is taking place.

In *Angel* 1997 Wallinger ran time in reverse: he filmed himself performing as a blind preacher apparently walking down an escalator running upwards. The 'preacher' can just be made out saying the first words of the gospel of St John, 'In the beginning was the word ...', which Wallinger recorded himself saying backwards (recalling Gary Hill's film *Why Do Things Get in a Muddle? [Come on Petunia]* 1984), until finally he ascends backwards up the escalator at Angel underground station, to the sound of Handel's 1727 coronation anthem *Zadok the Priest*. In this and other works, Wallinger seems to be attempting to prise apart the exploitation of religious representations and the need to which religion responds. (In fact, he literally effaces such representations in *Via Dolorosa* 2002, where he places a black square in the centre of the frame of Franco Zeffirelli's 1975 TV film *Jesus of Nazareth*, making the representation itself into a frame for what is not represented.) An analogue for this need is found in *Threshold to the Kingdom* 2000, for which Wallinger simply placed the camera facing the swing door of the arrivals gate at one of London's airports, showing the visitors and home-comers in slow motion to the sound of Allegri's *Miserere*, a setting of the 51st psalm ('Have mercy on me, God, in your kindness/In your compassion blot out my offence'), which for centuries was sung only in the Sistine Chapel. The threshold to paradise is evoked in one of modernity's 'non-places', a gateway policed by immigration officials rather than angels.

Mark Wallinger
Via Dolorosa 2002
Video projection,
crypt of Milan Cathedral
2002

Joshua Mosley
Lindbergh and the Trans-Rational Boy 1997
Computer animation and 16mm film, sound

Chen Chieh-jen uses long takes and reconstructions on site to create 'dialectical images' of a suspended history, opening up the past as a site of memory and unfinished business. In *Factory* 2003, a silent film shot on 16mm and transferred to DVD, textile workers in Taiwan return to the abandoned factory where they had worked until the owner closed it down without paying retirement or severance, a result of global capital's continual search for cheap labour. Passages showing the gestures and movements of the workers – their bodily memory of another time made present again – are intercut with footage from their protest. In *The Route* 2006, Chen made a 35mm film transferred to DVD of a protest that never took place at the Port of Kaohsiung, where the cargo ship Neptune Jade was unloaded in 1995. At the time, the Taiwanese dockers had not known that the ship had been forced to seek another port as a result of a dockworkers' strike at Liverpool and that it had been turned away by dockers across the world. The film thus reconstructs a past that never happened as a call for solidarity today. In another film, *Lingchi: Echoes of a Historical Photograph* 2002, shot in 16mm and transferred to DVD to make a three-channel projection, Chen makes a deliberately inaccurate reconstruction of Lingchi, a form of Chinese torture which involves the drugging and gradual dismemberment of its victim, which can be seen here as a harbinger of the dismembering and pain inflicted by modernity. In his work, documentary is transformed into the phantasmagoria of modernity and an exploration of alternative histories.

Different historical moments are brought together in the films of Yang Fudong. The five-part cycle *Seven Intellectuals in Bamboo Forest* 2003–7 combines references to the ancient stories of 'The Seven Sages of the Bamboo Grove' from the Wei and Jin dynasties of China with a setting in the 1950s and 1960s, when the role of intellectuals came into question. By taking a historical distance, the series shows the marginalisation of intellectuals – and, by implication, critical and political art – in the current epoch of globalisation and rapid economic development in China. The setting moves from the famous Yellow Mountain to city life in Shanghai, where the protagonists live an isolated life with little connection to their surroundings. They then move to the southwest of China, attempting to become involved with nature, before moving on in the next film to the isolation of a fishing island. Finally they return to the city to become a part of its life. From a Western perspective, the cycle appears to deal with the relation of the aesthetic – including the films' own dated beauty – to modernization, while at the same time including references which would only be evident to viewers conversant with the Chinese historical and cultural context. Yang Fudong's cycle is in effect traditional cinema presented in the black box of the gallery – while using the international art world as a way to get his work circulated, he reflects on the role of the artist in society.

In both mainstream cinema and artists' moving image, animation has increasingly become a feature, both when it is evident and when it is not. For artists, animation provides new ways of presenting narrative and exploring a subjective relation to history. History is related to fantastic narrative in the works of Joshua Mosley, which combine film with computer animation. Mosley's *Lindbergh ∞ and the Trans-Rational Boy* 1998 is about a child crossing the ocean in a small boat, powered by large mice in a treadmill, over which an airplane flies, as if looking for him. The accompanying speech is in an invented language and the atmosphere conveyed is that of infinite motion and of timelessness. The title hints at a darker side: that the boy might be the abducted son of Charles Lindbergh, the man who in 1927 made the first single-handed non-stop transatlantic crossing, and was later suspected of being a Nazi sympathizer. As the son rocks back and forth, urging the mice on, Mosley suggests he is not so much abducted as trying to flee the father. In this highly condensed narrative, we are shown something we will never fully understand (regardless of the subtitles),

Yang Fudong
Seven Intellectuals in Bamboo Forest 2003–7
35mm film transferred to DVD, parts 1–2 sound, parts 3–5 silent

but which hints at an attempt to escape from the burden of the past and the sins of the fathers into a timeless realm of 'in-between', which will combine motion with stasis.

From narrative to performance and back

Artists have tended to counter the potentially alienating effect of the digital moving image by emphasising corporeality. One strand of moving image grew out of the need to document performance art,[13] the documentation eventually becoming the work. This had the interesting effect of a work about embodiment also inscribing absence: what we view as present is the absence of that which is past. Important precedents for the role of bodily performance in relation to video are provided by Vito Acconci's work of the early 1970s, in which direct address to the viewer draws on the physical intimacy of the monitor, and Joan Jonas's videos including *Vertical Roll* 1972, where the video signal is out of sync with the monitor's raster image, so that the artist's performance in the black and white image is interfered with by a band that scrolls across the screen, drawing attention to the technological mediation of the body image. In relation to film, Dan Graham's work has been influential: in *Two Correlated Rotations* 1969, two men circle around each other filming with Super-8mm cameras; in *Body Press* 1970–2, a naked man and woman rotate cameras around their bodies in a mirrorised cylinder: in effect, the disembodied, perspectival gaze of the camera is re-embodied. During this period, Bruce Nauman was making works comprising films and videos of his actions in the studio, such as *Slow Angle Walk* 1968, which may be based on a description in Samuel Beckett's novel *Molloy*, in which the artist walks with high-angle steps and his hands behind him, recorded with the camera on its side so that when shown he appears to be walking on the wall, defying precisely the gravity and contingent bodily conditions that the 'Beckett walk' draws attention to.[14] If Bruce Nauman deals with the absurd, its intersection with melancholy is the topic of Bas Jan Ader's films – riding on a bicycle into a canal in Amsterdam in *Fall II, Amsterdam* 1970, falling from a tree in *Broken Fall (Organic)* 1971, crying for the camera in *I'm Too Sad to Tell You* 1970. The importance of this work to later artists may be seen in Georgina Starr's video *Crying* 1993, which is in effect a remake in video of Jan Ader's piece, while asking us to consider the difference between the tears of a man and those of a woman.

Moving image work since the 1990s dealing with the body marks a confluence of performance film and video with art that draws on mass culture and takes its place amid a world of commodities and advertising. An influential work in this confluence is Dara Birnbaum's video *Technology/Transformation: Wonder Woman* 1978, which appropriates footage from the TV series to repeat the transformation from everyday woman to superhero in scenes with explosions and mirrors, adding scrolling captions from the pop song 'Wonder Woman in Discoland': the secretary passes through an explosive moment to assume agency, but notwithstanding remains trapped in a fetishistic costume.

During the early 1990s, Tony Oursler created surrogate performing heads and bodies by projecting video onto objects: for example, in *System for Dramatic Feedback* 1994 moving image becomes puppet theatre, with the visitor bending forward to listen in on the mutterings of something like a psychotic ventriloquist's dummy, as in paranoia the projected inner voice returns to torment the subject from outside. In Oursler's works, the idea of the marionette – the mechanical human – is reworked via the projected image and voice, for a media age in which the distinction between inside and outside the subject has become permeable, and may have collapsed altogether.

Consciousness of the mediation of the body – through technology, as commodity, in genre – comes to be elaborated through narrative in the video of the 1990s. While during the 1960s and 1970s avant-garde cinema played with and

deconstructed narrative, much experimental cinema was outright opposed to it. The distrust of narrative continuity in avant-garde cinema emerged as a response to the way in which mainstream cinema constructed an ideological subject and locked him or her into the film. The rejection of narrative in experimental cinema occurred more because it distracted attention away from the medium itself.

Narrative returns in moving image art from the 1990s, if not earlier, but it returns affected by its critique, deconstruction, and rejection in the earlier movements. Douglas Gordon's *24 Hour Psycho* is a paradigmatic work in this respect, effectively combining the avant-garde's interest in reworking Hollywood with experimental cinema's use of devices to force the audience to become aware of the film's materiality. In displacing the medium to video, Gordon shifts the emphasis from the avant-garde's privileging of production to consumption, but in a way that opens up new possibilities for experiencing the moving image. By slowing down the film to such an extent, Gordon makes the narrative impossible to follow. However, he can assume that Alfred Hitchcock's *Psycho* is part of the cultural memory of his viewers and that it is so in a positive way, creating a tension between absorption in the details of the very slow-moving image, and the narrative retrospection and anticipation, so that a suspended, free-floating attention replaces the driving suspense of the movie.

The way that narrative devolves from the event in cinema is more often structured in relation to the beginning and end of the presentation: the event becomes the event that it is in relation to the conclusion of the sequence of actions to which it gives rise. Moving image artists cannot rely on their audience to remain to the end of a sequence, unless they explicitly trap them in a space, as in Janet Cardiff and George Bures Miller's *The Paradise Institute* 2001. The viewer enters a plywood pavilion to find themselves inside a miniature, old fashioned cinema auditorium. Wearing headphones to watch a drama unfolding on the screen, he or she also hears in surround-sound noises and voices from the audience, implying a collapse of the distinction between the illusory world of cinema and everyday reality.

Often the event presented in moving image art is the kind of event that might erupt in the viewers' lives, rather than being pre-structured by narrative. This effect is magnified by installation, since it brings the moving image event into the viewer's space, and thus closer to their everyday relation to the world. Because the events of life are not (usually) subject to narrative closure (the 'good death' is no longer a possibility), they maintain their enigmatic character, and, because they are unclosed, retain their capacity to give rise to unexpected turns. Moving image events may be more like this kind of 'life-event' than narrative events contained in an integrated story with a beginning and end. It is true that storytelling may form an aspect of moving image art, as in Gillian Wearing's *Confess all on Video. Don't*

Gillian Wearing
*Confess All On Video.
Don't Worry, You Will Be
In Disguise. Intrigued?
Call Gillian* 1994
Video, sound

Catherine Sullivan
The Chittendens 2005
Five-channel digital video
projection (transferred
from 16mm film)

Worry, You Will be in Disguise. Intrigued? Call Gillian 1994, an installation involving a video in which people who are masked tell stories of embarrassing and traumatic events in their lives. The generic aspect of the 'TV confession' is in tension with the apparently real and troubling events described, and perhaps precisely because of the mask, the viewer feels like the recipient of a confession from a real person, rather than the addressee of a fictional narrative. In works like this, moving image art draws on the presentness of the tradition of performance art as much as on TV and cinema. But because of its inherently voyeuristic structure, such video works achieve a one-way intimacy in place of the public, ritualistic dimension of performance.

This raises questions about the relation of moving image art to theatre. Catherine Sullivan's work consists both of live performances, and performances that are filmed and then edited, with voice-over and titles, into multi-screen works. This means that segments can be combined spatially, as well as in terms of a linear narrative sequence, enabling the viewer to make different kinds of connections. We find in Sullivan's work the confluence of earlier experiments in embodiment with the possibilities opened up by multiple-projection DVD installation. This large-scale environmental approach calls up the question posed to modernity by Baroque theatricality: in what sense may expressive gesture survive in an era when the body's movements have become increasingly mediated and automatic? Sullivan explores this question – the possibility of expression in an age of automatism – in installations such as *Five Economies (Big Hunt, Little Hunt)* 2002, *'Tis Pity She's a Fluxus Whore* 2003, and the five-channel video work *The Chittendens* 2005. In the latter, a collaboration with composer Sean Griffin, expressive gestures are subject to a complex, serial structure, as actors in period costume move through a series of spaces in an abandoned office building. The work becomes a meditation on the role of property and insecurity, self-possession and hysteria, in American history. In her video works from *Five Economies* to *Triangle of Need* 2007, which draw on various sources from cinema, literature, economics and architecture, history seems to course like an electric current through the bodies of the performers, whose movements often appear compulsive, blurring the distinction between the actor and the hysteric and calling for a response that is both synesthetic and interpretative.

Installation and the site of the viewer

In a number of path-breaking installations, Judith Barry draws on the model of the memory-theatre, conceived in the sixteenth century as a rhetorical aid, where the speaker, standing on the stage, would see objects and images in the auditorium as *aide-mémoires*, and she has also brought out the architectural possibilities of projected video, insofar as the latter is at once image and environment.[15] *In the Shadow of the City ... Vamp r y* 1982–5 comprised the panoramic projection of a Manhattan parking lot, with film-loops projected onto windows: the viewer is at once consumer of and consumed by the image. *Adam's Wish* 1988, a visual narrative of the 'fall' of the worker into a homeless encampment, projected onto a screen in the dome of the World Financial Center in New York, was an early exploration of the social transformations brought about by global corporate capitalism. In *The Work of the Forest* 1992, which was made for Fondation pour l'architecture in Brussels, video projections onto Art Nouveau screens suggested that the Congo Exhibition in the 1897 Brussels World's Fair used a museum-style presentation of artifacts to promote Leopold II's murderous colonial exploitation of the Congo. An artist who has developed the architectural approach of Judith Barry in a distinctive direction is Doug Aitken, whose edgy, multi-screen installation *Electric Earth* 1999 figures the nighttime wanderings of a young black man through the streets and parking lots of LA. Somnambulistic and plugged-in, the work drew on the codes of music video to combine a sense of alienation and

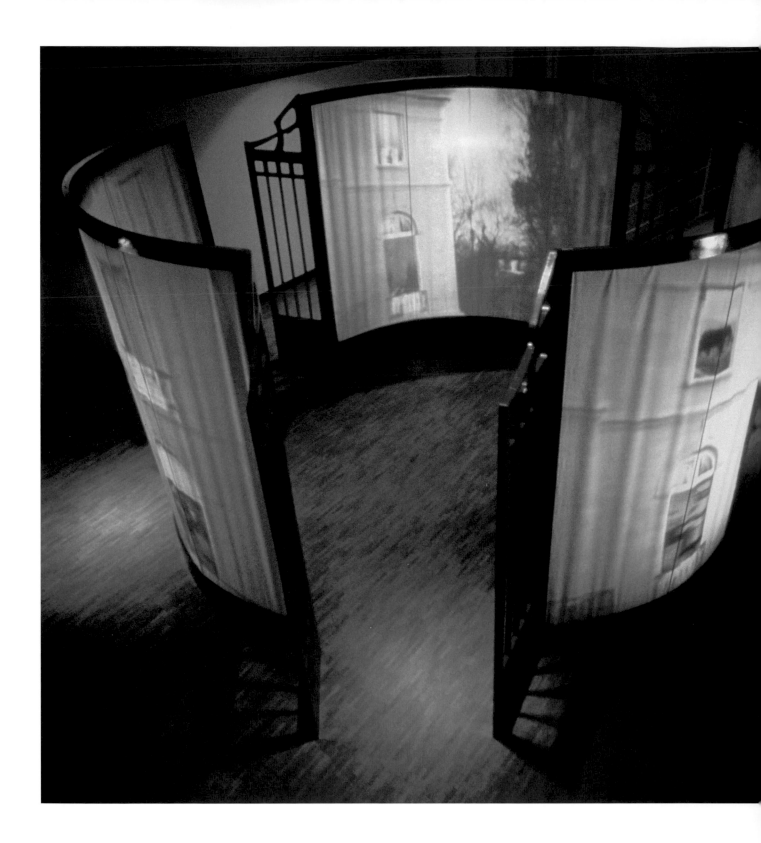

Judith Barry
The Work of the Forest
1992
Three-screen panorama,
three projectors, video
installation with sound,
Fondation pour
l'architecture, Brussels

Willie Doherty
Ghost Story 2007
Single-screen video
installation, sound

energy. The sound enhanced the immersive character of the installation, which invited the viewer to move through distinct spaces, surrounded by screen images, inviting a vicarious participation by means of the editing and the dance-like movement of the character.

Installation allows for an interaction between the mediation of the image and the immediacy of the physical experience of the viewer. While he draws on both cinematic and televisual genres, since 1990 Willie Doherty has used the installation form to create effects of physical unease and psychological paranoia. The mediated character of the moving image, which becomes apparent as soon as the viewer tries to interpret it, causes a reflection on the physical sensation. Doherty uses the decontextualisation of the image positively, to open up divergent interpretations of the image, which in many cases applies not only to the 'Troubles' in Northern Ireland, but also to other situations. For example, as the camera rotates around the shaved head of the actor in *Non-Specific Threat* 2004, the voice-over says 'I am anything you want me to be' and 'I am your victim/ You are my victim'. Equally, *Ghost Story* 2007 is specific to a Northern Irish landscape in which murder and atrocity has taken place, and evokes the 'wraith' from Irish mythology, but also applies to other situations in which traumatic memories of social conflict and death have been repressed. The physical effect of the camera moving down a road without reaching any destination evokes a sense of endlessness, the inter-cutting of other scenes introducing the non-linear time of memory, evoking the ways in which the past haunts the present.

To make films that confront the limits of visual representation, Steve McQueen draws attention to the physical relation of the viewer to the screen, and through the exploration of the aural and haptic dimension of the viewing experience, he opens up a different spatiality. Representation is shown to occur from a specific position that risks doing injustice to the other who is 'represented'. This may be himself as a black man, or other black subjects. In *Just Above My Head* 1996 attention is drawn to the framing edge of the film which completely fills the wall from floor to ceiling and from edge to edge, so the framing limits become physically manifest as architectural frame. The artist filmed himself walking along a road holding the camera low and shooting up towards his head, so that the viewer looks down towards the head on the screen, while looking upwards as identified with the camera position.[16] The advantage of this sort of installation becomes evident when the artist's head sinks to the bottom of the frame and is reflected in the polished floor within the space in which the viewer stands. The walk gives the impression of a march – recalling, perhaps, the marches in the US for the civil rights of black people, including the Million Man March of 1995. The focus on the head draws especial attention to the fact that this a representation of a black man, this entry of the image into real space generating a confrontation

with the viewer. A similar effect of bodily confrontation – as if in an attempt to overcome the limitation of the medium at the same time as drawing on its tradition – is achieved in *Deadpan* 1997, only there the artist's body is in stasis as the house-front falls on him, framing his stalwart body, practically motionless, contrasting with Buster Keaton's agitation in the film from which this gag is taken, *Steamboat Bill Jr* 1928.

McQueen's later films, *Caribs' Leap* and *Western Deep* (both 2002), further explore the play between the virtual space of the moving image and the actual space of the installation. *Caribs' Leap* does this by creating a space for the viewer between two screens: on one we see scenes from a beach in Grenada, the Carribean island where McQueen's parents were born, and on the other, figures falling through the sky. These recall the Caribs, indigenous people of the island, who threw themselves from a cliff rather than be captured by the invading French. McQueen thus creates a dialectical image of history and memory, activated in the space of the viewer. *Western Deep* consists of a single projection that presents a descent into a South African mine. Through its combination of representations of moments from the African miners' working lives – including a regimented and exhausting medical test – with scenes of darkness and flashes of light that become almost abstract, and the shock of unexpected sounds of machines and tools, the film problematises the relation between representation and experience: what we as an audience are experiencing in the installation exceeds representation, but we know at the same time that it cannot itself become a representation of the experience of the miners, whether because we cannot really project ourselves into their place (even if we might feel a sense of solidarity), or because their experience is unfathomable to us.[17]

Often, moving image installations strive to overcome the limitations of the convention of the single framed image. Multiple screen installation can present several scenarios at the same time, as is the case in Sam Taylor-Wood's *Pent-Up* 1996, which comprises five simultaneous projections of individuals, each suffering in their own way. It can also extend a single shot or sequence into an environment that engages the viewer at a physical level. This can be either immersive or cinematic. The twins Jane and Louise Wilson tend towards a cinematic use of multiple screens in which each remains distinct, often creating effects of symmetry, inversion and repetition, as in the installations that explore sites left over from the Cold War. In *Stasi City* 1997 they float through the old secret police headquarters in Berlin, ransacked after the fall of the Berlin Wall; the four-part video installation *Gamma* 1999 was shot at Greenham Common, a decommissioned American base in England that housed cruise missiles and was the object of anti-nuclear demonstrations: in both these works, the reminiscence of recent yet all but forgotten history becomes a phantasmagoria.

The immersive moving image installations of Pipilotti Rist, including *I'm Not The Girl Who Misses Much* 1986 and *Pickelporno* 1992, draw the viewer into a deliquescent, kitschy world of liquid pleasure – pleasure that is not, as it was with a previous generation of feminists, rejected because associated with phallic desire, but rather reworked as feminine pleasure and at the same time gently satirised. In *Ever is Over All* 1997, Rist is shown in slow-motion smashing car window screens with a long-stemmed flower as a passing policewoman salutes her, while another overlapping projection shows a field of the same type of flower – the act of vandalism, surprisingly colluded in by the law, represented here by a woman, seems like a liberating release while parodying the association of 'woman' with nature. Rist's work owes something to the videos documenting the scatological, transgressive performances of Paul McCarthy: while he subverts the idea of the heroic male genius-artist with a regression to perverse play, Rist instigates a presentation of female pleasure and its mass-cultural mediations.

The incorporation of bodily performance into more recent moving image

work is to be seen in videos and installations by Mona Hatoum, born in Lebanon and based in London. Exile is the topic of her video *Measures of Distance* 1988, in which the artist is filmed taking a shower, while letters written in Arabic move across the screen, and her voice-over translates letters from her mother. This concern with the body is extended into installation in Hatoum's *Corps Étranger* 1994, where a video of her skin and the inside of her body, taken with an endoscopic camera, is projected onto what is in effect an oculus on the floor of a circular chamber which is so confined that it pushes the entering viewer into close proximity with the image of the normally invisible pulsating internal organs, the 'real' of the body.

Shirin Neshat's installations frequently create a space in-between for the viewer, reflecting her own concern with exile – a sense of being between cultures – and gender positions. Both are perfectly woven together in *Turbulent* 1998, which comprises two projections facing each other. First we see a man singing a love song by the Sufi poet Rumi to an audience of men, while on the other screen a veiled woman waits. We then see her singing to an empty theatre, not words, but vocalisations that seem to vibrate with her body, reaching to something archaic. A symbolic relation to tradition and desire through language is confronted with the expression of a feminine enjoyment beyond language and desire. The Western viewer is thus faced with two kinds of otherness, and prompted to reflect on their difference.

Public intimacy and strangeness

An artist who took the intimacy of television as her starting point in moving image is Eija-Liisa Ahtila. She has used 16mm and 32mm film, video and DVD, and has shown work on monitors, in installations consisting of multi-screen projections, and has also made single-screen auditorium versions of the installation works. Her works are most effective in installation form, where the artist varies the number, size and positioning of the screens for each work, as well as the decor of the room. For example, the three screens of *The House* 2002 can be correlated to walls, and used to explore changing relations of interior to exterior. This film was based on interviews with mentally ill women, and deals with the permeable relations between reality and psychosis, in particular 'borderline conditions'.

From the time that her distinctive approach emerged in the series of mini-films or fiction-bulletins *Me/We, Okay*, and *Gray* 1993, the focus of Ahtila's work has been on human relationships and subjective experience. The possibilities of the medium – manipulation of time and narrative, having characters do things impossible in ordinary life, like fly or return after death – are always in the service

Eija-Liisa Ahtila
Consolation Service
1999
35mm film, Dolby digital,
with sound

of the emotions and identity of characters and viewers. Moving-image installation turns out to be the perfect medium in which to explore the shifts and vulnerabilities in the identity of contemporary men and women. Ahtila produces both single-screen 'auditorium' versions of her films, as well as multi-screen installation versions. In *Consolation Service* 1999, which is about the break-up of a marriage, Ahtila uses two screens side-by side either to suggest various separations, or else a third person showing a reaction to the two on another screen, in a shot/counter-shot sequence. This moves the story forward by combining the action on the right with commentary and expansion on the left, with its focus on emotions and details. After apparently falling through ice and drowning in a lake – which also serves as a metaphor for the relationship – the husband returns to bow to his wife, a moment of reconciliation with loss: the 'consolation service' of the title, which the film itself perhaps performs.

Gillian Wearing's work shows an acute sense of how intimacy is both facilitated and blocked in contemporary soicety. *Dancing in Peckham* 1994 shows the artist dancing to music that we cannot hear in a shopping mall – a private moment in a public space. This video may be compared with Sam Taylor-Wood's video *Brontosaurus* 1995, in which a naked man dances alone in a lit room at night. Taylor-Wood filmed his movements to fast techno-jungle music, then slowed down the projection, and accompanied it with a melancholy passage from Samuel Barber's *Adagio for Strings*, the combination giving the video an elegiac quality, which plays against the humour of the title combined with the pink toy Brontosaurus in the room, to place the emphasis on a sense of mortality – it becomes at the same time a celebration of the body and a *memento mori* in the context of AIDS. Both these works exploit the effect video has of simultaneously suggesting privacy – to the point of narcissism – and voyeurism. The dimension of redemptive identification through pop music in relation to trauma and loss is explored by Candice Breitz in her installation *Working Class Hero (A Portrait of John Lennon)* 2006. In twenty-five synchronised portrait-format videos we see fans singing the numbers from John Lennon's first solo album *Plastic Ono Band* 1970, in which the musician explored his childhood traumas: the works constitutes both a collective portrait of Lennon through identification, and portraits of individual fans widely ranging in age and from various ethnic backgrounds.

Wearing draws on the confessional possibility of video in *Confess All On Video. Don't Worry, You Will Be In Disguise. Intrigued? Call Gillian*, in which subjects

confess their personal fantasies, secrets and transgressions while wearing masks –
one man in a George Bush Sr mask talks of the way sibling incest has ruined his
life. In *Sacha and Mum* 1996, which draws on the codes of porn, the scene switches
to a bedroom, where, using actors, the 'mother' alternately, and ambiguously, hugs
and gags the 'daughter'; the repetitive inescapability of the situation is implied by
the way in which the video is played forward and back, frustrating any narrative
sense of direction and escape. Although with much edgier beginnings, Wearing's
work has followed a similar trajectory to that of Bill Viola, in becoming
increasingly painterly: her *Drunk* 1997–9 is a three-screen video projection of
a group of street drinkers set against a white background, and the piece is rife
with allusions to painting, including Pieter Breugel the Elder's villagers and,
when one of the drinkers lies across three screens, Hans Holbein's *Body of Christ
in the Tomb* 1521. This comparison raises the difficult question of whether this
is an exploitation of street-people for aesthetic purposes, or respectfully
attributing to them beauty and monumental grandeur.

Any true intimacy involves an encounter with otherness, which means
overcoming the projections by which we structure our experience. Film and video
seem, however, to be irredeemably 'projective' mediums, bound to the dialectic
of representation and abstraction. One way around this obstacle is by establishing
a connection between the filmic and the poetic image, not merely in some loose
and evocative sense, nor by equating the visual and the textual, but rather by
elaborating the figural and enigmatic dimensions of the visual. This has been
Jaki Irvine's approach, from her early Super-8 films to her more recent video
installations. In *Sweet Tooth* 1994 the voice-over tells the story of a young woman
who has lost all her teeth while the film shows us parts of casts of sculptural
figures and architectural moldings in a yard; in the exquisite film *Star* 1994,
another tale of loss is recounted over an image of the glittering crystal droplet
of a chandelier. In *Ivana's Answers* 2000, in which a walk in a park becomes a quest
for meaning, the rendering of the world as an enigmatic image which may not
provide any answers is made explicit in the scene in which a fortune teller sees
in tea-leaves 'someone whose body is made up of falcons sitting on a branch like
question marks', an allusion repeated later in the image of birds of prey in a cage,
an image which, in its photographic contingency, resists any simple assimilation
into the woman's narrative. Another installation, *The Hottest Sun, The Darkest
Hour: A Romance* 1999 comprises five short films that deal with loss and love –
a love that extends beyond the human to the animal, specifically to a dog, an Irish

Jaki Irvine
Star 1994
Super-8 film transferred
to 16mm film, sound

113

setter being crooned to by an androgynous woman in one of the films. Another artist who has explored the relation between women and animals is Lucy Gunning in *The Horse Impressionists* 1994, where a series of women are shown neighing like horses. The animal has also been the concern of some of the video installations of Marie José Burki since the 1980s, including *Paysage* 1989, which consists of two projections of a horse running in a circle, and *Intérieur II–V* 1995 in which videos of jumping birds in cages were shown in a gallery and in the windows of a Brussels office tower. If these films and videos concern themselves with an intensive otherness, an 'interior' that becomes an exterior, other artists concern themselves with 'extensive' otherness, that is to say, geographical and cultural otherness and racial difference.

Global archives

The availability of cheap video cameras since the 1990s has transformed the global archive. The camera can be pointed at a subject, and left on as long as the storage medium lasts (far longer than celluloid), producing an image instantaneously. Countless ordinary people have been recorded, or recorded themselves – with the advent of YouTube in 2005 these recordings could be uploaded and made available to anyone. Artists have participated in this phenomenon, rather than creating it, and, once the results have entered the public sphere, they pose the question of why a video of a particular person might be of interest to a large number of people who don't know the subject, and who, moreover, may come from different backgrounds and cultural contexts. Moving image video becomes a means of crossing borders, and of cultural translation.

Kutlug Ataman, a Turkish-born artist largely based in the UK, has confronted this dual challenge: the rendering-public of the intimate, and cultural translation. His first installation, *Semiha B. Unplugged*, first shown at the Istanbul Biennial in 1997, is a 465-minute single-screen monologue by the Turkish opera diva Semiha Berksoy, then in her eighties, which sustains the viewer's interest through the sheer force of her extraordinary personality and the sense also that she is a voice speaking of scandals and triumphs from another age. Subsequent films include *Women Who Wear Wigs* 1999, in which the wig-wearers speak in four simultaneous projections in a row, drawing attention to the way in which these are essentially speaking portraits. In *Twelve* 2003, six screens present people from an Arab community near the Syrian border in south-east Turkey who believe in reincarnation: video becomes a means of entering the psychic space of those whose beliefs we may not share. In *1+1=1* 2002 a Turkish-Cypriot woman talks in two facing projections of her life in a Cyprus divided into Turkish-Cypriot and Greek-Cypriot zones. Whereas this installation sharply represents the split in the woman's life, in *Stefan's Room* 2004, about a collector of moths and butterflies, the screens are arrayed around the installation space at different angles, reflecting the way in which the subject has surrounded himself with the objects of his obsession, the array of screens pointing to the strangeness and perhaps disorder behind an extremely neat and ordered room that houses thousands of dead insects. With *Küba* 2004 Ataman moved from the presentation of single or small groups of subjects, united by some obsession, practice or strange belief, to the attempt to make manifestly 'elsewhere' a place and its ethos. Employing used furniture, forty TVs are placed on tables or cabinets in front of forty chairs on which visitors can sit to hear the stories of forty inhabitants – men and women, young and old – of Küba, a small shanty enclave near Istanbul where the inhabitants, many surviving on the edge of criminality, some having suffered imprisonment and torture, are united in their defiance of authority. The installation leaves the visitor to decide how to move between the monitors, and to make connections between the stories of these individuals who share a place and form a community under difficult circumstances.

In *Dammi i colori* 2003 Anri Sala, an Albanian artist resident in Paris, shows the repainting with coloured rectangles of the previously drab facades of the houses of his birthplace, Tirana. The project, initiated by the mayor of the city, who is also an artist, seems like an allegory of the attempt to create a new model for society that would respect individuality while not giving way entirely to capitalist commercialism. This moment of suspense, of in-between, is also captured in the video *Blindfold* 2002, a double-screen installation in which both screens show a billboard that appears empty, but then catches and reflects the sun. This event, in which the time of nature makes an appearance in the awakening city, depends on the billboard not having been filled with an advertisement. In a state of incompleteness, something remains possible. In many of Sala's videos, it is incompleteness, discrepancy, and disjunction that involve the viewer in the act of looking and interpreting. In the video *Làkkat* 2004 – the title means 'one whose native tongue is different from the language of the place where he is' in Wolof, a local language in Senegal – words from the Wolof language are endlessly repeated by three boys in a half-darkness, supervised by a teacher: a presentation of language in its latency, and a world from which non-Wolof speakers are

Anri Sala
Blindfold 2002
Two video retro-
projections on
suspended Plexiglas,
surround sound

Pierre Huyghe
A Journey that Wasn't
2005
Super-16mm film and
HD video transferred to
HD video, sound

Marine Hugonnier
Travelling Amazonia
2006
Super-16mm film
transferred to DVD,
sound

excluded. In *Mixed Behavior* 2003 a DJ is playing his turntables under plastic sheeting in a rainstorm, while fireworks periodically explode to celebrate New Year's Eve in Tirana. While mostly he seems to be struggling to control his circumstances, occasionally, as if by some miracle, sound and light fall into harmony, as if he were playing the fireworks. This could stand as an allegory of contemporary moving image art – at once drawing on and subject to circumstance, using technology in such a way that the very hazards and disruptions to it create the sense of something larger, the possibility for a magical moment. This effect is only possible once the dimension of time is introduced into the work of art.

Pierre Huyghe, Dominique Gonzalez-Foerster and Marine Hugonnier share certain interests – perhaps one could describe it as an 'ethnography of space in a globalised world'. All three have made work involving moving image in relation to the idea of the park, and have also made films in locations far from Europe: Huyghe in Antarctica in search of the albino penguin (*A Journey that Wasn't*); Gonzalez-Foerster in Kyoto (*Riyo* 1999), at the Star Ferry Terminal, Hong Kong (*Central* 2001), and Copacabana, Rio de Janeiro (*Plages* 2001); and Hugonnier in Afghanistan and Brazil (*Ariana* 2002 and *Travelling Amazonia* 2006). Gonzalez-Foerster and Hugonnier have both drawn on the tradition of the essay film. While Huyghe is primarily interested in models of sociality and the mechanism of fiction generating fact, both Gonzalez-Foerster and Hugonnier are concerned with a certain mode of looking and experience, and their relation to filming. For example, in part of Gonzalez-Foerster's *Plages* we look down from a distance on a crowd on a beach that bears an abstract wave design created by Brazilian artist and garden architect Roberto Burle Marx, and we notice how the crowd follows the pattern of the design, becoming something abstract in its turn. In her digital installation *Exotourism* 2002, Gonzalez-Foerster projected the tourist gaze into the future of space travel. In much of her work there is a continuity across moving image, installation, architecture, urbanism and garden or park design. Hugonnier takes up the ethical implications of certain kinds of shot: the pan as a mode of dominating the landscape in *Ariana*, and the dolly shot in relation to the Amazon highway as a penetration of the rain forest in *Travelling Amazonia*.

The tension between the 'exotic' object and the subjectivity of the other is heightened in Fiona Tan's *Saint Sebastian* 2001: on one side of the screen is projected a video of young women in kimonos preparing for the archery competition of the annual Toshiya coming of age ceremony in Kyoto, and on

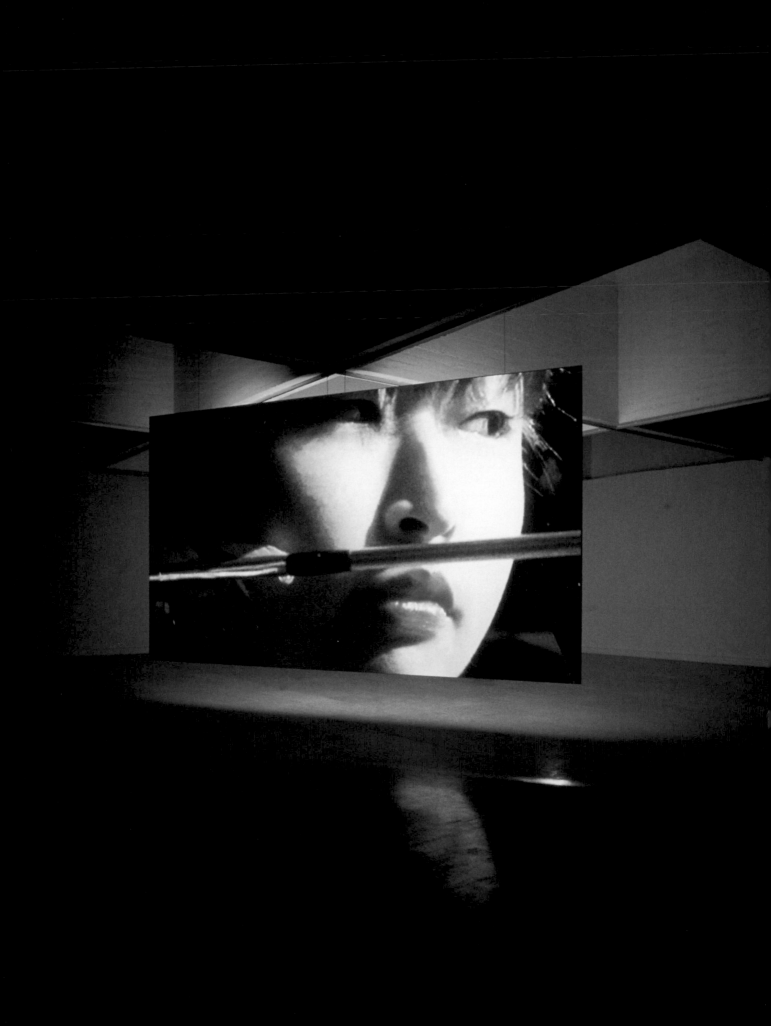

the other side we see the tension and release as the archer draws her bow past her cheek, and releases the arrow. We don't see it hitting the target: instead, emphasis is placed on what appears to be a ritualisation of desire, which leaves open the space for the reversal of gender roles suggested by the title – not only the replacement of the traditional male archers in paintings of St Sebastian by young women. We never see the target – all the emphasis is placed on the ritualisation of the act.

The sea has become the figure of a universal medium – the basis for passage – which reached its apogee in the period of colonialism and has since been superseded by air and digital communications. Both Tacita Dean's films of the 1990s and Fiona Tan's *News from the Near Future* 2003 refer to the sea and look back to a historical moment preceding ours. Tan's film draws on footage from the archive of the Filmmuseum, Amsterdam, all of it about water. It starts with a woman with a parasol and two children standing in the mouth of a cave, then shows ships, including a whaler, followed by a flooded Dutch town, and a man on a rock. The sea is a medium, literally a means of transport, especially in the age of imperialism, but it can also turn against humanity, leaving it seeming small and precarious.

Fiona Tan's work is about otherness – both the colonial relation to the other and the ways in which we identify with and differentiate ourselves from others in and through the image. Her video-portraits in *Countenance* 2002 and *Correction* 2004 restore something that Walter Benjamin saw as characteristic of early, long-exposure portrait photography: the time for the subject of the portrait to present themselves to the camera. *Countenance* consists of video-portraits of Berliners based on August Sander's photographic project 'Man of the Twentieth Century'. *Correction* comprises classic medium-shot ('American Shot') portraits of inmates and guards of a prison who do not move except to breathe or fidget. Six screens are arranged in a circle, and if the viewer is in the centre this reverses the gaze of the 'panopticon' as described by Jeremy Bentham.[18] There is an ambivalence to the portrait video that was brought out by Warhol in his film-portrait *Screen Tests* shot during the 1960s: it can both enable dignity and cause discomfort. In *Correction* Tan creates a situation where the ambiguity of the video camera is on display – it facilitates self-presentation, and maybe sympathy, but it is also allied with surveillance.

Spectacle and appropriation revisited

The emergence of moving image art marks the advent of a different kind of spectatorship. First of all, the control of time shifts from the viewer to the work: as Boris Groys points out, whereas the viewer of a painting can decide how long to look at the work, while the work remains the same, the viewer of a moving image has to submit to the time of the work, and can really only assert themselves by leaving.[19] Second, while the distance of the viewer from a painting or sculpture is related to their physical distance from it, in a moving image work this physical distance is considered in relation to a virtual distance. It could be argued that this is also the case with perspectival painting. However, with any painting the viewer is much more strongly aware of the painting-object than is the case with a moving image, particularly one that is projected. The tendency – which many moving image installations attempt to combat – is for virtual space to take over from the space of the bodily world.

The problem, then, is to reinstate distance within this experience of its collapse. What seems to be at issue today is not so much the relation of image to reality, for we have accepted that images form a part of reality, but rather the relation of the spectator to the image. Complex and multiple relations with the image may be maintained along the range from detachment to fusion. A single work may thereby encompass the birth and death of the spectator as a being who

1 See Jay David Bolter and Richard Grusin, *Remediation: Understanding New Media*, Cambridge MA/London 1999.

2 The most consistent recent attempt to transform the notion of medium has been that of Rosalind Krauss. See Rosalind Krauss, 'Reinventing Photography', in Luminita Sabau, Iris Cramer and Petra Kirchberg (eds.), *The Promise of Photography: The DG Bank Collection*, Munich, London and New York 1998, pp.33–40; *A Voyage on the North Sea: Art in the Age of the Post-Medium Condition*, London 1999; 'Reinventing the Medium', in *Critical Inquiry*, Winter 1999, vol.25, no.2, pp.289–305; '"And Then Turn Away" An Essay on James Coleman', in *October*, no.81, Summer 1997, pp.5–33; '"The Rock": William Kentridge's Drawings for Projection', *October*, no.92, Spring 2000, pp.3–35; 'Two Moments from the Post-Medium Condition', in *October*, no.116, Spring 2006, pp.55–62.

3 For discussion of the moving image in relation to TV, see William Kaizen, 'Live on Tape: Video, Liveness and the Immediate', in Tanya Leighton (ed.), *Art and the Moving Image: A Critical Reader*, London and New York 2008, pp.258–72.

4 See Tom Gunning, 'The Cinema of Attractions: Early Film, its Spectator and the Avant-Garde', in Thomas Elsaesser and Adam Barke (ed.), *Early Film*, British Film Institute, London 1989.

5 Marcel Proust, *Remembrance of Things Past. Volume 1: Swann's Way: Within a Budding Grove*, trans. C.K. Scott Moncrieff and Terence Kilmartin, New York 1982, pp.52–62.

6 Charles Baudelaire, *The Painter of Modern Life and Other Essays*, New York 1964, pp.1–40. Edgar Allen Poe's story 'The Man of the Crowd' was first published in 1840.

7 For the implications of movement in relation to still arts, see Jeff Wall, *Depiction, Object, Event*, Hermes Lecture 2006, 's-Hertogenbosch 2006, reprinted in *Afterall*, no.16, Autumn/Winter 2007, pp.5–17. See David Green and Joanna Lowry (eds.), *Stillness and Time: Photography and the Moving Image*, Brighton 2006.

8 See Laura Mulvey, *Death 24x a Second: Stillness and the Moving Image*, London 2006.

9 See André Bazin, 'The Ontology of the Photographic Image', in *What is Cinema?*, Berkeley 1967, pp.9–16.

10 See Michel Foucault, *The Birth of the Clinic: An Archaeology of Medical Perception*, New York 1994.

11 André Breton, 'Lightning Rod' (1939), in André Breton (ed. and introd.), *Anthology of Black Humour*, trans. Mark Polizzotti, San Francisco 1997, pp.xiii–xix.

12 For the pastness of the photograph, see Roland Barthes, *Camera Lucida: Reflections on Photogrzzaphy*, London 1981, pp.76–7.

13 For example, Joseph Beuys's performance *Coyote. I love America and America Loves Me* (1974).

14 For Nauman and Beckett, see Steven Connor, 'Auf schwankendem Boden', in *Samuel Beckett, Bruce Nauman*, exh. cat., Kunsthalle Wien, Vienna 2000, pp.80–7, English version on www.bbk.ac.uk/english/skc/beckettnauman.

15 It was devised by Giulio Camillo and described in his book *L'idea del Theatro* 1550. For a discussion see Francis A. Yates, *The Art of Memory*, Chicago 1966.

16 This kind of effect is created in Carl Theodor Dreyer's *Passion of Joan of Arc* (1928), and the walk echoes a moment in Robert Bresson's *Diary of a Country Priest* (1951).

17 For a brilliant discussion, see TJ Demos, 'The Art of Darkness: On Steve McQueen', *October* 114, Fall 2005, pp.61–89.

exists in a combination of separation from and identification with the image.

In the age of the internet, the moving image becomes one among many modes in which image and text circulate in the form of digital files – easily grabbed, downloaded, and remixed. An important precedent in work in film is provided by the work of Jack Goldstein, such as his loop *MGM* 1975, where the lion in the logo of the movie studio, isolated against a red background like a painting, roars again and again, the animal trapped in a corporate frame. Whereas the appropriation art of the 1970s and 1980s drew on 'originals' that were either unique or reproduced in analog form – such as a photographic print or reproduction, or a celluloid movie or movie still – the approach to already existing material of the twenty-first century tends to 'sample' from an infinite flow of digital still and moving images which have already been subjected to various transformations and displacements before the artist uses them. Seth Price's *Modern Suite* 2002 combines images of playgrounds grabbed from the web with a modernist-type soundtrack composed by the artist to display a utopianism rendered uncanny. Other videos, including *Film, Right* and *Film, Left* (both 2006) draw on advertising, internet clips, news footage and artists' films. Cory Arcangel hacked a Nintendo game to remove the figures, leaving only the cartoon-like *Super Mario Clouds* 2002–5 moving across the projection, creating a work using an already-obsolete games format that connects with the history of the representation of clouds as an index of time. His *Colors PE (Personal Edition)* 2006 takes the form of a freely downloadable video application that creates the effect of viewing movies by playing one line of pixels at a time: the work he produced from this was simply his personal choice of the film *Colors* (1988) by Dennis Hopper [20] – any user is free to create their own work. Daniel Pflumm makes videos as part of a broader practice involving appropriation. In 1997 he made *Questions and Answers CNN*, a video of two CNN reporters winking at one another, slowed down and turned into an endless loop. Other videos, including *Neu* 1999 (which formed part of an installation with lightbox images at the Gallerie Neu in Berlin), *Europaischer Hof* 2002, and *Paris* 2004, draw on and manipulate images of products, logos and advertisements. For all these artists, the moving image forms part of a wider system of the circulation of images and commodities, in which the artist intervenes to create displacements and personal versions.

Digital tools provide new ways to manipulate the image: transformations that occur without friction by comparison with earlier practices. Today, found material, rather than being re-presented or re-produced, is subject to processing in a form of 'post-production'.[21] Another way in which moving image work in the middle of the first decade of the twenty-first century differs from much of the previous film and video is that it is produced without the camera, by downloading from the internet.[22] It might be said that this was anticipated by artists who manipulated sequences from TV recorded on tape. One difference, however, is the continuousness of the internet as a medium: it is no longer a matter of 'pirating' or 'stealing' from one location in order to produce an image in another – as was the case with earlier 'appropriation' art – but rather of manipulations that take place within the same space, with the resulting images being very easily returned to circulation through a website. Perhaps once we are dealing with the kind of network that functions though links, in which images move and are in a constant process of transformation, it no longer makes sense to speak of moving image 'in the gallery'.

After the subject and beyond the screen

In addition to the expansion of other means of circulating images, the ways in which moving images are presented in the gallery have changed. By the late 1990s, digital projectors became affordable and easy to use. Often work made for film or on film was converted into digital video for projection. This also meant that the decision by certain artists – Tacita Dean, Stan Douglas and Rodney Graham among

18 For the implications of Bentham's idea of the Panopticon, see 'Panopticism', in *Michel Foucault, Discipline and Punish: The Birth of the Prison*, trans. Alan Sheridan, London 1977, pp.195–228.

19 Boris Groys, 'Movies in the Museum', in Rebecca Comay (ed.), *Alphabet City (Lost in the Archive)*, no.8, 2002, pp.94–108. See also Mark Nash, 'Art and Cinema: Some Critical Reflections', in Tanya Leighton (ed.), *Art and the Moving Image: A Critical Reader*, London and New York 2008, pp.444–59.

20 In his exhibition *Subtractions, Modifications, Addenda, and other Recent Contributions to Participatory Culture*, at Team gallery, New York, 29 Sept.– 4 Nov. 2006.

22 See Nicholas Bourriaud, *Post Production: Culture as Screenplay: How Art Reprograms the World*, New York 2000.

23 This is anticipated in the work of the late 1970s and early 1980s by Jack Goldstein, Dara Birnbaum and Jean Matthee.

24 Paul Chan questions the window as a model for the format of the moving image in 'On Light as Midnight and Noon', in *Paul Chan: The 7 ~~Lights~~*, exh. cat., Serpentine Gallery 2007 and New Museum, New York 2008, pp.114–20.

25 See Gilles Deleuze, *Cinema 2: The Time Image*, London 1989, p.125, and Daniel Birnbaum, *Chronology*, New York 2005. 2nd ed. 2007, pp.183–5.

them – to project from film projectors placed in the gallery was a specific decision that drew attention to itself. This serves to show how ubiquitous digital projection had become, to the point that it was the norm against which these 'obsolete' modes of projection stood out. During the middle of the present decade this situation began to change as flat-screen monitors became available. So there are now two forms of projection: one that derives from the magic lantern and passes through cinema; and another that derives from television, insofar as the image forms part of a piece of furniture, but the object mutates from being a 'box' to being a picture within a frame, therefore alluding to painting. As the world becomes a picture, so the picture becomes a world. Images are no longer representations but a part of the environment in which we live.

More often than not, what unites these two forms of moving image is the rectangular format. That this is associated with the Renaissance concept of picture as window is particular clear with the flat-screen monitor. A number of moving image artists throw into question the 'window' framework of the image that was put into place by Leon Battista Alberti in his treatise *On Painting* written in 1435,[23] creating projections with which the viewer has a different kind of bodily relation, whether immersive, or no longer based on the verticality of the body and the vanishing point in relation to a horizon line, a relation which, given the temporal nature of the work, can change drastically in the course of a viewing. The projection is capable of being 'unframed' – of filling the entire wall of a room, for example, enabling the viewer to forget its limits for a moment. It may also migrate off the wall, onto the floor or ceiling. Monica Bonvicini's *Destroy She Said* 1998 involves the projection of sequences from auteurist cinema featuring women clinging to walls and other architectural elements onto sloping screens that look like unfinished plasterboard walls in a room lit with a red light. The viewer is enabled to re-enact the way in which in the historic avant-garde of cinema architectural space became psychic space, and how that space was gendered. In *Knots + Surfaces* 2001, Diana Thater combined video, projected into the architectural space of the Dia Center, New York, with clustered monitors, to explore the geometry of the dance of the bee, and thereby the relation between the human being and nature. Paul Chan's shadow-play, *The 7 ~~Lights~~* 2005–7 involves angled projections of animations, composed in an almost musical way, that include shadows of objects, modes of transport and communication, and falling bodies moving in different directions through space, as the background changes colour, sometimes suggesting dawn or dusk. Through these angled projections on the floor as well as the walls, combined with an animated shadow-play in which images scroll or flow in different directions, Chan creates a three-dimensional space for a liturgy of historical loss and disaster without falling into a panoramic overview which would otherwise imply the sublime resurrection of the Western subject.[24]

The window model of representation tends to centre the world on a subject-voyeur who sees without being seen: cinema is in effect the apotheosis of this, insofar as the audience sit in a dark room, and the window is expanded to encompass the world. As opposed to this centering effect, the other forms of projection tend to posit a decentred or dispersed subject. By putting these two modes together, we can suggest that contemporary moving image work can reflect certain kinds of subjective experiences of new media – a subject simultaneously immersed and fragmented – while on other occasions providing a compensatory re-centring, and the reassurance that the subject remains in control of their world, where the image is framed and contained in a classic manner. Moving image art may present us with a critique of the panoramic order of total control, in the name of the other, or of the mortal, embodied subject. It may also carry us into topologies of being and time not previously part of human experience.[25]

John Wyver

TV AGAINST TV
VIDEO ART
ON TELEVISION

On a Sunday evening in December 1998, BBC2 transmitted *Fishtank*, made by the artist Richard Billingham.[1] The film is a dispassionate video-verité portrait of Billingham's parents and brother living in a high-rise council flat in the Midlands. There is only a minimal narrative; the father drinks heavily and the brother occasionally swats a fly. *Fishtank* is challenging, sympathetic, desolate and yet somehow positive. It also looks like nothing else you have ever seen on television.

Looking at this remarkable film nearly a decade on, and admiring its steely strengths, it now seems inconceivable that it was ever broadcast on terrestrial television, let alone in a weekend peak-time slot on BBC2. It was part of the *Tx*. arts strand and had crept into the schedules with minimal executive supervision. It is no longer possible for programmes to reach the BBC2 schedule in such a manner.

In the years since *Fishtank*'s broadcast, television has undergone a period of continuous and rapid change. At the same time, film and video artworks by Billingham and many, many others have established a central position in the gallery and the museum. It is now all too easy to forget that there were once marginal crevices, like the *Tx*. slot, for something that was understood as 'television art'. Such an idea today has no place in the schedules of mainstream broadcast or even digital channels. Nor, in either broadcasting or the arts, is the idea of 'television art' any longer a focus for propositions and debate. As the notion loses its contemporary purchase and enters history, it may be a fruitful moment to review where it came from, to consider its institutional histories, and to examine the ideas that underpinned it.

From the late 1960s to the late 1990s, there was a range of small-scale initiatives to make moving-image art for and with television. Parallel to these production projects were schemes, including some with which I was involved, to secure television screenings (and sometimes funding) for video- and film-art produced outside television. This essay attempts to offer a clear-eyed, sometimes sceptical review of a selection of key achievements in this history, largely drawn from Britain and the United States, together with an analysis of the rhetoric used to legitimate them.

Some interesting and distinctive video was created through these initiatives, although the majority of the work (and the bulk of the rhetoric around it) was conceived and defined 'against' television. Or rather, against what were perceived to be the essential qualities of a homogenous, ideologically undifferentiated medium. The social and political understandings of television and its audiences with which artists and critics worked were overwhelmingly negative, and the use of these ideas to legitimate 'television art' had the effect of closing down potentially productive dialogues with television. Those involved with television art were perhaps their own worst enemies.

Video about television
The first portable videotape recorder and player was introduced by Sony in 1965. This is conventionally taken as the starting point for video art, but even before this, artists like Nam June Paik and Wolf Vostell began working with televisions as objects.[2] In 1963 in Germany, Paik filled a room with randomly scattered and damaged televisions. Two years earlier, Vostell had distorted a television signal displayed in a Parisian department store. These exhibitions were amongst the earliest engagements with television in an art context, and for John Hanhardt, they laid bare the social and institutional functions of television as a medium. 'The achievements of Paik and Vostell,' he writes, 'were to strip television of its institutional meanings and expose it as a powerful co-optive force in capitalist society.'[3] This validation of video art as social critique, grounded in defining video *against* television, is one that finds many echoes in the later writings on the artistic form.

Many tapes made by artists in video's first decades took television and its images

Gorilla Tapes
Death Valley Days 1984
Video, sound

as subject. In tapes like *Variations on Johnny Carson vs. Charlotte Moorman* 1966 and *Variations on George Ball on Meet the Press* 1967 Paik manipulated off-air recordings. Dara Birnbaum re-edited fragments of popular TV shows to create parodies like *Technology/Transformation: Wonder Woman* 1978 and *Kiss the Girls: Make Them Cry* 1979. For David Ross, Birnbaum's practice of video transformation 'results in new understanding of the original form within a novel *critical* framework'.[4] In Britain, a number of the tapes that were grouped together as 'scratch', including Gorilla Tapes' *Death Valley Days* and Peter Savage's *Tory Stories* (both 1984), similarly re-worked television footage to critique both dominant forms of television and what was perceived to be the complicity of the medium with the radical Toryism of Margaret Thatcher.

Even when television wasn't the explicit subject-matter, the forms of early video (such as the use of extended duration or feedback loops) and its functions (including the documentation of causes and cultural groups denied access to broadcast) meant that video was framed by and, crucially, *against* the dominant moving images of the moment. With shared technology and production methods, it was inevitable that video would in large part be about and, once more, *against* what David Antin referred to as video's 'frightful parent',[5] broadcast television.

Video on television

As artists' engagements with video developed, there were numerous, invariably tentative attempts to work in and on and as television. Although public galleries in the United States, in Britain and across Europe began to show artists' videos from the early 1970s onwards, there was only minimal interest from the art market. Despite one or two experiments in creating editioned tapes, video's reproducibility was perceived to preclude any chance of developing video art in the commercial context.[6] Television rather than private galleries was perceived as a supplementary channel for distribution, and its attraction in potentially reaching large audiences (compared with museums) was obvious. Funding, too, might even be secured from television. The varying institutional contexts of television in the United States, Britain and other European countries offered different possibilities for entry.

The interpretation of the 'public service' mission of television in Britain, for example, suggested that both cultural and diversity arguments for artists' video might be made. In the United States, the need for public television to validate and distinguish itself from the mainstream networks appeared to offer an opportunity. During the 1970s, artists' video was as a consequence able to find a home at public broadcasting stations like WGBH, Boston, KQED, San Francisco, and, a little later, KCET, Minneapolis. In the 1980s in France, the new subscription service Canal+ used artists' video as part of its positioning as more modern and more technologically sophisticated than the existing state channels. Once a handful of early experiments had been achieved, 'television art' could be imagined and argued for. It is precisely this possibility that since 2000 has no longer been open.

The writing of history

Like any history in which many of the protagonists are still alive, the chronology of video art's development is contested. Nonetheless, a dominant history of its engagement with television has emerged. This tale, constructed in essays by, among others, Kathy Rae Huffman[7] and Dieter Daniels,[8] revolves around a succession of privileged moments, including the following:

● *Black Gate Cologne* 1968, which as Dieter Daniels observes, 'is often cited as the first television programme made by artists'.[9] This was a live event staged by Otto Piene and Aldo Tambellini and utilising the technology of a new 'Electronic Studio' at the German

Otto Piene and Aldo Tambellini
Black Gate Cologne 1968
Interactive television
project, sound.
Produced for
Westdeutscher Rundfunk
(WDR), Cologne.

broadcaster WDR in Cologne. The live images, which included elements of experimental film, were video mixed and two consecutive broadcasts were copied one on top of the other.

● *The Medium is the Message* 1969, the 'first television anthology of videoart',[10] produced at the public television station WGBH in Boston by Fred Barzyk. This half-hour programme showcased video work produced by artists including Peter Campus and William Wegman associated with collaborations between WGBH and the Center for Advanced Visual Studies at the Massachusetts Institute of Technology. Subsequent WGBH/CAVS projects included *The Very First On-the-Air Half-Inch Videotape Festival Ever* 1972 and *Video: The New Wave*, the first national PBS broadcast of video art in 1974.

● *Fernsehgalerie* 1969–70, produced by Gerry Schum.[11] Schum developed his concept of a 'Television Gallery' in two programmes for German broadcasters, *Land Art* 1969 and *Identifications* 1970. Neither anthology of short artists' works made for the screen was presented as 'video art'. The first offers contributions by eight artists, including Robert Smithson and Michael Heizer, identified with the emerging movement of working directly with landscape. Twenty artists contributed short segments to the second.

● Gerry Schum also produced two early television 'interventions' in Germany: Keith Arnatt's *Self Burial* 1969, in which a series of nine photographs of Arnatt gradually sinking into the ground were broadcast unannounced between programmes on eight consecutive evenings, and Jan Dibbets' *TV as a Fireplace* 1969. WDR 3 closed their transmissions for eight nights with a film by Dibbets of a burning coal fire. The strategy of inserting surprising or disturbing images without explanation into the broadcast schedule proved to be alluring for many artists over the following two decades.[12]

● *TV Interruptions (7 TV Pieces)* 1971, produced by David Hall with Scottish TV. Made for broadcast during the Edinburgh Festival, these short allusive works for television were shot on film and shown unannounced. 'That they appeared unannounced, with no titles, was essential', Hall later wrote. 'These transmissions were a surprise, a mystery. No explanations, no excuses.'[13]

● *Beeldende Kunstenaars Maken Video* was a three-part programme broadcast by the Dutch service NOS-TV in 1971. It was produced by the public foundation for the arts Openbaar Kunstbezit and included works by Ger van Elk, Jan Dibbets, Stanley Brouwn and Marinus Boezem.

● BBC2's *Arena: Art and Design* devoted a half-hour programme to a survey of artists' video in March 1976. The anthology included a new work by David Hall, *This is a Television Receiver*, and *Struggling* by Peter Donebauer, together with existing works by British and American artists.

More than thirty years on, each of these initiatives from *Black Gate Cologne* to the *Arena* anthology is seen as a privileged part of the creation moment of video art on television.

The legitimisations of such projects were various, but together with later initiatives, they can all be seen as reflecting to a greater or lesser degree what Marina Turco identifies as the 'modernist approach'. This, she suggests, 'claimed that artists were "more advanced" than those working in TV in interpreting the "formal" characteristics of the electronic medium and argued that they could warn the public against the political and psychological influence of the mass media and pursue a very different goal from those who made TV programs.'[14]

Martha Rosler offers a complementary characterisation of artists working with video: 'Many of these early users saw themselves as carrying out an act of profound social criticism, criticism specifically directed at the domination of groups and individuals epitomized by broadcast television and perhaps all of mainstream Western industrial and technological culture.'[15] David Hall, for example, wrote in 1976 of using in his early video work processes of deconstruction to 'decipher the conditioned expectations of those narrow conventions understood as television'.[16]

Video activism

Parallel to this early history of 'television art' is one that can be constructed to chart the attempts to achieve airtime for the social and political tapes made by groups

**Arthur Ginsberg and
Skip Sweeny with
Video Free America**
*The Continuing Story of
Carel and Ferd* 1972/5
Performance with three
video cameras and three
videotape recorders,
sound. Re-edited
as a single-channel tape,
1975.

like Videofreex, Global Village and TVTV in the United States and TVX in Britain.[17] *The Irish Tapes* 1973 and *The Continuing Story of Carrel and Ferd* 1972 were two early documentary projects that began life as multi-channel video presentations and then in 1975 were edited into single-channel tapes for broadcast on the public television station WNET. Also in 1972, Top Value Television (TVTV) produced two hour-long tapes at the Democratic and Republican National Conventions that presented a distinctive, subjective and involved picture of the political process. Jon Alpert's work, including *Cuba: The People* 1974 and *The Police Tapes* 1976 by Alan and Susan Raymond were further video initiatives that were taken up by broadcast television.

The video group TVX was founded in London by John 'Hoppy' Hopkins in 1969. Catalysed by the work of video activists in the United States, Hoppy was convinced 'that access to broadcasting did not necessarily entail conforming to its conventions.'[18] In June 1970, he was able to get on the air, as part of the BBC arts strand *Late Night Line-up*, low-gauge video footage of a police raid earlier in the day at the New Arts Lab. This activist approach to the medium flourished within the community video movement of the next fifteen years and continues to underpin the impressive achievements of projects such as *Undercurrents*,[19] 'the news you don't see on the news'. In today's media world, the web and DVDs facilitate distribution and new forms of collective production that entirely bypass the broadcast channels.

What the modernist approach and the social and political initiatives had in common was an interest in 'infiltrating' television. This notion extends the political strategies of many leftist groups of the 1960s and 1970s, whose members sought to achieve prominent positions in professions including journalism and broadcasting so as to influence the ideas and activities of, among other concerns, the media. This 'entry-ism' could be effected by the producer as an individual, to secure a role within the institutions producing television, or by means of images and ideas inserted into the nightly 'flow',[20] to work against the politics of the medium. There was a sense that artists might work in an engaged and effective way 'in the belly of the beast'.[21] What's important to recognise here is that whatever the motivations, it was (just) conceivable to think that television might open up sufficiently for those who defined themselves as artists, as well as other committed producers, to operate in this way. The opportunities were always marginal but they were at that point nonetheless real.

Television was many things to many people
What the history of early video on television invariably fails to recognise or explore is television's own rich history, both in the diversity of social and institutional positions and as a context for formal experimentation. This was the case at the time when video's initiatives were being developed, and it remains true in the writing of the history. 'Television,' Kathy Rae Huffman writes, 'the vast consumer of programming aimed at an ambiguous "mass audience," was conceived for consumption by the largest possible common denominator audience. TV remains the single most important reference point for determining uniformity in American culture.'[22] This is unarguable, but it is not the whole story. Television, whether in Britain, in the rest of Europe or even in the United States, was less homogenous than is usually allowed in video's telling of the tale. Nor should we ignore the extensive analysis of the disparate ways in which audiences actively consume and make sense of television's images.

Given the millions and millions of broadcast hours of television over the past sixty and more years, examples put forward to make the case for social and formal diversity within television can appear banal. But in the United States, for instance, the handful of achievements of securing slots for video art and documentarists need to be seen in a television context that also includes *Omnibus* and *NET Journal*,

or the films of Frederick Wiseman. In an eloquent tribute, Bruce Ferguson has made an exceptional case for the radical experimental aspects of the television work of mainstream comedian Ernie Kovacs.

Similarly, in Britain, the modernist formal strategies of artists working with video need to be considered alongside experimental productions within mainstream television, such as the drama series *Diary of a Young Man* 1964, written by Troy Kennedy-Martin and John McGrath, and *Gangsters* 1976–8, scripted by Philip Martin; with the poetic documentaries of filmmakers like Robert Vas and Marc Karlin; or with the formal innovations of arts programming like William Fitzwater's production of *Relay* 1971 (BBC), conceived and choreographed by Alwin Nikolais, with a Moog synthesiser score, and the 1968 studio broadcast by the BBC of a Michael composition with experimental video and sound mixing.

The writing of the history of television programming (as opposed to that of institutional structures) remains in its infancy, in both the United States and Britain, and access to a wide range of programming is still restricted. What this means is that the privileged productions of artists' video can claim a primacy for formal innovation in broadcasting that is, to state the matter crudely, unjustified. Even where the history of artists' video on television does acknowledge television's experimentation, elements tend to be appropriated as the pre-history of video art rather than being seen as primarily part of television's story. An example is *Jazz Images* 1964–6, produced at WGBH, where visuals were improvised along with jazz music in the studio, and which Kathy Rae Huffman, in her influential essay 'Video Art: What's Television Got to do with It?', folds nto the story of artists' video.

The importance of the 1980s
In the following paragraphs, there is a danger of nostalgia colouring the view of the period under discussion. I have endeavoured to avoid this, but perhaps it is unavoidable for someone who worked during the decade following the beginnings of Channel 4 in Britain. For there is no doubt that the start of Channel 4 in November 1982 changed television profoundly, and not only in the United Kingdom.

Channel 4 was conceived as a new kind of broadcaster. It was to be a publisher presenting programmes made by a wide range of producers, and from early on the channel's maverick Director of Programmes Jeremy Isaacs indicated that artists could and should be among those producers. Thanks to its complicated genesis in an unholy alliance of Tory politicians (seeking to deregulate the broadcasting industry), and energetic independent film-makers (who had a similar aim albeit with an entirely opposed rationale), the channel also had a number of statutory obligations, including the remarkable commitment 'to encourage innovation and experiment in the form and content of programmes'.

Artists working with video, together with producers including Anna Ridley and myself, made the case that they were well-placed to help fulfil this obligation, and a number of anthology initiatives were commissioned and broadcast, including the programmes *Video 1, 2, 3*, works made by Annalogue productions from 1982 onwards, and *Ghosts in the Machine* (1986 and 1988). These presented existing work and new commissions, and helped stimulate both additional funding from the Arts Council of Great Britain and, later, comparable presentations on BBC Television and by broadcasters across Europe. At the same time, and with an awareness of what was happening on Channel 4, initiatives in the United States, primarily on public television, also began to show and commission artists' video. Among the most significant projects are the series *Alive from Off-Center* (1984–7) and the productions of the Contemporary Artists Television (CAT) fund.

Two distinct strands can be recognised in the arguments for the significance and value of this work. Although this is to collapse a complex range of positions, the legitimation for these initiatives can be seen either as 'television' or as 'art'. The former position, to which I continue to subscribe, sees the value of work by artists on television as a contribution to the richness and complexity of television, and as enhancing the potential and formal possibilities of the medium. This underpinned both the *Ghosts in the Machine* series and the later *Tx* (1994–8). The critic Marina Parco characterises it as 'the postmodern approach' where 'all kinds of technological/commercial languages (from TV to video games, fashion design, etc) can be used by artists or redefined as art even if produced in a commercial context.'

For some artists and critics, embracing this argument meant abandoning vital and essential qualities associated with the idea of video art. And faced with television characterised as monolithic and repressive, they wished to retain a crucial difference for 'art'. This position was primarily for ideological reasons, but it was also convenient to help secure public arts funding for production. (It is fair to say that funders, at least in the UK, had an ambivalent attitude to the embrace of artists' work by television, both welcoming the access offered to wider audiences and remaining suspicious that broadcasting was simply using public funds to create cheap programming.)

Without greatly wishing to revisit previous exchanges, it is worth quoting from the most sustained defence written in Britain of the 'art' position. Michael O'Pray's nuanced and detailed essay 'The Impossibility of Doing Away with the Idea of Video "Art"' was written in reply to an earlier article in which I argued for video art (at least on television) to be seen alongside and as comparable in effects to a range of distinctive and creative television. O'Pray characterised this as 'cultural Thatcherism' and 'a post-modernist consumer aesthetic of shopping around the media supermarket'. 'The *necessity* of video art as art', he writes, 'on the contemporary scene flows precisely from its role as facilitator of the subjective, the "self" or the personal. In other words, the site of the subject – as artist, subject(-matter) and spectator – cannot find its fullest articulation in the general culture of images espoused by Wyver.'[23]

Unsurprisingly, I disagree, and offer in partial response the works of recognised and significant film-makers working within television (albeit outside a context of video art), such as Stefaan Decostere in Belgium, Alexander Kluge and Edgar Reitz in Germany, and of course the exemplary practice of Jean-Luc Godard. Each of these producers is directly concerned with articulating and exploring the subjective and the personal, yet 'Kluge and Godard are as far removed from the art-world locus of "video art" as they could possibly be; video for both of them is an intriguing, occasional, and new media alternative to film production. It is entered into as a way to occupy another site of delivery, entrenched broadcast television.'[24] There are many other documentary makers, too, less recognised perhaps, but equally committed to the expression of subjective visions with highly personal formal strategies. Robert Vas and Marc Karlin, Chris Petit and Adam Curtis are four such valued film-makers from Britain.

The television context that includes the work of such directors and also the contributions of video artists is significantly broader, and it can argued that it embraced arts programming and elements of music on television, as well as aspects of the highly concentrated forms of music videos and commercials. Yet video art had, as O'Pray's essay reflects, an uneasy relationship with this work, perhaps because its challenge undermines the institutional validation of 'art' with moving images. This, however, is not the argument for the concluding paragraphs of this essay. Rather, it is important to recognise what has happened to television since the late 1990s and to acknowledge that the contexts for such work are, at best, far more constrained.

The last decade

Some time around 2000, television changed fundamentally. Or at least, that's the date for the shift in Britain; comparable changes have taken place or are occurring across Europe, and it could be argued that the television in the United States was already in the form towards which the medium has most recently aspired elsewhere.

Before 2000, broadcast television was a comparatively rare commodity. In Britain, there were just five terrestrial channels, but from the late 1990s these were challenged by cable and satellite channels, and then by the tidal wave of digital developments, including many additional channels as well as games, the internet and much more. The terrestrial broadcasters recognised the threat posed to their audience share by these new services. And since they believed that their audience share was the key value underpinning either their public funding (in the case of the BBC) or their commercial revenue (ITV, Channel 4, Five) they each responded with a radical move towards the audience of the middle ground.

This shift marginalised or precluded the kinds of cultural slots or scheduling crevices that had permitted artists' video, among much else, to find a home within the schedules. Video art could be relied upon to deliver audiences or (the other new grail of broadcasters seeking to remain visible and viable in a multi-channel, multi-service world) press headlines and marketing buzz. And in part because neither the video community nor those committed to radical and distinctive moving-image work in other contexts could make a convincing case for its continuing importance, the disappearance was hardly noticed, never mind resisted. *Fishtank* and its like vanished from BBC2 and Channel 4 without a murmur – and the story has been similar in France, Germany and elsewhere.

It may be that the phenomena are closely linked (although this is a subject for future investigation) but at the same time as these changes were taking place in television, galleries both private and public as well as collectors and critics began to nurture and embrace video and film as installation. Increasingly impossible to access, television as a focus for artists' video was forgotten.

The achievements of video art on television over the twenty-five years from 1970 onwards are, it has to be admitted, minimal and modest. Interesting work was screened to audiences wider than the gallery or art cinema. Interesting work was also funded. Did the medium crack and crumble in the face of the modernist critique? Hardly. The wonder of television, however, is that individuals watch

Richard Billingham
Fishtank 1998
Video, sound
An Illuminations
Production for BBC
Television in association
with Artangel.

programmes in many different ways, and take for themselves many different things from them. That's where the potential of broadcasting artists' video lay, and also why television continues (alongside all the many other possible distribution channels) to be a place for which to aspire to create distinctive, surprising, perhaps even radical work.

1 *Fishtank* is an Artangel commission, and an Illuminations Production for BBC Television in association with Artangel. www.artangel.org.uk/pages/past/98/98_billingham
2 John G. Hanhardt, 'Dé-collage/Collage: Notes Toward a Reexamination of the Origins of Video Art' in Doug Hall and Sally Jo Fifer (eds.), *Illuminating Video: An Essential Guide to Video Art*, New York 1990, pp.71–9.
3 Ibid. p.72.
4 David Ross, 'Truth or Consequences: American Television and Video Art', in John G. Hanhardt (ed.), *Video Culture: A Critical Investigation*, New York 1986, p.176.
5 David Antin, 'Television, Video's Frightful Parent', *Artforum*, vol.14, no.4, Dec. 1975, pp.36–45.
6 After his Fernsehgalerie programmes (see n.11) Gerry Schum established one such project; it proved not to be commercially viable.
7 Kathy Rae Huffman, 'Video Art: What's TV Got To Do With It?', in Hall and Fifer 1990, pp.81–90.
8 Dieter Daniels, 'Television-Art or anti-art? Conflict and cooperation between the avant-garde and the mass media in the 1960s and 1970s'. www.medienkunstnetz.de/themes/overview_of_media_art/massmedia/1
9 Dieter Daniles, 'Black Gate Cologne'. www.medienkunstnetz.de/works/black-gate-cologne
10 Huffman in Hall and Fifer 1990, p.82.
11 www.medienkunstnetz.de/works/die-fernsehgalerie
12 Other such works, in addition to David Hall's *7 TV Pieces*, discussed above, include Bill Viola's *Reverse Television* 1983, made with WGBH, and Stan Douglas's *Monodramas* 1991.
13 David Hall, *19:4:90 Television Interventions*, exh.cat., Third Eye Centre, Glasgow and Ikon Gallery, Birmingham, London 1990.
14 Marina Turco, 'Changing history, changing practices: an instance of confrontation between video art and television in The Netherlands', p.1. http://comcom.uvt.nl/e-view/04-2/turco.pdf
15 Martha Rosler, 'Shedding the Utopian Moment', in Hall and Fifer 1990, p.31.
16 David Hall, 'British Video Art: Towards an Autonomous Practice', *Studio International*, vol.191, no.981, May–June 1976, p.249.
17 Deirdre Boyle, 'A Brief History of American Documentary Video', in Hall and Fifer 1990, pp.51–70.
18 Mick Hartnery, 'InT/Ventions: some instances of confrontation with British broadcasting', in Julia Knight (ed.), *Diverse Practices: A Critical Reader on British Video Art*, Luton 1996, p.28.
19 www.undercurrents.org
20 Raymond Williams' idea of 'flow' – the way in which television seeks to hold its audience from programme to programme -- was very influential in media theory at the time. Williams wrote that it was 'the defining characteristic of broadcasting, simultaneously as a technology and as a cultural form'; in Raymond Williams, *Television: Technology and Cultural Form*, Glasgow 1974, pp.86, 93.
21 This was the title of a broadcast programme written by the author for Granada TV in 1989 alongside *Video Positive '89*, a significant exhibition of artists' video at Tate and other Liverpool venues, 11–26 Feb. 1989.
22 Huffman in Hall and Fifer 1990, p.90.
23 Michael O'Pray, 'The Impossibility of Doing Away with Video "Art"', in Knight 1996, p.332.
24 Erika Suderberg, 'The Electronic Corpse: Notes for an Alternative Language of History and Amnesia', in Michael Renov and Erika Suderberg (eds.), *Resolutions*, Minneapolis 1996, p.112.

Christiane Paul

EXPANDING CINEMA THE MOVING IMAGE IN DIGITAL ART

The concept of the digital moving image is a broad area that is informed by several media histories, ranging from the live-action movie and animation to immersive environments and the spatialisation of the image.[1] The digital medium has affected and reconfigured the moving image in various ways and areas, and is redefining the very identity of cinema as we know it. The work of art in the age of digital reproduction takes for granted instant remixing and copying, without degrading of quality from the original to its multiples. By means of digital technologies, disparate visual elements can be seamlessly blended with a focus on a 'new', simulated form of reality rather than the juxtaposition of components with a distinct spatial or temporal history. Digital technologies challenge traditional notions of realism by facilitating the creation of composite or simulated forms of reality, and are frequently used to alter and question the qualities of representation. While temporal and spatial continuity can be maintained, the concept of reality may still be questionable. The digital medium does not rely on the ultimately linear structure of the film frame or electronic image but transforms the image itself as well as image sequences into discrete units that can potentially be remixed in new constellations, be it through software processes or interaction by the viewer.

When it comes to conventional cinema, digital technologies are playing an increasingly important role as a tool for production, post-production and screening, and even if a movie is not a special-effects extravaganza, images that seem purely realistic have often been constructed through digital manipulation. However, the use of digital technologies as a tool in the production of a linear film does not fundamentally challenge the language of film and the moving image as we know it and will not be the focus of this text.

We now associate cinema and the moving image mostly with live action, which in fact is only one strand of the moving image's history. The early moving images of the nineteenth century created by pre-cinematic devices were mostly based on hand-drawn images. This strand of the history of cinema would develop into animation, a medium that has gained new momentum and popularity through the possibilities of the digital medium and software such as Flash™ and Director™, which have contributed to a new wave of animation. Animation is one of the genres that is most resistant to classification, has continuously merged disciplines and techniques, and continues to exist at the border of the entertainment industry and artistic contexts. Pioneer animators, among them James Stuart Blackton, Winsor McCay and Emile Cohl, have had a profound impact on artistic experiments with animation. How far animation can and should be considered an art form is still the topic of debates, but it is certainly now more frequently incorporated into exhibitions. In 2001, for example, the P.S.1 Contemporary Art Center in New York devoted a whole exhibition to the topic *Animations*, juxtaposing different techniques and classics of the genre with projects by established artists.

In addition to the fact that new media have altered the status of representation and expanded the possibilities for creating moving images, be they live-action or animation, the digital medium has also profoundly affected narrative and non-narrative film through its inherent potential for interaction. The element of interaction in film/video is not intrinsic to the digital medium and has already been employed by artists who experimented with light in their projections (for example, by incorporating the audience in the artwork through 'shadow play') or with closed-circuit television and live video captures that make the audience the 'content' of the projected image and artwork. What is considered to be the world's first interactive movie, *KinoAutomat* by Radúz Činčera, was first shown at the 1967 World Expo in Montreal in the Czech Pavilion. Offering alternative versions of image sequences, the film required the audience to vote on how the plot would unfold. The potentially interactive nature of digital media has taken these earlier

experiments to new levels and has led to new forms of artistic exploration.

This text will give a broad survey of different manifestations of the 'moving image' in digital media – ranging from the (live) streaming image and the spatialisation of the image in immersive physical environments, to interactive narrative cinema and database cinema, 3D worlds and games.

Streaming images

A crucial aspect of the history of photography, film and video is the notion of realism, the recording of 'real events'. While the staging and manipulation of photographs and film is as old as the history of these media itself, the representation of reality is still an important aspect of these media and an arguable historical convention. The idea of realism has gained a new dimension with webcams that can transmit imagery from anywhere in the world in 'real time' over the internet. Although television has been presenting live events for quite some time now, there is still a fair amount of control and filtering involved in this type of one-to-many broadcasting system. Events that are 'streamed' live in a many-to-many broadcasting system such as the internet challenge and relinquish this form of control, and pose fundamental questions about representation and authenticity.

Artist Wolfgang Staehle, for example, has created a whole body of work that consists of webcam images streamed live over the internet, among them *Empire 24/7* 1999 – a live image of the Empire State Building that references Andy Warhol's *Empire* (a seven-hour long video of the Empire State Building); *Fernsehturm* 2001, a view of the TV tower in Berlin's Alexanderplatz; and a series of landscapes, such as the Hudson River Valley, exhibited at Postmasters Gallery in New York in 2004. Projected onto the walls of a gallery, Staehle's works suggest a constantly evolving photographic image that becomes a continuous record of minute changes in light and every aspect of the environment. Exploring the boundaries between reality and representation, the pieces raise fundamental questions about the nature of the 'live' (yet mediated) image and its place in the context of art. Does the 'live' image render obsolete previous art forms, such as photography or video, which can only depict moments that are frozen in time? What role do the aesthetics of processing and mediation play in our perception of an artwork? By now, we are used to seeing live images of landmark buildings or sites on television or through webcams. Encountering this type of image on the wall of a gallery or museum, however, constitutes a radical change of context

Wolfgang Staehle
Eastpoint 2004
Projected live video
transmission, silent

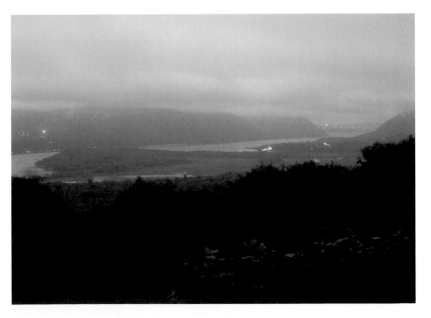

that raises fundamental questions about representation and the nature of art itself. Staehle's live views are highly ephemeral, time-based documents that cannot and will not ever be repeated (except as an archived version).

While Staehle's work focuses on issues of representation, many other artists working with the streaming image have explored the aspect of access, surveillance, authenticity and 'telepistemology', the study of knowledge acquired over a distance. 'Liveness', which suggests immediacy and authenticity, has become an obsession of Western culture (at least judging from the continuous stream of Reality TV shows), and, particularly in the case of webcams, oscillates between voyeurism and exhibitionism. Yet the 'liveness' we experience through webcams or television is always filtered through layers of mediation, which ultimately exclude 'immediacy' and raise questions about authenticity.

Refresh 1998 by the architects and artists Diller + Scofidio explored precisely these issues. For the online project, Diller + Scofidio presented a grid of twelve images, apparently filmed by webcams in different offices, showing everyday activities, such as the after-hours cleaning crew or an office romance taking place by the water cooler. However, only one of the images in the grid was in fact live, while the others were specifically filmed for the project with actors. The work questions both the status of the 'real' and the role of mediation, since the presence of the camera and awareness of being watched is acknowledged through subtle changes in people's behaviour.

Our perception of media is to a certain extent defined by the level of insertion or immersion we experience. Theorist Edmond Couchot has claimed that the electronic screen does not function like a window and does not carry the inside towards the outside but inserts the outside into the inside, at the place of the spectator. However, digital media entail many different forms and levels of insertion that require consideration. It is debatable whether webcams that offer a view into someone else's space will be perceived as a window into another world or as an insertion of that world into the viewer's space. In fact, these technological forms seem to operate precisely on the border of the inside/outside. No matter how imprecise it may be, the windows metaphor, a basic element of the concept of the desktop, may itself have induced the perception of 'looking out'. Video works capturing live images of the viewer or immersive environments to varying degrees insert the viewer into the environment and simultaneously create a gap and continuity between their physical existence and the virtual representation.

Immersive cinematic environments

Digital technologies offer multiple possibilities for cinematic representation in immersive installations, which further extend the type of spatialisation of the image in a physical environment that Gene Youngblood outlined in his book *Expanded Cinema* 1970. Among the pioneering artists who have addressed issues surrounding the spatialisation of the moving image in immersive installations are Jeffrey Shaw and Michael Naimark, who has carried out numerous studies in the field of 'dimensionalised movies'[2] and played an instrumental role in the creation of the first interactive videodiscs. Both Naimark's *Be Now Here* (begun 1995) and Shaw's installation *Place, a user's manual* 1995 combine various media trajectories, from landscape photography to panorama and immersive cinema. Naimark's and Shaw's works redefine the basic spatial characteristics of cinema as a projection onto a screen in a proscenium situation.

Naimark's *Be Now Here* is a virtual environment that consists of a stereoscopic projection screen and a rotating floor, from which the audience experiences the work. The imagery surrounding the viewer documents public plazas from the UNESCO World Heritage Center's list of endangered places (among them Jerusalem, Dubrovnik, Timbuktu and Angkor, Cambodia). Wearing 3D glasses, users can choose time and place by means of an input interface on a pedestal.

Michael Naimark
*Be Now Here Interactive
(Timbuktu, Mali)* 1997
Stereoscopic video
projection, input
pedestal and rotating
floor, sound

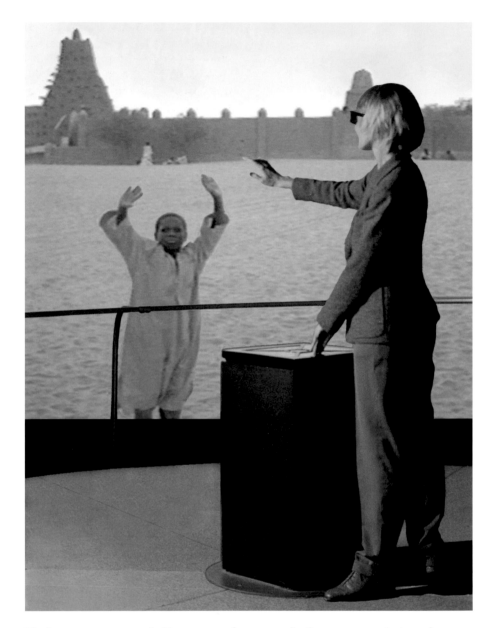

The imagery was recorded by means of a custom-built system consisting of two
35mm motion-picture cameras for 3D, one for each eye. *Be Now Here* creates a new
form of immersive film that combines expanded representation with traditional
notions of landscape photography as well as non-narrative cultural activism.
(Naimark mentions the work of Godfrey Reggio, the director of the 1982 movie
Koyaanisqatsi, and the films of Tony Gatlif as examples.)

Shaw's installation *Place, a user's manual* is similar in its basic set-up, also
making use of a cylindrical projection screen and a round, motorised platform in
its centre. The projected computer-generated scenery consists of landscape
photographs taken by a special panoramic camera in places such as Australia,
Japan, La Palma, Bali, France and Germany. The scenes are projected onto
a 120-degree portion of the screen, and users can travel through the scene, using
a modified video camera as an interface. By rotating the camera and utilising its
zoom and play buttons, viewers control their forwards, backwards and rotational
movements through the virtual panorama as well as the movement of the
platform itself. If users position themselves at the centre of the imagery, they
can reconstruct the original 360-degree camera view on the projection screen.
In addition, the surface on which the panoramas are positioned is inscribed with

a diagram of the Sephirothic 'Tree of Life' – a Kabbalistic graph of symbols that outlines the spiritual realm – so that each geographical place is connected to a symbolic location. Sounds made by the viewer are picked up by a microphone and trigger three-dimensional texts within the projected scene that comment on place and language, and temporarily inscribe the viewer into the scene. On a physical and symbolic level, the panoramic imagery is compared and connected to the architectural framework of the installation as well as the viewer's position within it. Both Naimark's and Shaw's works incorporate preconfigured elements, but allow users to take over the camera by navigating the space of representation. In the case of Shaw's piece, language and symbolism are more than added elements that are overlaid on images; they become part of the cinematic space.

Interactive narrative cinema

In addition to the navigational interaction exemplified by the works of Naimark and Shaw, the digital medium also offers possibilities for interaction that allow the audience to assemble and influence the story itself and construct a narrative film. Interactive narrative video and film is particularly challenging in that visuals tend to determine and characterise place, time and character in a more pronounced way than text. While a hyperlinked textual narrative also incorporates the elements of 'montage' or 'jump cuts', the visual translation of a scene remains an entirely mental event that will be informed by the interpretation and meaning the reader supplies.

Among the earliest interactive narrative films is Lynn Hershman's *Lorna* 1979–84, a project that unfolds on the television screen and is navigated by viewers via a remote control. The television is both the system of interaction and the only means of mediation for Lorna, a woman who leads a completely isolated and lonely life in her apartment. The disruptions in the non-linear narrative mirror Lorna's unstable psychological state. Depending on the viewer's navigation, Lorna's story has three possible endings: escape from the apartment; suicide; or the end of mediation by shooting the television. As Grahame Weinbren, who has created some of the classics in the genre of narrative video – *The Erlking* 1982–5 and *Sonata* 1991/3 – has pointed out, the abandonment of control over an image sequence implies giving up cinema as we know it. *Sonata*, a narrative in which the viewer is able to modify a flowing stream of story, blends two classical works: the biblical story of Judith, who seduced and decapitated the general Holofernes, and Tolstoy's *The Kreutzer Sonata*, in which a man's suspicion that his wife might have an affair with a violinist leads him to kill her. Viewers can move from one story to another or experience each of the stories from multiple points of view by pointing at the projection screen through a custom-designed interactive picture frame. The interface uses the metaphorical connotations of the (cinematic) frame as a structural confinement to highlight the levels of re-framing that unfold in interactive narrative. The fact that the two stories fused by Weinbren mirror and reverse each other in their focus on murder and seduction establishes a narrative framework for the reader that transcends the necessity for linear development.

The possibilities of interactive narrative are also at the core of Toni Dove's digital video installations *Artificial Changelings* 1998 and *Spectropia* 1999–2002, the first two installments in a trilogy of interactive films that address the unconscious of consumer economies. *Artificial Changelings* is the story of Arathusa, a nineteenth-century kleptomaniac, and Zilith, a woman of the future who is an encryption hacker. The installation consists of a curved rear-projection screen and four sensor-controlled zones on the floor in front of it. By stepping onto the interactive zones, viewers/participants influence and control the narrative: on the zone close to the screen, viewers find themselves inside a character's head; stepping on the next zone induces a character to address the viewer directly; the third zone induces a trance or dream state; the area most

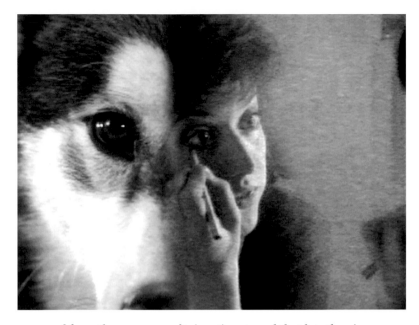

Grahame Weinbren
Sonata 1991/3
(Nicola Farmer as Judith
and Sonya)
Interactive film, sound

removed from the screen results in a time travel that lets the viewer emerge in the other century, switching from the reality of one character to the next. Within each of the zones, movements of the viewer cause changes in the behavior of video and sound. *Spectropia* uses the metaphor of time travel and supernatural possession to connect narratives that, respectively, take place in the future and in 1931, after the stock-market crash. The interface employs motion sensors, speech recognition and vocal triggers in order to enable viewers to navigate the spaces, speak to characters and have them respond, move a character's body or alter and create the sound design. Like *Sonata*, Dove's movies use mirroring stories (as well as consumer culture, emerging technologies and the economic and mental 'disorders' brought on by them) as a narrative technique for viewer orientation.

Database cinema
Digital interactivity is inextricably connected to the concept of databases, the possibility of assembling and reconfiguring media elements from a compilation of image sequences. Several artists – among them Jennifer and Kevin McCoy, Lev Manovich, and Thomson & Craighead – have explored the possibilities of the database as a cinematic and cultural narrative. As opposed to the non-linear narratives of Hershman, Weinbren and Dove, database cinema tends to focus more explicitly on the 'construction' of cinema and its language. Manovich's ongoing *Soft Cinema* begun in 2002, for example, uses custom software to assemble elements from a media database and edit movies in real time on the basis of the instructions given by the authors and their software. The project strives to investigate the effects of software and information technologies on subjectivity and the construction of architectural space in cinema.

Jennifer and Kevin McCoy, on the other hand, deconstruct cinematic language by using database narrative as a formal strategy and fusing the inherent characteristics of video and the digital medium in installation work. Their project *Soft Rains* 2003 consists of seven platforms, each of which uses miniature landscapes, interiors and 'actors' to construct tiny film sets that capture specific genres, such as the 1980s slasher movie or the 1950s melodrama. Suspended over the sets are dozens of miniature video cameras that capture images, which are then selected and edited by custom software into movies screened on the gallery walls. *Soft Rains* juxtaposes the concept of database cinema with the physicality of the 'movie set' and thus reintroduces physical location into the temporal depiction of spatiality that unfolds in the film sequences. The McCoys had already used the notion of database in their video installations *Every Shot Every Episode*

Jennifer and Kevin McCoy
Soft Rains (Suburban Horror) 2003
Mixed media sculpture with cameras electronics and video output, sound

2001 and *How I learned* 2002, which consist of videos on CD, which are neatly stacked or arranged on shelves and can be chosen and played by the viewer on a CD player hanging on the wall. While the works appear to be a video installation in the classical sense, they could not be realised without the digital medium's inherent possibilities for the classification, reproduction and reconfiguration of existing materials. *Every Shot Every Episode* literally consists of every shot in twenty episodes of the popular TV series 'Starsky & Hutch', broken down into a database of single units – such as 'Every Zoom Out' or 'Every Stereotype' – and thus exposes underlying stereotypes and cinematic formulas. *How I learned*, on the other hand, classifies the Eastern-Western television series 'Kung Fu' according to categories such as 'How I learned about exploiting workers' or 'How I learned to love the land' and highlights the cultural conditioning of behaviour.

Yet another approach to database cinema unfolds in the 'Template Cinema' series started in 2002 by the British artists Thomson & Craighead, which explores how the meaning of moving images is constructed through an interplay of imagery, text and sound. Their project *Short Films about Flying* 2003 is a networked installation and film projection that generates an open edition of unique cinematic works in real-time from existing data found on the Web. The imagery for each movie was 'shot' by visitors to a commercial website, which allowed them to remotely control a camera overlooking Logan Airport in Boston (the camera was ultimately taken offline for security reasons and the project now relies on archived footage). Pacing, pans and zooms were therefore created by Web visitors who – without their knowledge – became cinematographers. Text grabbed from a variety of on-line message boards is periodically inserted between scenes and creates cinematic inter-titles, while randomly loaded net radio provides a soundtrack. Depending on the accompanying music and text, very similar footage might invoke the atmosphere of a heist movie from the 1970s or a contemporary romance. As a field of artistic exploration, database cinema not only points to one of the fundamental characteristics of digital media – their inherent modularity – but investigates new configurations for narrative and the paradigms of time and space.

3D worlds and games

The most radical changes that the digital medium has brought about for the 'moving image' can be traced in entirely computer-generated 3D worlds that

can be created on the fly and occasionally incorporate artificial intelligence as a new narrative element. Gaming references in digital art have occasionally been called a 'trend' – a view that neglects many of the inherent connections between the two realms. Games are an important part of digital art's history in that they early on explored and established many of the paradigms that are common in interactive art. These paradigms range from point of view and navigation to linked, non-linear narratives, the creation of 3D worlds, and multi-user environments. While many computer games are extremely violent 'shooters', they often create sophisticated three-dimensional worlds, and it does not come as a surprise that artists have critically engaged with commercial games.

Part of artistic practice in this area consists of original games that have been written from scratch by the artists. Among these are Natalie Bookchin's online project *Metapet* 2002, a resource management game that develops a fictitious corporate scenario for virtual workers of the future, with ties to the Biotech industry; or Josh On's and Futurefarmers' *Anti-Wargame* 2002. A much broader field of artistic exploration is game modifications ('mods') in which artists use game engines as a tool for the creation of abstract art, or re-engineer existing games' structures and control mechanisms. Artists have also used online multi-user games as a stage for performances or activist engagement with the politics of a game.

Most computer games inherently rely on a 'spatial' narrative that is driven by a journey through locations and environments and by the goal to make it to the next 'level' of the game (levelling up) through accomplishing certain tasks. While many computer games certainly develop stories by creating worlds with inhabitants that support an overarching narrative, spatial and temporal continuity are seldom disrupted in the way they commonly are in movies – through montage, jump cuts, flashbacks etc – or written stories and novels. Elements of storytelling that usually do not prominently feature in games are extensive dialogue and fully developed characters – after all, the game's players ultimately determine how the story unfolds for them. Emphasis on dialogue and character becomes more pronounced in multi-player games that create exchanges between players, or in games that feature virtual non-player characters with Artifical Intelligence (AI). AI attempts to generate heuristics, symbols, or rules to find solutions for problems of control, recognition, and object manipulation, and is commonly used in games for tasks such as collision control or behaviours such as fleeing, seeking and attacking. Another area of AI in games consists of human-machine communication and the creation of non-player characters who are capable of interaction and learning. The narrative potential of games still remains under-explored and has become an increasing focus of both the gaming industry and artistic investigation.

Some artists, such as Eddo Stern and Cory Arcangel, have also used and modified materials from existing computer games to create linear, digital movies. Stern's *Sheik Attack* 1999–2000 and *Vietnam Romance* 2003 are digital films that are entirely compiled from sampled computer games, graphics and music. While *Sheik Attack* puts viewers into the perspective of an Israeli commando on a mission inside Lebanon during the days before the Six Day War in 1966, *Vietnam Romance* remixes the Vietnam conflict as a nostalgic and romanticised experience. Stern's films foreground the military-corporate connection in the development of digital technologies and computer games and examine the effects of mediation in the creation of fantasies and ideologies.

The film installation *Super Mario Movie* 2005 by Cory Arcangel and Paper Rad (Ben Jones, Jessica Ciocci, and Jacob Ciocci), who developed the set design and screenplay, equally modifies existing materials in order to create a movie, but focuses on retro-aesthetics and the graphic language of old computer games. The *Super Mario Movie* – projected both onto a screen and architectural elements

Eddo Stern
Sheik Attack 2000
Digital video, sound

(stacked cubes) – consists of a cartridge of the 1984 video game *Super Mario Brothers 1*, to be played on the Nintendo Entertainment System (NES). Arcangel hacked the game cartridge and reprogrammed it to create a 15-minute movie that uses original graphics from the game but transforms it into a psychedelic fantasy world described by Arcangel as 'castles floating on rainbow colored 8bit clouds, waterfalls, underwater dungeon nightmare rave scapes, dance parties, floating / mushrooms level scenes, Mario alone on a cloud crying.' While the project labels itself and is experienced as a movie, it also points to fundamental differences between cinema and the digital moving image. The NES can potentially synthesise any sort of video signal but this 'video' is neither shot with a camera nor edited by means of computer technology: it purely consists of code and, in the case of *Super Mario Movie*, has been written from scratch by the artist (without altering the graphics chip that came with the original cartridge).

The previously outlined categories of the digital moving image – from immersive environments to interactive narratives and database cinema – certainly describe distinctive features of 'digital cinema', but it would be misleading to suggest that all projects can be clearly delineated according to this taxonomy. Many art projects exist between or combine several of the categories described above. John Klima's installation *Train* 2003–4, for example, is a non-linear cinematic narrative that unfolds in 3D moving images and incorporates elements of artificial intelligence and database cinema, yet presents itself as an installation. The artwork takes place on a physical model railroad with two trains that can be guided by the viewer's cellphones. As its cargo, each of the trains carries a Nintendo GameBoy, a hand-held game device, which shows

Cory Arcangel and Paper Rad
Super Mario Movie 2005
Handmade hacked Nintendo game cartridge, sound, Deitch Projects, New York

John Klima
Train 2003–4
Interactive mixed media
sculpture with
electronics, sound

a 3D model of the scenery as the train passes through. The 'landscape' depicted on the model railroad suggests scenes from eight movies – such as the beach scene in Roger Vadim's *And God Created Woman*, a factory with protesting workers (*Norma Rae*), punks in a desolate neighborhood (*Sid & Nancy*), and a painter with an easel in a landscape reminiscent of the South of France (*Lust for Life*). As viewers navigate the train through these scenes, they pick up characters from the respective movies – Brigitte Bardot, Norma Rae, Nancy Spungen, Vincent Van Gogh and others – which appear as 3D figures on the screen of the GameBoy. These seemingly mismatched characters – all outcasts and rebels in their respective societies – then start having a conversation, which is based on lines from the original movies. The artist collected sound clips from the movies in a database and wrote a so-called 'conversation engine' that relies on artificial intelligence to create dialogues that reflect the characters' respective personalities. On one layer, *Train* traces a technological evolution from the railroad and the telegraph – used for facilitating the signalling and scheduling of trains – to computing devices, which also incorporate switching and relay systems. On another layer, the artwork comments on the transformations in cinematic storytelling by creating virtualised actors that are modelled after their cinematic counterparts and 'screened' on mobile devices while original movie dialogue is remixed and scripted according to an artificial intelligence engine. *Train*, in particular, illustrates the modularity of the digital medium and its possibilities to reconfigure cinematic language on multiple levels.

Another example of an emergent movie script and dialogue is the online project *Unmovie* 2002 by Philip Pocock, onesandzeros, Gregor Stehle and Axel Heide. *Unmovie* is an open system of cinematic possibilities that unfolds on several platforms. On the 'Stage' of the project, visitors can engage in a dialogue with five characters ('actor-media'), which are represented by texts that they have written: Nietzsche is embodied by the entire text of *Beyond Good and Evil*; Dylan by his song lyrics; Tarkovsky by the book *Sculpting in Time*; Geisha by the chat log of an androgynous cyberlover character; and Dogen by the teachings of a thirteenth-century Zen master. Using artificial intelligence, the characters select and speak lines from their texts according to a simple underlying logic. When a user enters into a dialogue with the characters, they store his/her language, so that new vocabulary and syntax are introduced over time and change the characters themselves. The combined dialogue of visitors and the characters creates 'The Script', which in turn drives 'The Stream', a streaming movie constructed from net-videos stored in a database. These video segments are assembled according to links between the keywords associated with the clips and topics emerging on 'The Stage'. *Unmovie* relies on a fairly open system that results in the construction of ever-evolving associative scripts and image sequences that create an (un)movie.

The use of partly automated 'systems' for the creation of a movie that is shaped by the agency of artists/filmmakers, the audience and software is still in the experimental stages and raises multiple questions about agency and the function of fundamental elements of moviemaking (script and storyline, cinematography, actors, editing etc). There is no doubt that digital technologies will continue to affect cinema and its language in multiple ways. It remains to be seen whether our notion of cinema will be fundamentally transformed in the future or if digital technologies will lead to a hybridisation of the cinematic and a split into multiple forms of the moving image.

1 The presentation of moving images on multiple screens or on a spatial arrangement of projection surfaces. Abel Gance's epic silent film *Napoléon* 1927, which was made to be screened as a triptych via triple projection, was one of the first instances of the use of 'spatialisation'.

2 Michael Naimark's 'Dimensionalization Studies' began as an informal collaboration at Interval Research in 1993. The studies were based on deriving depth information from stereoscopic pairs of images, then turning the 2D pixels into 3D 'points in space'. The latter are similar to 3D computer models in that arbitrary viewpoints can be displayed but differ from them in that the computer has no 'knowledge' of any given scene's contents.

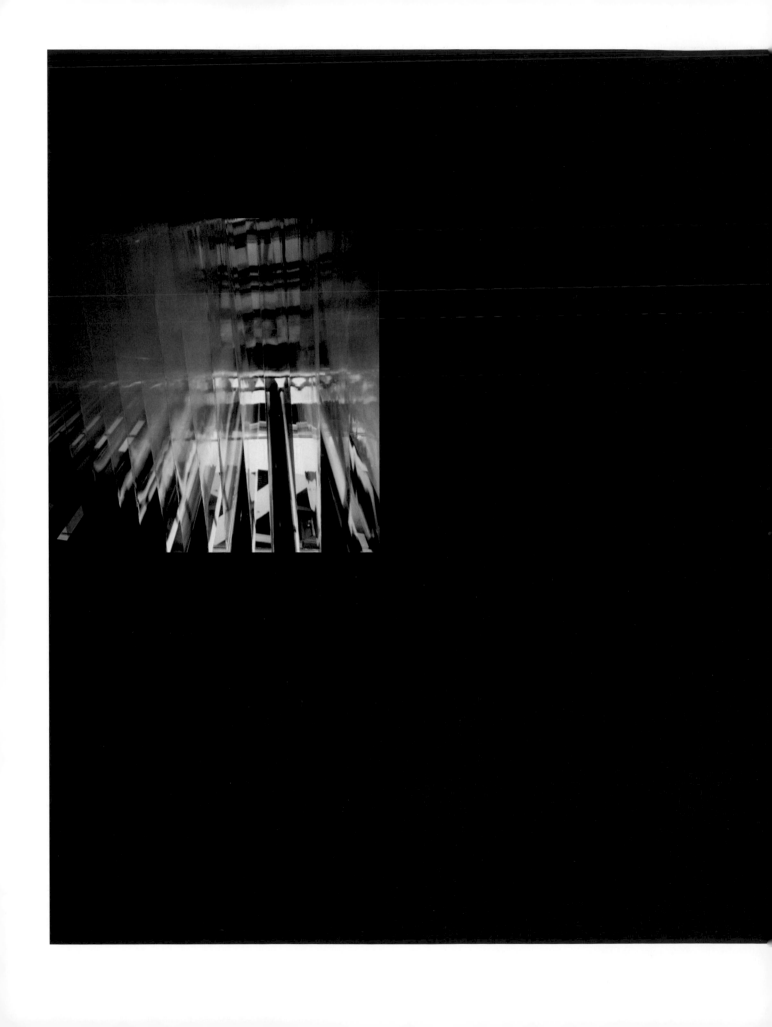

Pip Laurenson

VULNERABILITIES AND CONTINGENCIES IN FILM AND VIDEO ART

Introduction

The growing interest in artists' film and video made in the 1970s has meant that some early works are now entering the market for the first time. This raises questions about whether their identity should be determined by the historical period in which they were made, by the history of their display, or by the moment at which they are redefined for the market.[1] This essay looks at the particular vulnerabilities of time-based media works and the relationship of these questions to their conservation.

Vulnerabilities, conservation and the relationship to the medium

Time-based media works are vulnerable to two types of change. They can be stripped away from the medium in which they were made and they can be divorced from the conditions and technologies of their original display.

Whereas traditional artworks rely on physics to bind them to their supports, the relationships that tie time-based media works to a particular set of parameters are constructed. The material support of a work of art has traditionally been the focus of fine-art conservation. Charged with the responsibility to minimise loss and damage to the material elements of a work of art, the suggestion that conservation might need to broaden its sphere of interest sits, somewhat uncomfortably, as a threatened loss of clarity to its traditional remit. Within the conservation of modern art, the formalism characterised by Clement Greenberg, with its reductive focus on the physical medium, was in accord with the concerns of traditional conservation. However, in the art that reacted to Greenberg, the relationship to the materials changed, rendering the material form, as Robert Morris famously put it, 'less *self* important', with aesthetic terms of reference existing as 'unfixed variables that find their specific definition in the particular space and light and physical viewpoint of the spectator'.[2]

When artists employed found or industrially fabricated objects in the creation of their works, their relationship to and interaction with their materials changed radically. However, despite this, an object remained the result. This enabled conservation to carry on as if the conservation object had not undergone this radical change.

Lying somewhere on a continuum between performance and sculpture, the time-based media installation lacks a material object that can be identified as 'the work', undermining the traditional notion of what constitutes the object of conservation. The relationship between the particular aspects of the medium and the identity of the work is not a given, but is both constructed and uncovered in the development of the identity of the work. This process has a particular relationship to time. Given that time-based media works are dependent on technologies that become obsolete, the myth of the timeless art object is quickly exposed. The work's identity comes rapidly into question as external pressures for change take hold and decisions as to what can change and what must remain have to be made. For example, a once-ubiquitous piece of equipment like a slide projector is now an object for specialist enthusiasts, and a technology that once symbolised a connection between art and the everyday is now obsolete. In the conservation of artists' installations that employ time-based media, the fact that the work only truly exists in its installed state refocuses the conservator's attention on the intangible and the temporary. However, this temporary quality may not have been apparent, or of interest, to the artist when making the work, since installing it in the gallery gives the illusion of completing it in a form that will persist.

The incidental and the significant

Entering a corridor within a museum to see Bruce Nauman's *Art Make-up* 1967, I hear the sound of a 16mm film projector. Once inside the room, however, I see

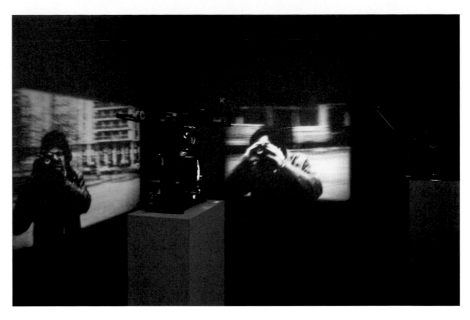

four images that were shot on film but are now on video. The contrast is low; if
you look closely, you see that the surface of the image is constructed from the
pixel blocks of a liquid-crystal panel of a video projector and the picture has none
of the clarity of a film image. The caption reads:

> 16mm film 4 parts:
> No. 1 white, color, silent, 10 min.
> No. 2 Pink, color, silent, 10 min.
> No. 3 Green, color, sound, 10 min.
> No. 4 Black, color, sound, 10 min.

The first line refers to the medium in which the work was made and originally
shown, but the addition of 'sound' to the description of the third and fourth
channels refers to the later addition of the sound of a film projector to the video.
The message is mixed.

Although it is still possible to see that the work was shot on film, the direct
link to the original technology of its production and display has been lost, bar the
addition of the sound of the film projector to the otherwise silent image. Nauman
gives the following reason for his decision to add the soundtrack of the film
projector to the video image:

Pip Laurenson *Was the decision made because of the interest in the experience of the
viewer? The sound being part of that?*
Bruce Nauman *Yes, because no sound is also different – silent projection – and because
it is a reproduction of the original rather than the original, it's an odd thing to think
about. I wasn't particularly interested in having ... the projector [visible] on the DVD,
that wasn't part of the piece necessarily.*
PL *So, in a way, the aspect that you originally experienced was only the sound because
the projector was out of view?*
BN *Yes.*
PL *But I guess some people would know they are looking at ...*
BN *... a film rather than video.*
PL *Would you rather it was shown on film? Does it bother you when those sorts of links
get broken down? Some artists talk about authenticity in this context.*
BN *The technology is still not that hard to come by, so you could do it that way if you
wanted to. I think it's when you're dealing with having to maintain some technology that
pretty much has gone, you have to decide whether that's really part of the piece or if it can
be changed ... There's a certain kind of precision in film that is different to video and if it's
important to maintain that then you have to pay attention to it.*

Not all change is loss, and all loss – whether it concerns the fading of a watercolour or the distortion of a Naum Gabo sculpture rendered in a mutable plastic – is incremental. Nauman succinctly sums up the issue: 'You have to decide whether that's really part of the piece or if it can be changed.'[3] In the context of *Art Make-up* (and these decisions are work-specific) he came to the conclusion that film was not a necessary part of the work but that the sound of the projector was. This seemingly minor decision points to the extraordinary capability of time-based media works of art to allow for decisions to be made to save certain elements of the originating medium whilst discarding others. What this quote from Nauman demonstrates is that the artist is able to define the relationship of their work to their medium and can, to some extent, pick and choose what to save and what to discard.[4] What is considered to be the work can be physically peeled away from the technologies originally used to make and display it and, although qualitatively different, the work remains recognisable. Residue from these technologies remain: a particular quality in the colour, a certain layering of textures, film scratches, audio pops or constraints of duration.

There is obviously something in the logic of these reproducible media that allows, and in fact necessitates, these shifts between formats and technologies. For example, in the world of analogue media, the negative is distinct from the film print, the master video from the sub-master; the format the work is shot on is not the same as that used for display. The digital clone collapses older analogue distinctions, and the fast-changing technological environment races from a new format to obsolescence well within an artist's lifetime. Add to this the broadening of the scope of what can be considered the artistic medium to include other genres and phenomena such as fiction[5] and we see how the focus of conservation might mirror this shift to become liberated from the purely material.

The conservation of time-based media works of art
The conservation of time-based media works is organised around the articulation of the decisions (to paraphrase Nauman) of what is part of the work and what can be changed. Its role is to ensure that we can continue to display the work in the future and that what is displayed can be judged as the 'same' work. Here, as in the performance of musical works, the concept of the 'same' is understood through a notion of identity reached through 'work-defining properties'. The nature of these work-defining properties will depend, in part, on the artist and how they chose to specify the conditions for their art.[6]

The conservation of film and video requires pre-emptive activity from the moment a work is made. At Tate, for video works, an archival master is produced from the best available artist's master and held in a dry, cool environment on a professional uncompressed format, which is then migrated (transferred to new stock and if necessary new formats) every five to seven years. In the next few years, we will see a move to the storage of uncompressed video as data on servers and data-tape formats such as LTO.

At Tate it is not unusual to show 16mm film works in the gallery for periods of either six or twelve months. This requires the production of a large numbers of prints. Since it is unlikely that the artist will relinquish their negative, especially in the case of an editioned work, Tate acquires an inter-positive, two inter-negatives and two check prints, as well as a print that has been supplied by the artist as reference for grading. In addition, the sound elements of the film are archived as a digital file and an optical-sound negative. These components enable Tate to work with the few remaining laboratories processing 16mm film to produce accurate and good-quality prints. The archival material for film is kept in a specialised sub-zero humidity-controlled store.

While many technical challenges in the preservation of film and video have been successfully addressed, new challenges, like the impending obsolescence of

film and the shift to the use of computers in the production of an interactive video environment, constantly emerge. Although the preservation of the media elements is central to the role of conservation, the greater challenge is to understand what, of both the tangible and intangible elements, it is that we are trying to preserve. There are technical and conceptual problems concerned with what can be changed and what must be saved. The criteria used to decide what is important to preserve are what render the conservation of time-based media works of art different from that of an archive. Part of that difference is that the significance of the medium goes beyond its role as a carrier for an image.

Meaning and the medium

It is about life ... which is what film is about
Dan Graham[7]

The value that an artist finds in a particular medium for a time-based work will determine their attitude to whether it is important that the relationship with that medium is maintained in future displays. Decisions made to use a medium when it is ubiquitous are very different from those made when it is on the verge of obsolescence. In the early 1970s artists like Dan Graham were working with film and also beginning to experiment with video. At this time it was video that was large, cumbersome, expensive and constraining compared to 8mm and Super-8mm film, which could be sent away for processing at the local pharmacy and came back the next day. For Graham, his use of film was about immediacy and the everyday.

> I was attracted to film for the same reason I was attracted to the photos of conceptual art. It was because you could use a fixed-focus instamatic camera and you had these very inexpensive Technicolor loop projectors. So the presentation was simple, basic, elementary, cheap ... The great thing about the films was that I could do them outside the studio. They became landscape pieces. It's an advantage that you couldn't get with video at the time.[8]

The connotations of 8mm film in the 1970s are very different from the use of film by an artist today, in the dying days of the medium. Now it is video that is ubiquitous, instant, easy to use and cheap.

Some artists working today may decide to use film as a material in making a particular work but not as a display medium. For example Rosalind Nashashibi, when talking about her work *Hreash House* 2004, speaks of how the process of shooting on film infuses structure and discipline into the way she works. Using a 100ft film magazine running at 24 frames per second means that each magazine will capture approximately two minutes of footage. Nashashibi describes this engagement as a performative aspect of working with film. This, and the fact that film does not allow her instant playback of her footage, helps her to capture the energy of a situation.[9] However, in this instance she decided to display the work as video.

Of artists currently working in film, it is Tacita Dean's installations that are completely embedded in the apparatus of the medium. For her, film is about time and the trapping of light within the physical strip of 'celluloid'.[10] She also consciously employs an analogue display medium through which you can hear time passing like 'the prickled silence of mute magnetic tape or the static on a record'.[11] Dean is unequivocal about the profound connection of her works to film. From the moment she conceives of a piece, it is developed within the constraints of film. In contrast to the passive eye of video every element of film is actively constructed, decisions have to be made about time, light and focus and the sound has to be constructed and added as a later part of the process. As Dean puts it, 'It's a medium of illusion and artifice'.[12] Because of the centrality of film to

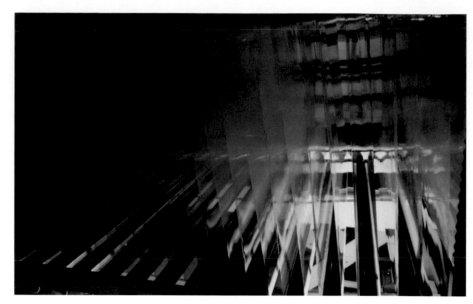

her work, Dean has been forced to confront the impending obsolescence of her medium. 'Obsolescence is about time in the way film is about time: historical time; allegorical time; analogue time'.[13]

There is a marked contrast between the precision with which artists are currently choosing film as a medium and the carelessness of a discourse within which 'film' and 'video' are used interchangeably within the art market. Here the legend '16mm film transferred to DVD' has become a common if impenetrable statement. It might be a reflection of how the work was made, a comment about the history of the work, evidence of an act of what has been termed 'remediation'[14] or a description of a work made at an earlier time and now repackaged in a convenient collectable form for the purposes of sale. A video may also be called a 'film' to give it a sense of seriousness and weight, even if this bears no relationship to either its natal or actual material reality.

Within contemporary art museums, historical accuracy is not highly valued with regard to media technologies. Some artists may feel that using technologies that have now become rare is out of keeping with the spirit in which the work was made, tying a work anachronistically to a particular time. It is unclear whether the contemporary art museum has a responsibility to represent this relationship to history in the way the work is displayed. There is understandable curatorial uncertainty about whether these ties are incidental (or even the criteria used to make these judgements, with some very clear exceptions where the artists themselves have insisted on these relationships being maintained).

As with the relationship to its medium, the relationship of a time-based media work to the technologies and conditions of display are mutable. This means that if they are considered to be part of what defines the work, then this must be explicitly specified. At the moment when the work is made, in the majority of cases, the fast-changing technological environment on which these works depend is invisible. For artists to construct these relationships they need to be prompted to imagine the future and often this is a function of being collected by a museum.

The time-scale of the museum is beyond the scope of what is customarily considered by artists entering a collection and a consideration of the historic may well be beyond the point an artist wants to consider the future of their work. At some point these challenges become the responsibility of the museum. For example Dean makes a distinction between the obsolete and the rare, the former being a concept which is central to her work and the later being something that no longer interests her.[15] This shift will purely be a factor of time: problematically, with technology based works, potentially less than the time it takes for a work to

move from a contemporary art museum to an historic art museum. Just as the narrow understanding of medium as material support has been challenged and subsequently expanded, this extended understanding of the notion of the medium has catapulted conservation into broader domains.

Conclusion

The conservation of time-based media works becomes a question of relationships and dependencies; for example, the importance of each element of the work as displayed at a particular time in a particular place to its enduring identity and certain logical relationships, such as the relationship of the medium in which the work was constructed to the way in which it is displayed.

Although the artist is not the only voice to determine what is important to preserve in a work, it is certainly the primary voice early in the life of a work. Artists working within the context of museums that collect their works and a buoyant art market are likely to be asked questions relating to the future of their work early on. Where this discourse becomes problematic is when these questions are asked retrospectively about works made within a different context, when there was little market for them and few museums were buying artists' film and video.

Many works were originally created and shown in a non-museum context and come to the museum in a secondary form; a derivative. Others were never intended as public pieces but are now repackaged for a booming market. In the majority of cases, the responsibility is passed to the artist to say what must stay and what can be changed. The media and conditions of display may be physically contingent, but this does not mean that they are incidental. In many ways, time-based media installations are presented in our museums as if their material identity were as defined and persistent as a painting. It is as though their absorption by the museum and their integration into collections serves to conceal their different nature. In navigating this territory, conservation must not only continue to preserve the ability to display these works, but must also record the back story for decisions made about the forms in which they are realised, both now, in the past and in our projections into the future.

1 For a broader discussion of the concept of identity for time-based media works of art see P. Laurenson, 'Authenticity, change and loss in the conservation of time-based media installations' in *(Im)permanence: Cultures in / out of time*, Center for the Arts in Society, Carnegie Mellon University, Pittsburgh 2008.

2 Robert Morris, 'Notes on Sculpture Part II', *Art Forum*, no.5, 1966, pp.22–3.

3 Bruce Nauman, unpublished interview with Pip Laurenson, Bryony Bery, Jane Burton, Tate, London 2004.

4 Interestingly, Nauman awards himself no special authority over this decision, leaving open the possibility that others might make a different decision.

5 See Rosalind Krauss, *A Voyage on the North Sea: Art in the Age of the Post-Medium Condition* for an exploration of the idea that Marcel Broodthaers's medium is fiction (Krauss 2000 p.46–7).

6 P. Laurenson, 'Authenticity, change and loss in the conservation of time-based media installations' in Judith Schachter and Stephen Brockmann (eds.), *(Im)permanence: Cultures in / out of Time*, Pittsburgh 2008.

7 Dan Graham describing *Sunrise to Sunset* 1969 in an interview by Eric de Bruyn in A. Alberro (ed.), *Two-way Mirror Power: Selected Writings by Dan Graham on his Art*, Cambridge and London 1999, p.98.

8 Ibid., p.105.

9 R. Nashashibi, unpublished interview with Pip Laurenson, Tate, London 2006.

10 'Celluloid' is used here in the generic sense of photographic film rather than the specific original sense of cellulose nitrate and a plasticiser such as camphor.

11 Tacita Dean in G. Baker (ed.), 'Artist Questionnaire: 21 Responses', *October*, no.100, 2002, p.26.

12 Tacita Dean quoted in M. Gronlund, 'Artworker of the week No. 60: Tacita Dean', *Kulturflash*, 6 July 2006, p.171.

13 Tacita Dean in Baker 2002, p.26.

14 J.D. Bolter and R.A. Grusin, *Remediation: Understanding New Media*, Cambridge and London 1999.

15 Tacita Dean in Baker 2002, p.26.

FURTHER READING

Editor's Note

George Baker, Matthew Buckingham, Hal Foster, Chrissie Iles, Anthony McCall, and Malcolm Turvey, 'Round Table: The Projected Image in Contemporary Art', *October*, vol.104, Spring 2003, pp. 71–96.

David Curtis, *A History of Artists' Film and Video in Britain, 1897–2004*, London 2006.

Gilles Deleuze, *Cinema 1: The Movement-Image*, trans. H. Tomlinson and B. Habberjam, London 1986.

Gilles Deleuze, *Cinema 2: The Time-Image*, trans. H. Tomlinson and R. Galeta, London 1989.

Noam M. Elcott, 'Darkened Rooms: A Geneaology of Avant-Garde Filmstrips from Man Ray to the London Film-Makers' Co-op and Back Again', *Grey Room*, vol.30, Winter 2008, pp.6–37.

Anne Friedberg, *The Virtual Window: From Alberti to Microsoft*, Cambridge, Mass. 2006.

Jörg Heiser, *All of a Sudden: Things that Matter in Contemporary Art*, Berlin 2008.

Chrissie Iles (ed.), *Into the Light. The Projected Image in Contemporary Art 1964–1977*, New York 2001.

Malcolm Le Grice, *Experimental Cinema in the Digital Age*, London 2001.

Tanya Leighton (ed.), *Art and the Moving Image: A Critical Reader*, London and New York 2008.

Matthias Michalka (ed.), *X-Screen: Film Installations and Actions in the 1960s and 1970s*, Cologne 2004.

Mike Sperlinger and Ian White (eds.), *Kinomuseum: Towards an Artists' Cinema*, Cologne 2008.

Life Itself! The Problem of Pre-Cinema

Eric Kluitenberg (ed.), *Book of Imaginary Media*, Rotterdam 2007.

Laurent Mannoni, *The Great Art of Light and Shadow: Archaeology of the Cinema*, trans. Richard Crangle, Exeter 2000.

Philippe-Alain Michaud, *Aby Warburg and the Image in Motion*, trans. Sophie Hawkes, New York 2004.

Laurent Mannoni, Werner Nekes, Marina Warner, *Eyes, Lies and Illusions: The Art of Deception*, London 2004.

Marina Warner, *Phantasmagoria*, Oxford 2006.

Movements in Film

Kerry Brougher et al, *Visual Music: Synaesthesia in Art and Music Since 1900*, New York 2005.

David Curtis, *A History of Artists' Film in Britain*, London 2008.

Peter Gidal, *Materialist Film*, London 1989.

Alexander Graf and Dietrich Scheunemann (eds.), *Avant-garde Film*, Amsterdam 2007.

Jackie Hatfield (ed.), *Experimental Film and Video*, Eastleigh 2006.

Standish Lawdor, *Cubist Cinema*, New York 1975.

Chris Meigh-Andrews, *A History of Video Art*, Oxford 2006.

A.L. Rees, *A History of Experimental Film and Video*, London 1999.

P. Adams Sitney, *Visionary Film: The American Avant-Garde, 1943–2000*, New York 2002.

An Art of Temporality

Gregory Battcock (ed.), *New Artists Video: A Critical Anthology*, New York 1978.

Dara Birnbaum, *Rough Edits: Popular Image Video*, Halifax 1987.

Benjamin Buchloh and Dan Graham (eds.), *Video Architecture Television: Writing on Video and Video Works*, Halifax 1979.

Douglas Crimp (ed.), *Joan Jonas: Scripts and Descriptions, 1968–82*. Berkeley 1983.

Stan Douglas and Christopher Eamon (eds.), *Elsewhere: The Cinematographic in Art*, Stuttgart 2008.

Gary Hill, Chrissie Iles and Heinz Liesbrock, *Gary Hill: Selected Works & Catalogue Raisonne*, Cologne 2001.

Branden W. Joseph, *Beyond the Dream Syndicate: Tony Conrad and the Arts after Cage*, Cambridge, Mass. 2008.

Constance M. Lewallen (ed.), *A Rose Has No Teeth: Bruce Nauman in the 1960s*, Berkeley 2007.

Barbara London (ed.), *Bill Viola*, exh. cat., Museum of Modern Art, New York 1987.

Matthias Michalka (ed.), *X-Screen: Film Installations and Actions in the 1960s and 1970s*, Cologne 2004.

Gene Youngblood, *Expanded Cinema*, New York 1970.

Moving Image in the Gallery in the 1990s

Stefano Basilico, Lawrence Lessig and Rob Yeo, *Cut: Film as Found Object in Contemporary Video*, Milwaukee 2004.

Daniel Birnbaum, *Chronology*, New York 2005, 2nd ed. 2007.

Claire Bishop, *Installation Art: A Critical History*, London 2005.

David Campany, *The Cinematic*, London and Cambridge, Mass. 2007.

Catherine Elwes, *Video Art: A Guided Tour*, London 2004.

David Green and Joanna Lowry, *Stillness and Time: Photography and the Moving Image*, Brighton 2006.

Boris Groys, 'On the Aesthetics of Video Installations' in Peter Pakesch (ed.), *Stan Douglas: Le Detroit*, Basel 2001.

Laura Mulvey, *Death 24x a Second: Stillness and the Moving Image*, London 2006.

Patrice Petro (ed.), *Fugitive Images: From Photography to Video*, Bloomington 1995.

David A. Ross, *Seeing Time: Selections From the Pamela and Richard Kramlich Collection of Media*, exh. cat., San Francisco Museum of Modern Art 1999.

Jean-Christophe Royoux, 'Cinema as Exhibition, Duration as Space', *Artpress*, vol.262, Nov. 2000, pp.36–41.

Michael Rush, *Video Art*, New York 2007.

TV Against TV: Video Art on Television

Doug Hall and Sally Jo Fifer (eds.), *Illuminating Video: An Essential Guide to Video Art*, New York 1990.

John G. Hanhardt (ed.), *Video Culture: A Critical Investigation*, New York 1986.

Julia Knight (ed.), *Diverse Practices: A Critical Reader on British Video Art*, Luton 1996.

Dorine Mignot (ed.), *Revision: Art Programmes of European Television Stations*, Amsterdam 1987.

Michael Renov and Erika Suderberg (eds.), *Resolutions*, Minneapolis 1996.

Ira Schneider and Beryl Korot (eds.), *Video Art: An Anthology*, New York and London 1976.

FURTHER READING

Expanding Cinema:
The Moving Image in Digital Art

Project URLs

Diller + Scofidio, *Refresh*
 www.diaart.org/dillerscofidio
Toni Dove:
Artificial Changelings
 www.tonidove.com
Spectropia
 www.tonidove.com
John Klima, *Train*
 www.cityarts.com/train/index.html
Jennifer and Kevin McCoy, www.mccoyspace.com
Soft Rains
 www.flickr.com/photos/mccoyspace/sets/126343
Every Shot Every Episode
 www.flickr.com/photos/mccoyspace/sets/124273
How I Learned
 www.flickr.com/photos/mccoyspace/sets/327764
Michael Naimark, *Be Now Here*
 www.naimark.net/projects/benowhere.html
Josh On and Futurefarmers, *Anti-Wargame*
 www.antiwargame.org
Jeffrey Shaw, *Place – a user's manual*
 www.jeffrey-shaw.net/html_main/frameset-works.p
 hp3
Eddo Stern:
Sheik Attack
 www.eddostern.com/sheik_attack.html
Vietnam Romance
 www.eddostern.com/vietnam_romance.html
Thomson & Craighead:
Short Films About Flying
 www.thomson-craighead.net/docs/sfaff.html
Template Cinema
 www.templatecinema.com

Books

Christov Bakargiev, *Animations*, exh. cat., PSI
 Contemporary Art Center, New York 2002.
Sean Cubitt, *The Cinema Effect*, Cambridge, Mass. 2005.
Jeffrey Shaw and Peter Weibel (eds.), *Future Cinema: The
 Cinematic Imaginary after Film*, Cambridge, Mass.
 2003.
Lev Manovich and Andreas Kratky, *Soft Cinema:
 Navigating the Database* (DVD with 40-page booklet),
 Cambridge, Mass. 2005.

Vulnerabilities and Contingencies in
Film and Video Art

Electronic Arts Intermix
 http://resourceguide.eai.org
Matters in Media Art
 www.tate.org.uk/research/tateresearch/
 majorprojects/mediamatters/
Chrissie Iles and Henriette Huldisch, 'Keeping Time:
 On Collecting Film and Video Art in the Museum', in
 Bruce Altshuler (ed.), *Collecting the New: Museums and
 Contemporary Art*, Princeton 2005.
J. Sterrett and C. Christopherson, 'Toward an
 Institutional Policy for Re-mastering and
 Conservation of Art on Videotape at the San
 Francisco Museum of Modern Art' in S.J. Fifer et al
 (eds.), *Playback: A Preservation Primer for Video*, San
 Francisco 1998, pp.55–59.
Bill Viola, 'Permanent Impermanence' in M.A. Corzo,
 Mortality Immortality?: The Legacy of 20th-Century Art,
 Los Angeles 1999, pp.85–94.

COPYRIGHT

PHOTOCREDITS

INDEX

INDEX

INDEX